M000223189

108

1966. Walker Evans

New York in Photobooks

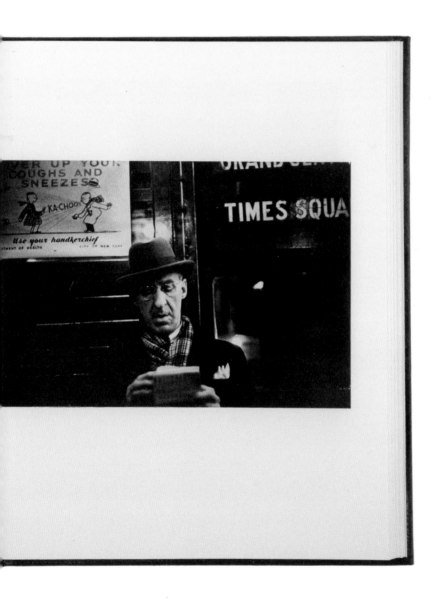

Edited by Horacio Fernández
RM
Centro José Guerrero

Characterized by its willingness to try out different exhibition formats suited to the expression of new artistic, critical, or theoretical visions, the Centro José Guerrero has always considered photography one of its priority interests. This is to be expected of an institution devoted to the exploration of and debate around contemporary culture. Photography and cinema configured the imaginary of the twentieth century and, although they have undergone a profound transformation in the twenty-first, the effects of their symbolic hegemony persist, even in other increasingly predominant forms of communication. Although these forms may have emerged out of the framework of digital culture, they follow in large measure the path of those tutelary languages.

Certain scientific paradigms have also changed as we now approach this study. The vehicles of the transmission of photography have been more closely examined. Instead of understanding photographic images as autonomous entities, isolated like works in a museum (the photo as painting), a more organic approach has gained increased importance, with an emphasis on the historical contexts in which photographs have circulated: predominantly newspapers, magazines, and books.

Horacio Fernández is one of the pioneers of the history of the photobook, on the strength not only of his publications, but also of his concern to free up the ways in which this new museum object can be displayed in an exhibition hall. In this respect, *New York in Photobooks* is one more chapter in the general history of the photobook.

New York wrested from Paris the title of "capital of modernity" in the course of the twentieth century. In Granada we have a certain familiarity with the metropolis. It is linked to the memory of José Guerrero, but also to that of the García Lorca family (firstly by its impact on the poet, and then because it welcomed his family) and to that of many of our contemporary creators, and not just visual artists and writers. Living there today, for example, are the conductor Pablo Heras Casado and the singer-songwriter Lara Bello.

It makes sense: as the iconic city of modernity, New York has been a focus of worldwide attention, an object of contemplation and astonishment to the most diverse sensibilities. It is not surprising, therefore, that it has inspired so many photobooks by so many photographers around the world: a rich panorama that includes all the genres.

This book and the exhibition it accompanies provide an enjoyable vision of that panorama. A vision not entirely free of nostalgia, since it is also inevitably a vision of the past and of the cultural and emotional landscape that nourished the dreams (and nightmares) of several generations, including our own, whatever our age may be.

Fátima Gómez Abad
Cultura y Memoria Histórica y Democrática

New York in Photobooks
Horacio Fernández

Like so many other cities, New York is photogenic. It is full of little corners where one pauses to frame an image and snap the shutter, obtaining what will probably be just another commonplace photo, one more looked for than found, all too familiar beforehand. The snapshots of photo-tourism, happy relics of a bygone futurism, are *de rigueur* in Metropolis, Gotham City, the Big Apple, Cosmopolis, or whatever New York is called.

Better to set aside the old postcards and eternal souvenirs, for New York is also omnipresent. It is the setting of countless representations, frequently not only supplying the context, but even becoming part of the plot. It plays of course a central role in *On the Town, A Bronx Tale, Manhattan, King Kong*, and *Taxi Driver*, to mention but the tip of the iceberg of a long line of motion pictures. It can be heard in the voices of Sinatra, Lou Reed, and Joey Ramone. It is art and part of the stories of James Baldwin, Djuna Barnes, Isaac Bashevis Singer, John Cheever, Nabokov, and Richard Price. It is present in the poems of Hart Crane, García Lorca, Ginsberg, Langston Hughes, Mayakovski, Frank O'Hara, and Whitman. It is the raw material of novels by Auster, Bellow, DeLillo, Dos Passos, Dreiser, Fitzgerald, Salinger, Capote, Puzo, Roth, and Wolfe.

At the same time, New York is an important subject of that kind of narrative composed of photographs arranged on a support of paper and glue, fragile and yet resistant, which since the Renaissance we have called a book. Photobooks, to be precise, unique and intimate on private shelves, multiple and accessible in libraries and bookstores. They constitute a decisive part of our past, remaining with us and likely to continue to do so in the future, though they may change their appearance now and then.

Books are to be looked at and to be read. Photobooks, moreover, possess a particular defining characteristic: in them, the images are the "text," a text to be read. The sense of the reading is produced every time a page is turned, feeding the flame of a narrative that may be as descriptive or a metaphorical as any other offered by words alone. But in this case, the rhythm of the sequence of images creates continuity and redeems the original sin of the photograph, which is generally isolated from what precedes and what follows it: a pure frozen present, with no more past or future than some imagined ellipse. This limitation is happily resolved in a motion picture, which a photobook resembles much more than it resembles a collection of paintings in a museum.

Every photobook is a forest proud of its individual trees, a group of images that are neither autonomous nor obliged to be confined within a frame in order to gain a sense of their own identity or essence. On the contrary, in these books, photos are the subordinated clauses of a text with a beginning and an end: a mosaic that only acquires meaning when all the parts combine to make a coherent and legible whole.

There many, many books about New York with photographs in them. If you write "New York pictorial works" in the search engine of the OCLC, it turns up forty thousand titles. If you add the word "photography," the figure is considerably reduced, but the engine still shows more than 5,600 books in thirty different languages. Obviously they are not all photobooks, but there are still far more

photobooks among them than contained in *New York in Photobooks*, a selection that makes no pretention to canonicity and has the modest aim of making better known fifty magnificent examples, commented on by the varied voices of a good company of artists, collectors, museum conservators, curators, editors, writers, photographers, historians, and journalists. *New York in Photobooks* seeks to deal with the city of skyscrapers in as many different ways, and from as many different angles, as possible. In other words, it is a selection of photobooks about, according to, against, before, behind, beneath, between, by, from, in, next to, of, on top of, out of, towards, under, until, with, and without... New York.

The first on the list is *Empire State: A History* (1931), published by a real estate developer, which boast of numbers (all world records), tons of material, giddy construction feats (in the famous photographs of Lewis W. Hine), and above all the tall, heavy, dizzying piles of money spent and invested. It is a book placed at the service of cold hard cash and of the most stereotypical icon of the city, the skyscraper, which plays the starring role or has a cameo appearance in almost all the books to follow, including a collective work about 9/11, which closes out the selection.

Here is New York (2002) has an urgency about it: it is a farewell to a city that will never be the same, the interment of suddenly obsolete ways of taking photos, and a monument to the people who lived through that day with their digital cameras. A genuine "photographic democracy" in terms of authorship, content, and form. More than nine hundred images by almost five hundred photographers who together tell a story full of details, a choral portrait of the city in which architecture is less important than people: the demonstration that cities are made of flesh, not of stone.

Between these two extremes, some of the photobooks celebrate the city, making the reader feel proud to share the lives of others. *The Sweet Flypaper of Life* (1955), for example, one of the masterpieces of the genre, a collaboration between the photographer Roy DeCarava and the writer Langston Hughes, who tell the story of the everyday lives of the ordinary people in Harlem as an uninterrupted succession of marvels. The book confirms in passing the notion that the extraordinary things about life are not hidden: it is simply very difficult sometimes to see them.

Literature and photography make a good couple in *The Sweet Flypaper of Life* and in many other photobooks, as for example *The Bridge* (1930), by poet Hart Crane and photographer Walker Evans, one of the important New York photobooks that is missing from this limited selection. Present, on the other hand, are literary photobooks such as *New York* (1956), a collection of images by various photographers introduced by Françoise Sagan, and *Le New York d'Arrabal* (1973), with photos and supposedly scandalous commentaries by the writer Fernando Arrabal. More singular is the 1966 edition of García Lorca's *Poeta en Nueva York*, from the beautiful Palabra e Imagen collection, with photos by Maspons + Ubiña that fulfill at least in part the original intentions of the poet, who wanted his verses—"my soul in photographs and lilies"—to be accompanied by photos (which unfortunately we will never see).

A Way of Seeing (1965) is another banquet, a genuine celebration of bustling New York street life through the knowing and sympathetic gaze of Helen Levitt. The photos by Sam Falk in *New York True North* (1964) also extol the city, which in the 1960s was going through one of its finest hours, at the zenith of its political, economic, and cultural influence. The decline, however, followed immediately thereafter: the collapse of many values mistakenly believed to have been eternal.

New York kontrasternas stad (1969) shows the joyful and carefree face of the city and its people, but also contains all too many glimpses of a more disturbing underside. The spectacle of politics, increasingly polarized, and the almost continual contrast

between the best and the worst astonished the author, Hasse Persson, a traveler/photographer, who had been spoiled at home by the comforts of the welfare state.

Persson was a foreigner in New York who later became a New Yorker, like other authors of photobooks in our selection, wandering photographers who sooner or later found themselves in New York and undertook a series about the city which would end up being a photobook published perhaps in Utrecht, like the bestselling paperback *Hier is New York* (1960), with photos, almost always in dialogue with others, by Kees Scherer, or perhaps in Prague, where in 1966 there appeared the beautiful *New York*, designed by Jaroslav Fišer out of a handful of souvenirs, the words of Miroslav Holub, and the photographs of Eva Fuková, Milo Novotný, and Marie Šechtlová.

There are variations on the classic travel book (illustrated for many years with engravings and then later with photographs), beloved of those lazy but curious readers who prefer to travel without leaving home and to participate in the adventures of others as if they were their own. In these books, seeing (as the saying goes) is believing, but also discovering and even knowing, an illusion that tends to require a convincing text to go along with the photos.

A travel photobook in which illustrator (both photos and drawings) and writer coincide is *Cecil Beaton's New York* (1938). They suited each other so well that the prepared photos, the snapshots, and the shorthand text are greater than the sum of their parts, describing, evoking, and commenting on an effervescent urban life which, in the second edition, ten years later, has lost some of its fizz. Less appealing are *Greenwich Village Today & Yesterday*, with close-up photos by Berenice Abbott of the New York neighborhood par excellence around 1949, and the children's photobook *Young Folks' New York* (1960), by Suzanne Szasz, an exhaustive guide for young and old alike.

Deserving of special mention is a sentimental traveler, André Kertész, who settled in New York and in 1976 devoted a splendid textless photobook to the city, *Of New York...*, in which many of his classic photographs are reproduced by a strangely silvery photogravure process. Kertész's photos are always balanced and elegantly composed, but there are some, more unsettling and even premonitory of dire events, that reveal a wizard capable of experimenting with both modernity and tradition, two elusive concepts pursued in fleeting, even evasive, situations which are nevertheless captured with docility by the gaze and technique of the master.

New York Proclaimed (1965) is another marvelous travel photobook, this time with images by Evelyn Hofer and a text by V. S. Pritchett. It presents Hofer's trademark imperial portraits of ordinary people, alongside details of spectacular New York architecture, all immaculately printed. A successful combination, often repeated, which the photographer Victor Laredo invokes in the title of his 1964 photobook, which reveals not a trace of dehumanization: *New York People & Places*.

Sometimes the place conceals the people, as in the monumental *Manhattan Magic* (1937) by another traveler: Mario Bucovich. In her masterpiece *Changing New York* (1939), Berenice Abbott documented the thousand faces of a city in a process of continual transformation, in which the lifespan of buildings is barely fifty years, and the pressure exerted by money suppresses any temptation of nostalgia. As the poet James Merrill wrote in 1962: "As usual in New York, everything is torn down / Before you have had time to care for it."

A singular piece in this record of the continual exclusion of the past in the history of New York (free of archaeological remains) is *The Destruction of Lower Manhattan*

(1969), in which Danny Lyon documents the demolition of an entire neighborhood, undertaken in order to build another one and to erect, among other things, the Twin Towers, whose destruction by terrorists would mark a before and after in the symbolic significance of the skyscraper and of the city itself.

There are photobooks in favor of and against New York. In general, the criticisms are rather more complicated than what one sees on television. Then there are the propaganda sermons in photobook form, some of them genuine super-productions commissioned by governments that are not required to give explanations about their decisions or their expenditures. Books that sometimes make a big impact, in spite of their content. But there are no such grandiloquent photobooks about New York, although there are some modest ones, such as *Harlem Stirs* (1966), an indictment by Anthony Aviles and Don Charles of social inequalities, which also happen to be racial barriers. The intention of the book is transparently clear: to contribute, through words and images, to changing things, or at least to denouncing injustices.

In any case, there are aspects of New York that automatically elicit sympathy, as for example the diversity of its inhabitants, almost all of whom have come from somewhere else. This is the case of many big cities, but it is by no means so noticeable in all of them. New York is an open city in which there seems to be room for everything and almost everyone, even the most minor of minorities. Jan Yoors's photobook *Only One New York* (1965) is dedicated to all these *metics* of a city without any identity of its own, except that of all the identities it contains: a genuine treasury of differences that make it possible to affirm that New York is not the same as the United States, nor does it represent the rest of the Americas, of Europe, Africa, or Asia, in spite of containing a considerable portion of all these worlds, remarkably gathered together, in harmony, in one big city.

A very fragile harmony. It coexisted for many years with a cold war that produced countless propaganda works designed to provoke bad vibrations on either side, though for different reasons, depending on what constituted political correctness in one or the other camp. New York is no paradise in *Die explodierende Metropole* (1967) or in *New York Ansichten* (1988), two photobooks supposedly in the travel book genre published in the former East Germany, with photos by Karol Kállay and Arno Fischer less aggressive than the texts, but which insist nevertheless on subjects such as Milord Consumption and his inseparable handmaidens Poverty and Trash, the continual presence of racial segregation, and the alienation concealed by the false joy of the crowds, made up in fact—oh horrors!—of nothing more than lonely, depressed, anonymous people.

All this has little to do with another photobook published behind the Iron Curtain, in this case in Budapest. In *New York, New York* (1972) there is no lack of critical images, nor of others that show an appreciation of the city's rich urban life. The curious thing is that they are all enveloped in a dirty, toxic atmosphere, generated in the darkroom by Lorinczy György, who achieves a convincing semblance of the decline and chaos of the city in the 1970s, with city hall almost bankrupt and entire neighborhoods abandoned to their fates.

New York, New York is an almost unique photobook, but not so far removed from a genre now all but extinct, yet at that time highly prized by the editorial boards of magazines and newspapers: the photo essay. Groups of photographs that require hardly any text to say everything there is to say. *New York–100th Street* (1969) by Bruce Davidson is an extraordinary photo essay, produced from within, which refrains from poetical commentaries or moral censure: a display of information without opinion that leaves the reader in peace and allows complete freedom to his or her judgment.

There is poverty, to be sure, but also beauty and empathy, which Davidson was able to capture again, this time in color, in *Subway* (1986), a photobook made up of anonymous passengers on the New York subway system. An illustrious precedent to Davidson's book was produced by Walker Evans in his *Many Are Called*, with its evocative biblical title. Though not published until 1966, these portraits of sad, serious urban commuters were taken by Evans in the late 1930s: the zombie survivors of the Great Depression in photos more black than white.

The justly famous *Naked City* (1945) shows a city as complex and multiple as its inhabitants. Weegee's masterpiece of photojournalism proves that some photobooks can be those "great narratives" so sought after in literary workshops. In *New York in Photobooks*, there are other fine examples of photo essays, such as *Correspondance new-yorkaise* (1981) by Raymond Depardon, a diary in images that questions the limits of photojournalism, and *Chelsea Hotel* (1983) by Claudio Edinger, an affectionate collective portrait that does justice to its subject-matter, yet another theme among so many possible ones, since whatever can be photographed can also be composed and presented in book form.

Chelsea Hotel is full of artists and eccentrics, a slice of the singular New York art world, which is also the subject of other photobooks, including *New York: The New York Art Scene* (1967), a documentary reportage, studio by studio, opening by opening, of the very active New York art milieu, by Ugo Mulas. One of the main figures in that milieu was Robert Rauschenberg, who used photography as yet another tool in his own work and in 1982 published an artist's photobook, *Photos In+Out City Limit New York C.*, a small portion of a colossal and impossible project: to photograph nothing less than everything in existence. Another artist's photobook is *OK OK No New York* (1984), by Lenke Rothman, who took advantage of her stay in New York to collect found images as sporadic, modest, and significant as her own exciting works. As for so-called urban art, the benchmark photobook is *The Faith of Graffiti* (1974), with photos by Jon Naar and a text, so understanding and favorable as to be almost condescending, by Norman Mailer.

Some photobooks share a family resemblance with cinematic works, such as Nobuyoshi Araki's *New York* (1966), a travel diary in images of an excursion to New York by someone who seems to want to get back home as soon as possible. Although less subjective, closer to a documentary account, *Metropolis* (1934) is also cinematic in style, the photos being the field work of an ethnographer, Edward M. Weyer, who was accustomed to taking notes, including photographic ones, of all relevant details. There are others that have more to do with comic books and advertising, the sources of the imagery in one of the strangest books in our collection, *New YO.rK.* (1983), by the great graphic designer Juan Fresán.

Film, comics, and advertising are part of what has been called pop culture by some, low-brow culture by others... in contrast to other culture so high as often to be inaccessible, doubtless because it is not within reach on a sunny sidewalk crowded with people. The moment has finally come when we can bring on stage the crowd, that shapeless mass that forms and dissolves for no reason, attracting like a magnet the idle, the indecisive, and above all those who search merely for the satisfaction of searching, the *curious*, a club that admits street photographers as members and whose patron saint could well be Edgar Allen Poe's "man of the crowd." An apparently "decrepit old man," but capable in fact of running from one end of the city to the other to be in time for when the theaters get out, of frequenting the most crowded plazas and other places always full of people, a tireless urban traveler who knows all the shortcuts by heart, who "refuses to be alone," and whose only home is

1983. Juan Fresán

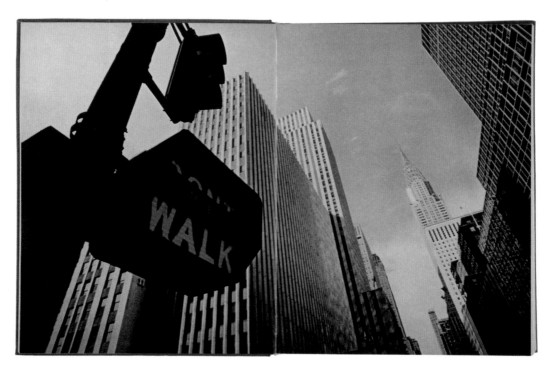

1967. Karol Kállay

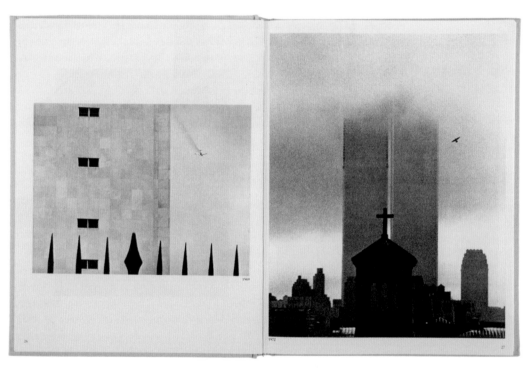

1976. André Kertész

the street itself, who refuses to let himself be read or studied by anyone and who neither gives nor asks for explanations.

If we substitute theaters for discotheques and plazas for dark, unsafe, even dangerous alleyways, that man could well be Keizo Kitajima, preparing his phantasmal *New York* (1982). Perhaps that is also how *Facing New York* (1992) was made, with Bruce Gilden in the role of the man of the crowd who never sleeps, stubbornly haunting the same sidewalks in search of the most stylish people, equipped with William Klein's secret weapon: the camera of truth.

Indeed, William Klein's *New York* (1956) is the great masterpiece of street photography. Its full title—*Life is Good & Good for You in New York*—comes from an advertisement for one of the big department store and must be understood precisely backwards, as a cruel irony. And the subtitle—*Trance Witness Revels*—is a declaration of principles, a coded self-portrait of the photographer, who has cited among the sources of his inspiration things as varied as family photo albums, the theater of the absurd, tabloid newspapers, and, of course, street life.

Klein's book changed urban photobooks forever, but it must be acknowledged that street photography existed before him, as for example in the photographs by Henri Cartier-Bresson that stand out in an otherwise run-of-the-mill travel book entitled *New York* (1949), full of clichés not contributed by him. Or in the photographs taken in the 1930s by Aaron Siskind and published in *Harlem Document* in 1981, around the same time as *Harlem no Hitomi* (1985) by Nobuo Nakamura, a friendly enough portrait of the streets and people of the neighborhood, but our sympathy for the latter volume cannot conceal the decline and diminishment manifest in even a cursory perusal of the two books side by side.

By that time, by the 1980s, there are countless men of the crowd with cameras of truth enjoying the passionate "crowd baths" recommended a hundred years before by Baudelaire. The street is the city: it defines and describes it. As Jane Jacobs has written, when the streets are interesting, the city is too, but when they are sad, the city becomes depressing.

The exploration and portrayal of the street is certainly the central theme of photobooks devoted to New York. The street is also present in almost all the books mentioned above in other contexts, especially those by Weegee, Levitt, L rinczy, and Araki, and in many other variations. Sometimes it is the darkly impenetrable street of *Mon Kuni New York* (1974) by Daido Moriyama, and sometimes the setting of romantic nighttime adventures, as in *Invisible City* (1988) by Ken Schles, or of chance encounters in the wee hours, as in *In My Taxi* (1991), by Ryan Weideman.

But it is also true that the street can be something different, without drama or lighted streetlamps, but rather with the fine weather that invites us to enjoy Saul Bellow's *Seize the Day*, the American version of the classical and ever compelling *carpe diem*. All this and more takes place in *Found in Brooklyn* (1996), a bucolic photobook by Thomas Roma, who not so long ago, in 2013, also published *The Waters of Our Time*, a lovely emulator of *The Sweet Flypaper of Life*, which seeks to recreate its imitation of life and keep the flame burning.

It turns out in the end that New York is not exhausted by Manhattan, nor of course by the street either. If you look a little closer, the street was already there, as near as Monterroso's dinosaur. At least photographers have always thought it was worth their while to look for it, for, as Henry Miller has written, "in the street you learn what human beings really are; otherwise or afterwards, you invent them. What is not in the open street is false, derived, that is to say, *literature*."

New York: Photographs in Books, Books in Stores
Jeffrey Ladd

I.

New York City, perhaps more than any other metropolis in the world, has been the muse of countless photographers throughout the medium's history. Paris, the City of Lights, or Tokyo might be close contenders, but in the world of *photography books*, New York City seems to have influenced the making of more of the landmark photobooks that became influential worldwide to the progress of photography than any other city. One only has to look at a partial list of books included in this exhibition to see how broadly photographers have attempted to shape a vision/version of "their" New York: Berenice Abbott's *Changing New York*; Weegee's *Naked City*; William Klein's *Life Is Good & Good for You in New York: Trance Witness Revels*; Roy DeCarava's and Langston Hughes's *The Sweet Flypaper of Life*; Helen Levitt's *A Way of Seeing*; Bruce Davidson's *East 100th Street*, and dozens of others. This essay, however, concentrates less on those particular accomplishments that have been spotlighted and studied elsewhere in such depth that I cannot add anything of further value. What follows, rather, is a recollection about New York City from one of its former residents, about the curious inner workings of its book culture and how that culture shaped many photographers' lives, work, and photobook libraries—most notably my own.

Before the internet and the convenience of information at one's fingertips, photographers relied on learning about the medium's history and the work of others through two main avenues: exhibitions and printed matter, specifically books and magazines. Among visual artists, books cemented new work into their conversations. To photographers, *the book*, as opposed to single prints, became the most important vehicle for ideas, aspiring to elevate the medium to greater heights, for a book's editing, design, sequence, and context transcended the individual images and caused new ideas and meanings to resonate, which added up to a greater work of art. And, unlike exhibitions, a book enabled those masterworks to remain within arm's reach for a lifetime. Like great works of literature, a photobook's complexity is elastic, expanding or contracting with each reading, as the artist's understanding of the medium becomes more sophisticated. In a way, photobooks and the proliferation of art schools teaching photography created the *demand* and *audience* for contemporary photography, an audience made up mostly of other artists and photographers. To venture into a photobook festival or art book fair today is to see that most of the consumers also happen to be practitioners.

Unlike books of fiction, these expensive-to-produce art books were usually printed in limited print runs of a few thousand copies and tailored to what was in fact a fairly limited audience. Even in those small numbers a photography book would rarely find its audience immediately. In the business of publishing, this struggle for an audience not only made photography books less than attractive to take on as projects; if sales were disappointing, publishers would dump off unsold copies to "remainder" houses in an effort to recoup some of their investment. There are dozens of stories (even from the 1980s and within my short time in photography) of photobooks of the highest accomplishment languishing in unsold

remaindered stacks for a fraction of their original cover price. Unlike nowadays, when each year sees the production of thousands of different photography books and it is nearly impossible (even with the internet!) to keep informed of every book, there was a time up until the early 1970s when a whole year's worth of photography books might only amount to a couple dozen different titles. Many bookselling strategies were designed to make photobooks appeal to a wider consumer market and escape the "photo-ghetto" by publishing thematic books on a variety of subjects, such as reportages on *city life*. New York, "the city that never sleeps," was one of those topics that could actually sell books and appeal to a larger market.

II.

My introduction to photography books came in the fall of 1987, after moving to midtown Manhattan to study as an undergraduate photo student at the School of Visual Arts. As among many students before me, in the classes of our freshman year, photobooks quickly became the focus of discussion. Much of my understanding of the history of photography was punctuated by mention of the great photobooks that had been produced. Mentors of mine stressed the importance of discovering the difference between individual pictures and books, as well as the differences between books which simply showcased the *accomplishments* of an artist—such as exhibition catalogues—and those which were *full artistic statements*, aspiring to the level of great social commentary, literature, or poetry. Concentrating on those differences completely overturned my previous perception of photography: books were now so tightly wed to photographs that they became almost inseparable. I might have appreciated certain individual pictures in books over others, but I had also become sensitive to the second nature of books, the underlying meanings that were made by associating strings of photographs.

As a young artist, the other reason books had such an impact on me was that, although I often went to exhibitions, I never felt completely comfortable in museums. Even to this day, there is an ever-present self-consciousness I feel, due to the institutions themselves with their collections of incalculable wealth, the surveillance by guards, the frames and pedestals loaded with implications of class and hierarchy: it all seemed incompatible with enabling a truly personal connection with the work within the walls of such an establishment. Whereas a book is something you hold in your hands, usually in your own environment; you manipulate it at will; you establish your own guides of conduct, uninfluenced by external pressures. The implied hierarchy found in museums between art and viewer is upended. Books level the playing field, so that one can thread the intellectual landscape of photographs. In the best examples, the meaning lies somewhere in the connections between the pictures, as if the photographic equation of one plus one has somehow given a sum of three.

My growing obsession culminated in the habit of scouring the miles of bookshelves in every bookstore New York had to offer—a tendency so irresistible that it became a part of my daily routine as a photographer.

III.

"New York was an inexhaustible space, a labyrinth of endless steps, and no matter how far he walked, no matter how well he came to know its neighborhoods and streets, it always left him with the feeling of being lost. Lost, not only in the city, but

within himself as well. Each time he took a walk, he felt as though he were leaving himself behind, and by giving himself up to the movement of the streets, by reducing himself to a seeing eye, he was able to escape the obligation to think, and this, more than anything else, brought him a measure of peace, a salutary emptiness within."

The above quotation from Paul Auster's novel *City of Glass* will, without Auster's intention, ring true as a succinct summation of the mindset of many photographers, including myself, who have mined urban areas as a subject for photographs. The Bronx-born photographer Garry Winogrand once famously said that for him to photograph was "to get totally out of myself. It's the closest I come to not existing" (a rather *Zen-like* thought coming from a "lion of a man" who, according to his friend Tod Papageorge, drank coffee as if he "wanted to chew the cup"!) That near impossibility of walking a city of such crushing density, while being clear of thought and unselfconscious yet hyperaware of your surroundings, is the key to working freely and unrestrictedly photographing strangers. Walking aimlessly (or perhaps one should say, *intuitively*) up and down streets and turning corners left or right on a whim may seem an easy task, but to sustain it for six or eight hours a day is anything but easy. Photographers develop strategies. For me, it was essential to have a *destination* tucked into the back of my mind, whether or not I actually arrived there. Once that *destination* was established, my *walk* would be mostly on autopilot, allowing the work to happen. Since I was book-obsessed, I would intentionally organize my wandering through the city to cross paths with different used-book stores every couple of hours, when I needed a break or to escape the weather.

A typical day might start on 34th Street and Eighth Avenue, where I would pick my *destination*, for instance, Westsider Books, a small, overstuffed used-book store up on the Upper West Side at 81st Street and Broadway. Slowly, perhaps over the course of a couple hours, I would walk the forty-plus blocks photographing a few rolls of film along the way. At the bookshop I would see if there were any books of interest, rest a moment, and then start over. I would photograph my way across to Argosy Books on 59th Street near Bloomingdale's, then maybe down and west to Hacker Art Books at 57th and Sixth Avenue, then further down to Gotham Books on 47th Street in the heart of the diamond district, then back over to the East Side to Ursus Books on Madison and 63rd, then all the way down to 12th and Broadway and into The Strand. Then, if I wasn't too exhausted, I might head over to Mercer Street Books or a few blocks further to A Photographer's Place, a bookstore dedicated entirely to photobooks, before grabbing the train back to Brooklyn. At home, I might have six or eight rolls of film from the day stuffed in my pockets (documenting the day's journey!) and one or two books in my shoulder bag. Repeat this discipline three or four days a week for twenty-five years and you build up not only a large body of photographic work but, if you can afford it, a good reference library as well.

IV.
With the advent of internet commerce, along with our confidence in buying everything under the sun off a computer screen, it became possible to assemble a complete library without leaving your house. Of course, this has made the brick-and-mortar used-book store all the less common, a disappearance I lament. New

York was once a Mecca for used-book shops. The legendary "Book Row" on Fourth Avenue alone hosted a continuous line of forty-eight different bookshops within just a few city blocks until the late 1960s. A few dozen held on through the 1990s, scattered throughout the city, but high rents and the impact of internet buying threaten to force them out.

Throughout their existence, New York's used-book shops were fed by a very healthy supply of titles, many of which came directly off the street. When moving or in need of quick cash, people sold their books or, in an effort to rid themselves of them quickly, simply stacked them at the curb for the taking. Since New York is a book-lover's city of 8.5 million residents, it is no wonder that it is possible for streets to be lined with the finest literature and art books. So much so that an entire underground market in previously-owned books was created and remains to this day.

Booksellers I knew would tell stories about their best *suppliers*, who would "make the rounds" of the stores with boxes full of books to sell. They knew which bookstores bought which types of books and who paid the best, offering their wares accordingly. Even segments of the city's homeless population occasionally "dealt" in used books, selling either right off the sidewalk—lining up their goods on flattened cardboard or makeshift tables—or offering them to used-book stores. Those willing to *dumpster-dive* and paw through curbside demolition containers full of someone else's belongings might discover that *one man's garbage is another's man's gold*. If you think that is an exaggeration, New York City itself hosts a huge once-a-year book auction of thousands of boxes crammed full of printed matter of every kind: books, magazines, and ephemera collected from among the personal belongings of city residents who have died and have no known next of kin. For book junkies who are aware of this auction, it is a way of unearthing amazing collections and rare editions year after year.

Much like being open to finding photographs in the most unexpected of places, book searching also meant being open to matters of possibility. You didn't just look for photobooks in the photography section of the bookstore: you looked in the *politics* section, the *pets* section, the *women's studies* section, the *history* section, the *architecture* section, the *travel* section, on the understanding that not every photobook *looks or acts* like a typical photobook. Mis-shelving by inexperienced booksellers has been responsible for thousands of surprising finds or books languishing for years in a kind of *bookstore purgatory*.

The stories of *great finds* are a staple of book collectors and, much like old war stories, they are often full of an adrenalin rush and a hint of hyperventilation. As on a sweltering hot afternoon in the early 1990s, when I was in a very unpromising thrift shop on Eight Avenue and 50th Street and found a near-perfect and signed copy of Roy DeCarava's and Langston Hughes's *The Sweet Flypaper of Life* from 1955 *underneath* the bookcase (25 cents); or when I saw a copy of *William Eggleston's Guide* being sold right off the sidewalk at St. Marks Place and Second Avenue, lying between a pair of roller skates and a knot of extension cords (2 dollars); or a copy of Lee Friedlander's *The American Monument* at a library sale (5 dollars); or Garry Winogrand's *The Animals* in the *pets* section of a store in New Jersey (1 dollar); or a first edition hardcover of Josef Koudelka's *Gypsies* at a flea market on Sixth Avenue(15 dollars, expensive!). I have had experiences like these on many more occasions over the last thirty years and each time, at that moment, it held an excitement equivalent to finding a Picasso painting at a yard sale.

Unfortunately, except in some of the least-explored corners of the world, that era of the discovery of books in stores by the average enthusiast is mostly over. For better or worse, the internet has enabled information to be shared and most used-book sellers use sites such as AbeBooks or eBay to check any book's estimated "value." This has led to a vast over-appraisal of the value of many photography and art books. Prices of hundreds or even thousands of dollars for a single book are nearly impossible to justify when the chance of their sale is almost nil. There are simply not enough high-end collectors to have created a realistic market for those prices, yet prices for some books are slow to recede from those levels because of a few unique sales in the past.

V.

When looking at the genre of photobooks focusing on New York City, one quickly realizes two things. First, although New York is composed of the five different boroughs of Manhattan, Queens, Brooklyn, the Bronx, and Staten Island, the vast majority of photobooks describe Manhattan Island. This is initially understandable, since the idea of Manhattan's streets and skyline are etched into most people's imaginations, whether they have visited the city or not, but to a New Yorker, this myopic vision might be equal to admiring the skin but ignoring the vital organs of one's body. This oversight becomes more ironic when faced with the fact that the borough of Queens is the most ethnically diverse urban area on the planet, yet I am at odds to name a single notable photobook dedicated to its cultural wealth. The northernmost borough, the Bronx, has several books dedicated to it but unfortunately nearly all of them concern themselves with the danger, crime, and general collapse of her southern neighborhoods during the 1970s and '80s. Brooklyn, the most populated of all the boroughs, has a few books dedicated to its communities but again, nothing that comes even close to Manhattan. The most notable are those by the Brooklyn-based photographer Thomas Roma, who not only has photographed there almost exclusively for over forty years, but also produced twelve photobooks, eight of which describe his native Brooklyn, and two of which, notably, are co-authored with texts by his son Giancarlo Roma. As for Staten Island, we can only hope that someday it gets its due in a great photobook.

The second thing one notices is that the bar for the "New York photobook" was set very high in the earliest of days of halftone reproduction, which enabled photos to be set into book form. In 1890, the publishing house Charles Scribner's and Sons released the Danish photographer and reformer Jacob Riis's book *How the Other Half Lives* and—although it is absent from this exhibition, owing perhaps to its being a book of three hundred pages of text that incorporated only 18 photographs and 23 engraved illustrations—I consider this the first New York photobook. Curiously, since it is a sociopolitical rant against the structures of tenement buildings and the overcrowded slums of the Lower East Side that had become the home to tens of thousands of immigrants seeking a "better way of life" in the United States, the first New York photobook turns out not to celebrate the city, as most of the photobooks that followed would, but to criticize the inadequacies of coping with its growing population in humane ways.

Where New York photobooks have flourished is in the sub-genre of so-called *street photography*. Street photography has become so closely tied to New York

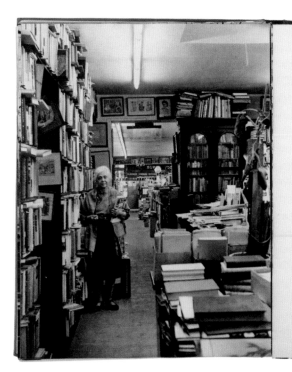

for iced tea, just add sugar from the bowls on the tables, and water, and get lemonade—for nothing.

There are elderly retired school teachers living in the back halfrooms of working women's dormitory establishments who know just which trash baskets in the streets or subway stations are likely to contain relatively clean and unruffled copies of the latest *New York Times* or *Herald Tribune*, which they scan for their own purposes: free concerts at the Brooklyn Museum or the auditorium of the New York Historical Society; free lectures or film showings at the museums; free poetry readings, chamber music concerts, record concerts, lectures or documentary film showings at the Donnell Library in East 53rd Street; meetings and debates at the U.N. open to the public. And there are those who can well afford to buy the *Times* or *Herald Tribune*, but swore off and took to the trash bins in April, 1963, when, after the prolonged newspaper strike, the price was raised from five to ten cents.

But all this is peddling compared with the opportunities offered by the hundreds of press parties given by business organizations throughout the fall, winter and spring seasons either in their own quarters or at hotels or restaurants. Publishers give parties to launch new books or authors, manufacturers to launch new products, and garment firms to launch new styles. There are two- and three-day trips by private airplane to The Company's plant city or cities, with luncheons and dinners at the local country clubs; there are ship launchings, restaurant openings, cocktail parties at trade conventions in the hotels, and company anniversary banquets. The food and drink on hand at these functions can often be elaborate and is invariably plentiful. How does the professional free-loader latch on to all this? One way is to get to know the press and public relations people who receive more invitations of this kind each day than they can possibly accept. One either goes along as a guest of the gentlemen or ladies of the press or is handed their invitations. People with long experience in running press parties in New York can recognize the clinker with the other fellow's legitimate invitation in his hand, but seldom, if ever, is he dealt with as a gate crasher, as long as he looks reasonably respectable. Why bother? The clinker helps to swell the crowd and the food and drink he consumes will never be missed.

To the food editor, fashion editor, transportation editor, gossip columnist, television or radio reporter, for whom most of these parties are intended, going to one of them is but a chore in the daily round of making a living. But, to the unaffiliated free-loader with time on his hands, working at his absorbing job of "making out" in New York, they are a gift which he can accept without obligation and enjoy even more than those for whom the gift is intended—proving that in New York the cracks in the system are

OPPOSITE
Gotham Book Mart and Frances Steloff, owner

87

1964. Víctor Laredo

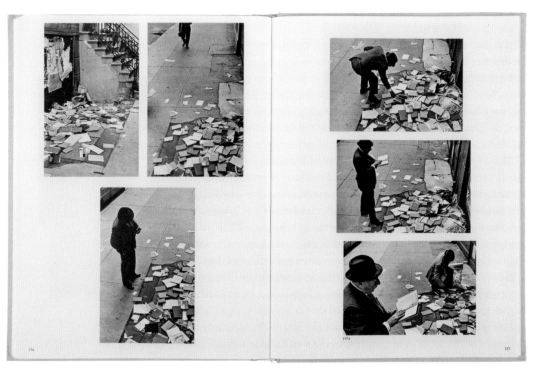

1976. André Kertész

City, owing to a few influential photographers, that the parade of successors dedicated to seeking out the theater of the streets is virtually endless. Although so many have tried, very few have actually accomplished a great book that extends beyond just being a collection of their best shots. The raucous blast of William Klein's *Life Is Good & Good for You in New York: Trance Witness Revels* (1955) and the stoop-life poetry of 1930s Spanish Harlem in Helen Levitt's *A Way of Seeing* still stand, over fifty years after their publication, as two examples that trump most of the New York "street books" to follow. Even Garry Winogrand, whose name is practically synonymous with New York street photography, never attempted a book of street work per se. He found the term *street photographer* absurd—"I'm just a photographer!"—and his books concerned themselves rather with various themes of animals, women, and the news media. For this writer, it is a slightly troubling thought that books like Klein's from half a century ago still dominate the vision of the city, since what *can be seen* of the city from those books largely no longer exists. That is not to say that the genre has been "done" and is thus "exhausted," but many of the most recent books, such as Bruce Gilden's *Facing New York* or Ryan Weideman's *In My Taxi*, seem to include interesting photography, but it is debatable whether they are photobooks that significantly add to the genre or challenge their predecessors.

The last book represented in this exhibition—*Here Is New York*—is an appropriate endpoint for, although it is centered on a single event, it is a view of the city by and for its residents and marked a very important change in the city and its attitude towards photography. *Here Is New York* employed a crowd-sourced approach to compile photographs by professional and amateur photographers alike after the September 11th attacks on the World Trade Center. It included images made by people of all walks of life: rescue workers, firefighters, office workers, tourists, passersby, journalists, policemen and policewomen, mothers, fathers, sons, and daughters. The book is relentless in its approach, with over 900 photographs that attempt catharsis through the display of images ranging from stylized photojournalism to direct, at-the-moment, objective recordings. There is no hierarchy to the images, just one voice following the next in a collective effort to describe a horrific moment in the city's history. The project started when a small group of photographers and editors that included Gilles Peress, Alice Rose George, Charles Traub, and Michael Shulan, opened two small storefront exhibition spaces in Soho, a few dozen blocks north of the World Trade Center site, and invited anyone to contribute images. Subtitled *a democracy of photographs*, all pictures donated were anonymous, hung without credit or framing. The exhibition changed continuously and attracted three thousand viewers per day. It was a remarkable moment, when photography was a key factor in bringing millions of people together, quite possibly the only moment in the city's history when New York actually became the "melting pot" it has so often been described as.

For this New Yorker and many others, that moment would come to mark the end of an era. The fears of further attacks and subsequent crackdown on civil liberties made being a photographer of street life in New York a nightmare. Photography became a very suspicious activity after 9/11, and that suspicion was not limited to the act of photographing bridges or tunnels, which might be an understandable concern. New laws forbade people from loitering on street corners and made it acceptable for police to detain photographers and question them about why they were photographing specific areas. It was impossible to explain to

suspicious, impatient police officers that you were doing "street photography," following in a century-old tradition of the practice. Many buildings added to the security teams working directly on the sidewalk, prohibiting people from photographing in the direction of their properties. Even other New Yorkers became more suspicious of photographers after being continuously bombarded by subway announcements proclaiming "If you *see* something [suspicious], *say* something." You soon felt your livelihood was being sacrificed to fear. After roughly twenty years of photographing New York, I decided to look for my subject elsewhere.

VI.

New York, that city of "inexhaustible space," that "labyrinth of endless steps" described by the books in this exhibition, is now photographed and recorded more than ever. Ubiquitous cellphone cameras, surveillance video, and point-and-shoot cameras record life in an almost "real-time" mode. Nearly every experience and nearly every step of millions of people are now mediated through images, and the ocean of images floods sites like Facebook, Instagram, and other social media. Older models of photography and our interaction with images are being redefined at a perplexing rate. Where will this take photography and the description of cities like New York in the future? Will this endless stream of images lead to books which—like the tracing of the characters' footsteps in Paul Auster's novel *City of Glass*—create a bigger, more defined, and truer representation of that enigmatic labyrinth called New York City?

The view of
New York
is different
from here

In the richest city in the world
825,000 New Yorkers live in buildings with
unsafe stairs, rotted window frames, plas-
ter holes, or other potentially dangerous
conditions.
20-30% of Negro and Puerto Rican fami-
lies live in delapidated or substandard
housing, as compared to 6% of other fami-
lies.
Some New Yorkers live in quarters which
are physically sound, but too overcrowded
for physical and mental health.
The following are classified as crowded:
39% of Puerto Rican renter households
24% of Negro renter households
10% of other renter households
Housing Statistics Handbook
Mayor's Housing Executive Committee

Anyone who probes even slightly beneath
the surface of juvenile crime will usually
find that it is rooted in a depressing tangle
of problems that have been either ignored
or inadequately dealt with. Among the
major and most common of these are
grinding emotional and economic depri-
vation, discrimination resulting in inade-
quate educational and employment
opportunities, wretched housing, illegiti-
macy, physical and mental illness, paren-
tal neglect, and homes racked by divorce,
desertion, death and separation.
*Community Service Society Bulletin, No.
596*

About 10 percent of Harlem consists of
parks and playgrounds, compared to over
16 percent for N.Y.C. as a whole. The total
acreage of 14 parks and playgrounds is
not only inadequate, but all the parks are
esthetically and functionally inadequate
as well [and] the parks on the western
border of the area are virtually useless be-
cause they are built on extremely steep
hills. For many of the children, then, the
streets become play areas. The rate of
death due to motor vehicles among per-
sons under twenty-five is 6.9% per 100,000
in Harlem, compared to 4.2% per 100,000
for all of N.Y.C.
N.Y.C. Dept. of Health

1966. Anthony Aviles, Don Charles

Empire State / A History

This book is an account of events that took place between August 1929 and May 1931: a period of less than two years in which the Empire State Building was planned and constructed. Published to coincide with the opening ceremony, the book served as a sort of promotional brochure. The directors of the project congratulate themselves on the challenges faced and overcome, from the initial idea of erecting the highest building ever constructed to its inauguration. The narrative describes with superlatives the epic feat. Everything is in capital letters, imposing, all but impossible to achieve. The cover is a full-page reproduction of the mural that welcomes visitors to the building, a backdrop to the triple-height lobby: the aluminum silhouette from the top of which the spire of the building radiates the rays of the sun behind it.

The contents are divided into twenty brief sections, with titles in upper-case letters, through which the reader moves in a pulsing rhythm. "FIFTEEN DESIGNS ARE REJECTED"; "THEN COMES THE SIXTEENTH PLAN"; "EMPIRE STATE IS BUILT ON PAPER"; "THE WORLD IS LET IN ON THE SECRET".... The narrative moves from exploit to exploit: "UP–UP–UP," as the building grows by an average of four and a half floors a week. The final chapter—"WHAT EVERY BODY WANTS TO KNOW ABOUT EMPIRE STATE"—sums up the milestones attained: capacity for up to 80,000 people; the fastest elevators in the world; the most steel ever used on a single project; four thousand workers a day; the finest observation deck over a metropolis that abounds in the craziest dreams of literature and science. All in the service, and to the glory, of mankind, as well as being a gigantic piece of real-estate speculation.

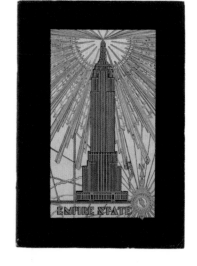

There is no indication of the authors of the text, the design, or the drawings. The only credits go to Lewis H. Hine (several of the photographs) and Alfred E. Smith, president of the investment corporation that operated the building, who signed the initial dedication: as if, in the face of the magnitude of the project, such details were insignificant. The dizzying images of proud workers in perilous situations (shared, it should be noted, by the photographer) have become legendary. The rest of the images were taken by Knickerbocker Photo Service, the agency that recorded the daily progress of construction.

Alfred E. Smith says so in his first sentence: the Empire State Building is dedicated by its creators to the business and industry of the entire world. It has combined the efforts of the best brains, the most skilled workers, and best materials, all assembled in a harmonious whole. The book is the story of an incredibly optimized process of work coordinated by the inexorable demands of cost, time, and structure, to the delight of all and especially of architects and engineers. [C. G. G.]

New York: Empire State 1931 / 310x217 mm, 48 pages, illustrated softcover / brochure prepared by Publicity Associates, Empire State Building / 56 b&w photographs, 7 by Lewis W. Hine / 12 drawings / photogravure printed by Select Printing Company, New York

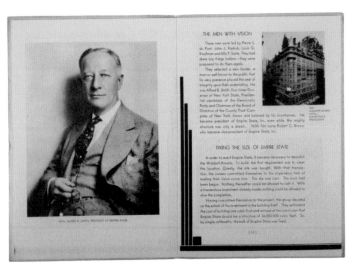

HON. ALFRED E. SMITH, PRESIDENT OF EMPIRE STATE.

THE MEN WITH VISION

These men were led by Pierre S. du Pont, John J. Raskob, Louis G. Kaufman and Ellis P. Earle. They had done big things before—they were prepared to do them again.

They selected a new leader, a man so well known to the public that his very presence placed the seal of integrity upon their undertaking. He was Alfred E. Smith, four times Governor of New York State, Presidential candidate of the Democratic Party and Chairman of the Board of Directors of the County Trust Company of New York, known and beloved by his countrymen. He became president of Empire State, Inc., even while the mighty structure was only a dream. With him came Robert C. Brown, who became vice-president of Empire State, Inc.

FIXING THE SIZE OF EMPIRE STATE

In order to erect Empire State, it became necessary to demolish the Waldorf-Astoria. To build, the first requirement was to clear the location. Quietly, the site was bought. With that transaction, the owners committed themselves to the stupendous task of making their vision come true. The die was cast. The work had been begun. Nothing thereafter could be allowed to halt it. With a tremendous investment already made, nothing could be allowed to slow the completion.

Having committed themselves to the project, the group decided on the extent of the investment in the building itself. They estimated the cost of building one cubic foot and arrived at the conclusion that Empire State should be a structure of 36,000,000 cubic feet. So, by simple arithmetic, the bulk of Empire State was fixed.

[15]

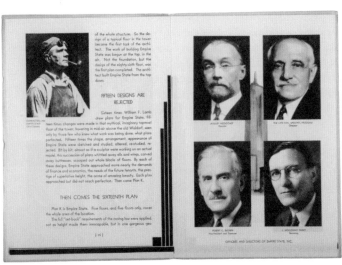

of the whole structure. So the design of a typical floor in the tower became the first task of the architect. The work of building Empire State was begun at the top, in the air. Not the foundation, but the design of the eighty-sixth floor, was the first plan completed. The architect built Empire State from the top down.

FIFTEEN DESIGNS ARE REJECTED

Sixteen times William F. Lamb drew plans for Empire State. Fifteen times changes were made in that mythical, imaginary topmost floor of the tower, towering in mid-air above the old Waldorf, seen only by those few who knew what work was being done, what plans perfected. Fifteen times the shape, arrangement, appearance of Empire State were sketched and studied, altered, revolted, rejected. Bit by bit, almost as if a sculptor were working on an actual model. His succession of plans whittled away sills and wings, carved away buttresses, scooped out whole blocks of floors. By each of these designs, Empire State approached more nearly the demands of finance and economics, the needs of the future tenants, the prestige of superlative height, the acme of amazing beauty. Each plan approached but did not reach perfection. Then came Plan K.

THEN COMES THE SIXTEENTH PLAN

Plan K is Empire State. Five floors, and five floors only, cover the whole area of the location.

The full "set-back" requirements of the zoning law were applied, not as height made them inexorable, but in one gorgeous geo-

[16]

OFFICERS AND DIRECTORS OF EMPIRE STATE, INC.

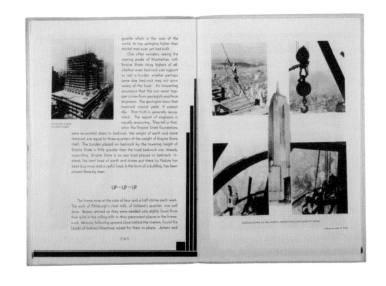

granite which is the core of the world, its top springing higher than mortal man ever yet had built.

One often wonders, seeing the soaring peaks of Manhattan, with Empire State rising highest of all: whether ever bed-rock can support so vast a burden: whether perhaps some day bed-rock may not grow weary of the load. An interesting assurance that this can never happen comes from geologists and from engineers. The geologists know that bed-rock cannot yield. It cannot slip. That truth is generally recognized. The report of engineers is exactly reassuring. They tell us that, when the Empire State foundations were excavated down to bed-rock, the weight of earth and stone removed was equal to three-quarters of the weight of Empire State itself. The burden placed on bed-rock by the towering height of Empire State is little greater than the load bed-rock was already supporting. Empire State is no new load placed on bed-rock. Instead, the inert load of earth and stones put there by Nature has been dug away and a useful load, in the form of a building, has been placed there by man.

UP—UP—UP

The frame rose at the rate of four and a half stories each week. The work of Pittsburgh's steel mills, of Indiana's quarries, was well done. Beams arrived as they were needed only slightly hours from their birth in the rolling mills to their permanent places in the frame-work. Masons, following upward close behind the riveters, found the blocks of Indiana limestone raised for them to place. Joiners and

[20]

1934
Edward M. Weyer **Metropolis / An American City in Photographs**

Apart from the title, which recalls Fritz Lang's 1927 masterpiece, *Metropolis* contains others references to cinema, such as *Manhattan Medley*, a short film made in 1931 by Bonney Powell, fourteen stills from which are included in the book. Urban documentaries were common in the 1930s in New York, starting with an avant-garde classic, Paul Strand's and Charles Sheeler's visual poem *Manhatta* (1921), the portrait of a living being that breathes through its chimneys and smokestacks.

Like other documentaries, *Metropolis* follows a model. In this case it is Walther Ruttmann's *Berlin: Symphony of a Metropolis* (1927), a frenetic series of everyday activities moving from morning to night: it begins with the arrival in the city; continues through the empty streets at dawn; follows with the bustle of morning rush hour and the incessant rhythms of the working day, interrupted at noon hour... This gives way to the pleasures of leisure and the animation of afternoon cafés, followed by the lights of the city during the interminable night. *Metropolis* also begins in the morning and closes at the "end of day," with the New Yorkers in their homes or in bars, accompanied by the dancers photographed by Remei Lohse. The city is portrayed from without and from within, in the streets and in people's living rooms. The book is an introduction to the nervous system of the city, to its industry and commerce, to its work and leisure time...

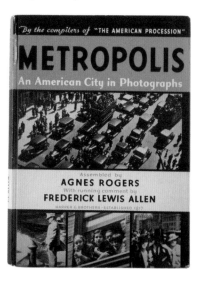

Particularly noteworthy in *Metropolis* is the work of Edward Moffat Weyer (1904-1998), who took four-fifths of the photographs. Anthropologist, member of the Explorers Club, and author of the study *The Eskimos* (1932), whose teachings were applied to record the life of New Yorkers, Weyer used the methods of sociological research and sought to find the necessarily variable constants of a common experience, replete with differences. Far removed from the inevitable superficiality of travel photography, Weyer was a rationalist who had to discard a lot photographs in order to render his metropolitan documentary plausible.

Metropolis is a book to be experienced actively: it is both novel and report, feature film and documentary. In the end, the reader decides. No one is obliged to take it one way or another. You can go it through like a hurried tourist, but you can also identify yourself with (or distance yourself from) its content, as though it were a theater play... or scrutinize it through a microscope, like a scientist, perhaps Weyer's preferred method. In any case, *Metropolis* bears no resemblance to an academic treatise. Like most photobooks, it is the result of teamwork. The team in this case was made up of Weyer and Agnes Rogers and Frederick Lewis Allen, responsible for the editing and commentary of *Metropolis* and of other photo-stories published in those years on subjects such as the years between the two world wars (*I Remember Distinctly*, 1947) and changes in the social status of women (*Women Are Here to Stay*, 1947). [H. F.]

Second edition / New York and London: Harper & Brothers 1934 / 310x235 mm, [192] pages, illustrated hardcover, illustrated dust jacket with sticker / assembled by Agnes Rogers / 304 b&w photographs, 251 by Edward Moffat Weyer and 53 by Frederick Bradley, Bonney Powell, Remei Lohse, Lewis W. Hine, Russell Lynes, and Peter A. Juley / text by Frederick Lewis Allen / designed by A. W. Rushmore / photogravure (aquatone process) printed by Edward Stern Co.

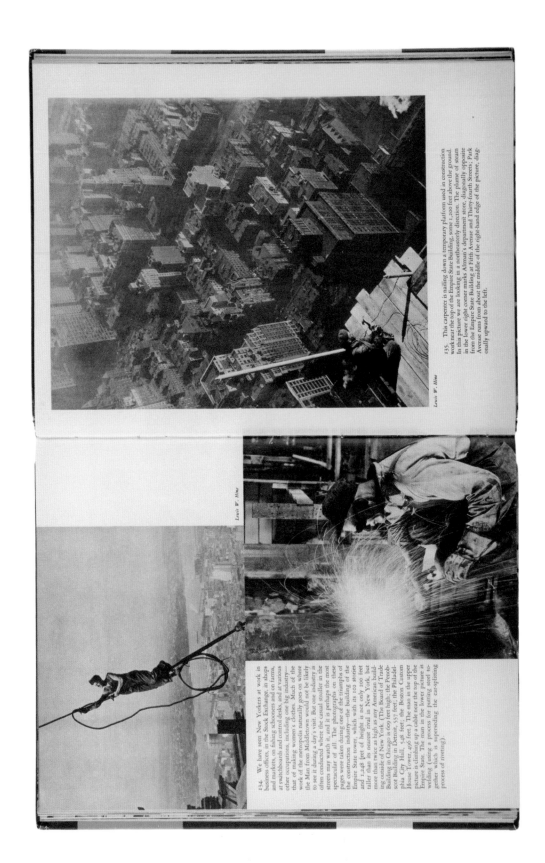

Lewis W. Hine

135. This carpenter is nailing down a temporary platform used in construction work near the top of the Empire State Building, some 1,200 feet above the ground. In this picture we are looking in a northeasterly direction. The plume of steam in the lower right corner marks Altman's department store, diagonally opposite from the Empire State Building at Fifth Avenue and Thirty-fourth Streets; Park Avenue runs from about the middle of the right-hand edge of the picture, diagonally upward to the left.

Lewis W. Hine

134. We have seen New Yorkers at work in business offices, in the Stock Exchange, in shops and markets, on fishing schooners and on farms, at switchboards and control desks, and at various other occupations, including one big industry—that of making women's clothes. Much of the work of the metropolis naturally goes on where the Man from Middletown would not be likely to see it during a day's visit. But one industry is often conducted where the casual stroller in the streets may watch it, and it is perhaps the most spectacular of all. The photographs on these pages were taken during one of the triumphs of the construction industry—the building of the Empire State tower, which with its 102 stories and 1,248 feet of height is not only 1,200 feet taller than its nearest rival in New York, but more than twice as high as any American building outside of New York. (The Board of Trade Building, Chicago is 609 feet high; the Penobscot Building, in Detroit, 557 feet; the Philadelphia City Hall, 548 feet; the Boston Custom-House Tower, 496 feet.) The man in the upper picture is climbing up a cable near the top of the Empire State. The man in the lower picture is welding (using a process for putting steel together which is superseding the ear-splitting process of riveting).

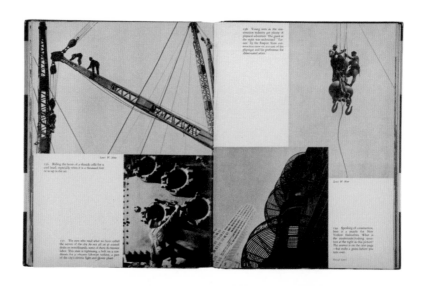

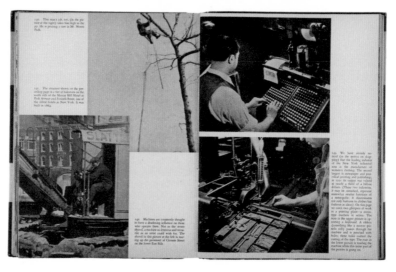

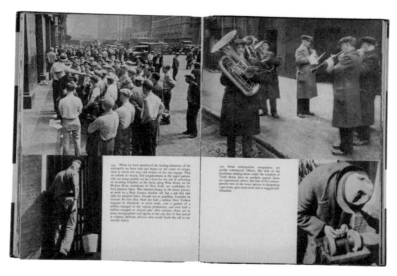

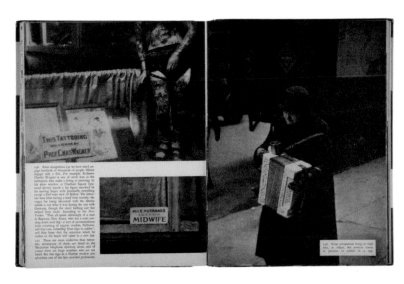

146. Some occupations (as we have seen) engage hundreds of thousands of people. Others engage only a few. For example, Professor Charles Wagner is one of seven men in the metropolis who make a living at tattooing. In his show window at Chatham Square (pictured above) stands a lay figure inscribed by his moving finger with practically everything except a bird's-eye view of Bellevue. The tattooists have been having a hard time recently; the vogue for being decorated with the electric needle is not what it was during the war with Germany, though the short bathing suit has helped their trade. According to the New Yorker "They sit apart, admiringly of a man in Bayonne, New Jersey, who had a train running down each leg—a sort of accommodation train consisting of engine, coaches, Pullman, and box cars, extending from hip to ankles", and they hope that the semicolon which he inshes on the beach will usher in a new day.

147. There are more midwifery than tattoo practitioners of shorts are listed in the Manhattan telephone directory alone, and of course there are large numbers who are not listed. But this sign in a Harlem window also advertises one of the less crowded professions.

148. Some occupations bring in high fees; to others, the patient comes in person, or cockels in a cage.

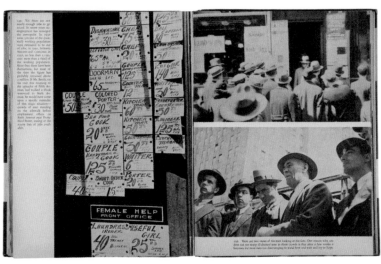

150. There are two views of the men looking at the lists. One reason why one does not see many ill-clothed men in these crowds is that after a few weeks it becomes for most men too discouraging to stand here and wait and try to look.

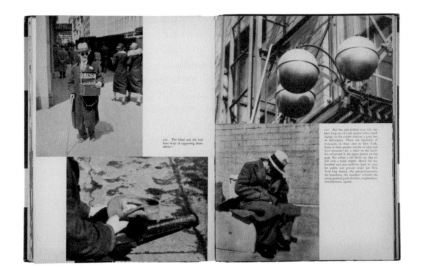

151. The blind and the halt have ways of supporting themselves—

152. But the able-bodied man who has been long out of a job cannot collect much change on the street without a grim loss of self-respect. There are hundreds of thousands of these men in New York, some of them possess articles of value and have structure—as a man on the lower left pictured is the upper picture on this page. But unless a job shows up, that of lies only a brief respite. Hence the one hundred and nine million spent in 1931 for public and private relief (in New York City alone); the piteous extremities, the bread-lines, the squatter colonies, the overpopulated park benches, in prisons, breakdowns, suicide.

Mario Bucovich **Manhattan Magic** / **A Collection of Eighty-Five Photographs**

Dated June 1937, on board the *Queen Mary*, the brief text that introduces *Manhattan Magic* ends with an impassioned paragraph in which Bucovich recalls a night the previous winter. From the top of the Rockefeller Center he was gazing at a starry firmament, not above him, but at his feet: the city of New York with its thousands of windows lit up. This evocation of the city's nocturnal magic seems to pair his book with Brassaï's *Paris de nuit*, though Bucovich's book belongs much more to the daytime, as it happens: the night reveals the city's formidable charm, it is true, but for Bucovich real magic is in no need of such mirages. For him, the magic resides in a "collective spirit" capable of erecting fifty-story buildings and towers a thousand feet high. Bucovich felt it had been created thus not out of a local necessity or by natural expansion, but rather by the strength of a daring new dream: granite seeking new forms of expression. And he concluded euphorically to the effect that, although thousands of years of tradition and conventionalism had decreed that it could not be done, the skyscrapers of steel, stone, and glass had sealed those lips forever.

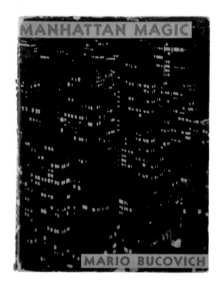

It is precisely in the waters of the Atlantic that the book opens, with the *Queen Mary* in the harbor and the skyline of the city in the background. Bucovich moves on immediately to the stone giants, the protagonists of this "song of New York": human presences can be made out as tiny marks on the pavement, ants at the feet of the colossi. Bucovich carefully situates every character in the book, for the buildings are actually treated as characters: beings that make Manhattan a magical island, in which human audacity, ingenuity, and the will to power have been put to the test. Bucovich was interested in cities as works of art in themselves, as his previous books attested: one was devoted to Berlin (with a text by Alfred Döblin) and another to Paris. That was before Bucovich fled, like so many others, the invasion of the swastikas. In the United States he would produce *Washington D.C., City Beautiful*. In his book about Manhattan—*about*, or *with*, or *for*, or *by*, or *in*: almost any preposition would apply, except *without*—the iconic landmarks are not neglected, from the Empire State building to the Chrysler building, from the Flatiron to the Brooklyn Bridge, the subject of some of the finest images.

Born into the Austro-Hungarian nobility, Baron von Bucovich had collaborated in Paris with Germaine Krull and was a good friend of Sasha Stone, the photographer who produced the unforgettable cover of Walter Benjamin's *Einbahnstrasse*. It is precisely with a nod toward Stone that the magic of this Manhattan ends: Bucovich approaches the end of Broadway (220th Street and Ninth Avenue) to immortalize the ONE WAY street sign that indicated where the city ended and the future began. [J. B.]

New York: M. B. 1937 / 305x230 mm, 96 pages, index, loose photographic data, illustrated softcover, spiral binding / 93 b&w photographs, 85 by Mario Bucovich, 8 by Dr. D. J. Ruzicka / foreword by Mario Bucovich / photogravure printed by The Beck Engraving & Company, Philadelphia

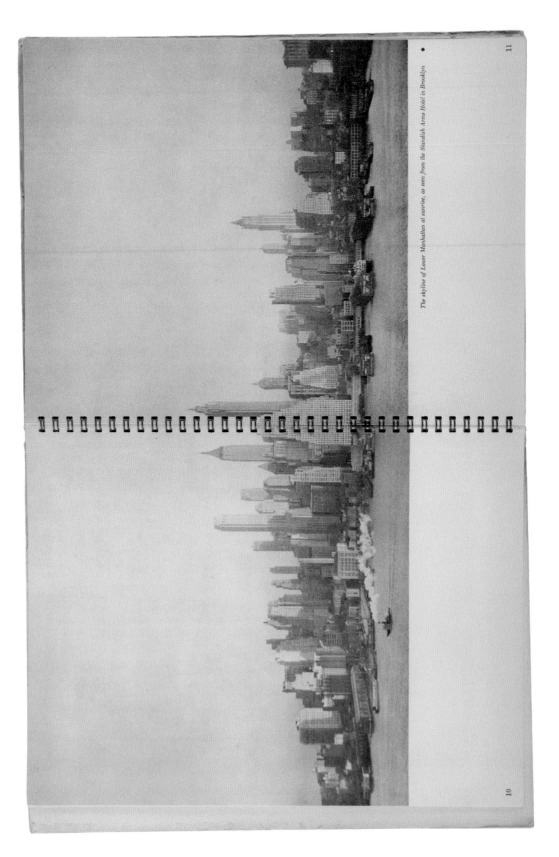

The skyline of Lower Manhattan at sunrise, as seen from the Standish Arms Hotel in Brooklyn

The footpath, Brooklyn Bridge. This bridge was the first to connect Manhattan with Brooklyn; today there are forty-eight bridges built by the city

29

The Towers of Lower Manhattan, as seen from Brooklyn Bridge ●

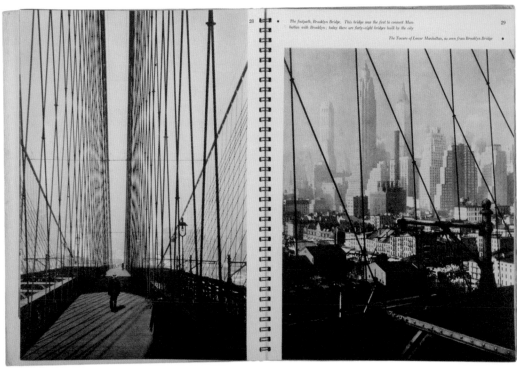

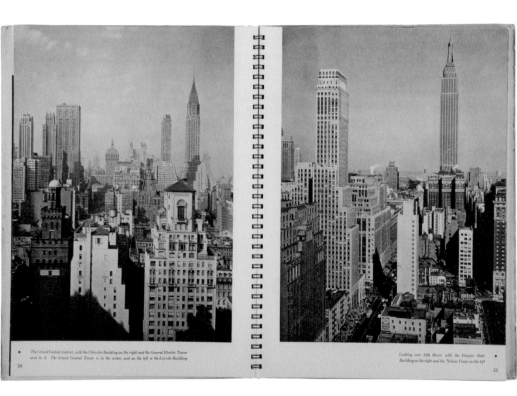

● The Grand Central district, with the Chrysler Building on the right and the General Electric Tower next to it. The Grand Central Tower is in the centre, and on the left is the Lincoln Building

50

Looking over 35th Street, with the Empire State Building on the right and the Nelson Tower on the left ●

51

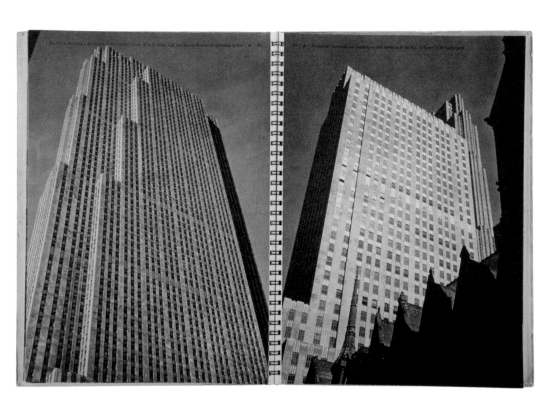

• Looking north over 5th Avenue, from the roof of the Hotel Gotham at 55th Street and 5th Avenue. In the foreground to the right is the Squibb Building

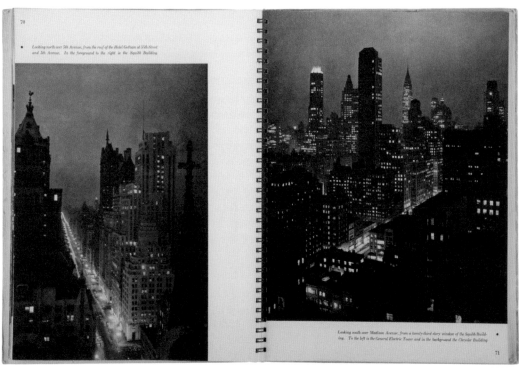

Looking south over Madison Avenue, from a twenty-third story window of the Squibb Building. To the left is the General Electric Tower and in the background the Chrysler Building •

1938
Cecil Beaton's New York
1948
Cecil Beaton **Portrait of New York**

In October 1938, two editions of *Cecil Beaton's New York* were printed in London, bound in yellow cloth. The dust jacket shows the author, high up in a building, casting a sheaf of papers out over the city at his feet. It is a self-portrait with a photograph of his face stuck on and a Rollei camera: Beaton as photographer. And also as artist, writer, and even decorator: of houses, theaters, movie stars, and kings of the stock market.

The foreword informs us that the book is not about history, economics, politics, or religion... No, it is only the "catalogue" of a foreigner's "impressions." An exercise in impressionism, then. Literary impressionism—based on vignettes with sparks of humor and gossip—and also visual impressionism: drawings that bring out the hypertension of the city, full during the daytime of people in offices, stores, bars, or movie theaters. The same people who, at night, move among the flotsam of popular dance spots and, above all, the more exclusive salons, the milieu in which Beaton himself lived and which he described in magazines such as *Vogue* (from which he was fired for using an inappropriate word in one of his nervous, so apparently innocent drawings).

The more than one hundred and fifty photographs in the book make up a more settled—at times even predictable—version of the city. The publishers asked for postcard images that would sell in England and Beaton complied by supplying them with clichés (set off at times by showy frames), with the help of Joseph Cornell, an artist with character, always on the lookout for the found objects with which he made his marvelous boxes and collage films.

There are other photos as well. Some of Beaton's images reject the commonplace. There are also the glamour magazine portraits, presented in collage form. In the most interesting images, the streets offer everything from the shadows of petty crime to everything a bride could desire. The finest images are enlivened by friends of Beaton's (such as the poet Charles Henri Ford) who accompanied the photographer on his excursions and posed as onlookers.

Ten years later, Beaton revised the book, rewriting and re-illustrating it. He claimed the city was ever more beguiling and mysterious, though the truth is that *Portrait of New York* is no longer the self-portrait with extras that the first edition was. This time the cover shows an urban streetscape in muted tones, colorless, without lights or neon: a watercolor the recalls the antediluvian "artistic" photographs of the Camera Club. The war had left the city more uniform and less neurotic. New York had changed, and its melancholy chronicler underscored the difficulty of returning to the old urban ways. Beaton reproduced his mélange of photography, drawing, and reportage, but it was cut back: there was no "Personality Loop" (the most entertaining and gossipy chapter in the previous book), fewer drawings, and fewer photos by others. On the other hand, there were other new ones by Beaton in which he and his accomplices interpret the streets of the city. [H. F.]

London: B. T. Batsford 1938 / 230x155 mm, viii+262 pages, yellow cloth, illustrated dust jacket / 49 photographs, 2 photocollages with 42 additional photos, 60 b&w drawings, color frontispiece and text by Cecil Beaton / 71 b&w photographs by Higdon Cato, Ewing Galloway, Hans Groenhoff, Fritz Henle, E. O. Hoppé, R. J. Nesmith, Ben Shahn et al. / designed by Brian Cook

London: B. T. Batsford 1948 / 230x155 mm, viii+136+[64] pages, gray cloth, illustrated dust jacket / 59 b&w photographs, 13 b&w drawings and text by Cecil Beaton / 32 b&w photographs by Higdon Cato, Ewing Galloway, Fritz Henle, E. O. Hoppé, Ben Shahn et al. / designed by Brian Cook

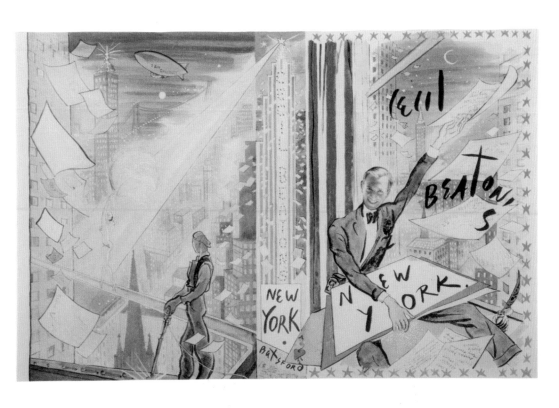

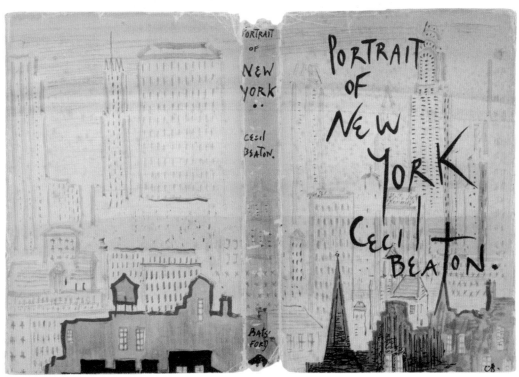

BOWERY DESIGN

JUNK PLOT

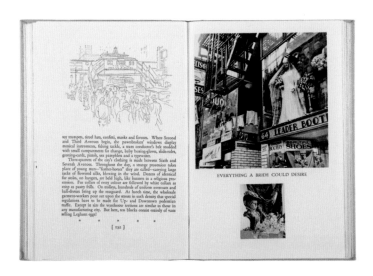

toy trumpets, tinsel hats, confetti, masks and favours. Where Second and Third Avenues begin, the pawnbrokers' windows display musical instruments, fishing tackle, a tram conductor's belt studded with small compartments for change, baby boxing-gloves, slide-rules, greeting-cards, pistols, sex pamphlets and a typewriter.

Three-quarters of the city's clothing is made between Sixth and Seventh Avenues. Throughout the day, a strange procession takes place of young men—"feather-horses" they are called—carrying large tacks of flowered silks, blowing in the wind. Dozens of identical fur stoles, on hangers, are held high, like banners in a religious procession. Fur collars of every colour are followed by white collars as crisp as pastry frills. On trolleys, hundreds of uniform overcoats and ball-dresses bring up the rearguard. At lunch time, the wholesale garment-workers pour out upon the street in such density that special regulations have to be made for Up- and Downtown pedestrian traffic. Except in size the warehouse sections are similar to those in any manufacturing city. But here, ten blocks consist entirely of vans selling Leghorn eggs!

* * * * *

[132]

EVERYTHING A BRIDE COULD DESIRE

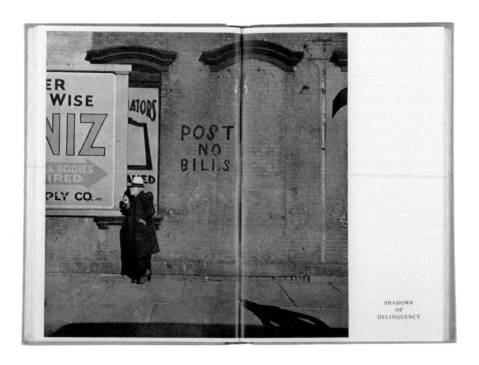

SHADOWS
OF
DELINQUENCY

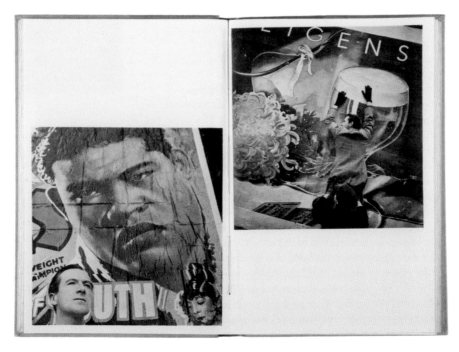

Berenice Abbott **Changing New York**

Upon its release in April 1939, *Changing New York* was showered with critical praise. Berenice Abbott's pictures of a rapidly-changing city were admired as "real photographs" by Edward Weston and called "the best of documentary photography today" by the influential young critic and curator Beaumont Newhall. If Abbott's photographs are paradigmatic of a documentary turn in the visual arts during the 1930s, the photobook that reproduced them testifies in turn to the challenges of collective cultural production under the auspices of the Federal Art Project (FAP), a program that employed thousands of artists as part of the United States government's response to the Great Depression.

Changing New York turned out to be a very different publication to the one originally envisioned by Abbott and her life companion, the art critic and writer Elizabeth McCausland, who was commissioned to supply captions for the photographs. Editorial decisions about what images to include out of the hundreds of New York photographs taken by Abbott for the FAP between 1935 and 1938 left her frustrated, as some audacious shots of downtown Manhattan— where contrasts between old and new were most conspicuous—were ignored to make room for more conventional pictures of modern buildings.

Initially peppered with aesthetic and political commentary reflective of her progressive views, McCausland's captions were likewise edited to ensure the book would interest a wide audience and generate good publicity for the FAP, beleaguered by substantial funding cuts. Similarly, the writer's proposal for a dynamic layout juxtaposing images and text with a cinematic sensibility was rejected in favor of a rather conservative design, featuring a seamless flow of double-spread units, each with a single photograph on the right-hand page and its corresponding caption on the left-hand one.

Published to coincide with the 1939 World's Fair in Queens, *Changing New York* was thus shaped into something of a guidebook, providing an orderly itinerary across the city's boroughs. Following Manhattan's historical pattern of urban development, the book takes viewers on a photographic ride from Bowling Green, on the island's southern tip, all the way north to the recently-completed Washington Bridge, before moving eastward to the Bronx, Queens, and finally Brooklyn. As the journeys progresses, captions offer concise, light-hearted context about the photographed sights, whether the modern headquarters of one of the city's dailies or a food peddler laboring in the streets of the Lower East Side.

Changing New York was born out of Abbott's fascination with the bustling, modernizing metropolis she returned to in 1929 after nearly a decade in Paris. Beyond her passion for the city, however, the book also speaks of a larger context: the slow rise of New York as the center of the art world during the interwar period. A metropolis yearning to assert its growing cultural prominence found in Abbott and McCausland a team of steadfast and perceptive advocates: a photographer and a writer committed to crafting a discerning record of urban renewal, however compromised it may have been as it made its way into print. [M. O.]

New York: E. P. Dutton 1939 / 290x225 mm, 208 pages, cloth, illustrated dust jacket / 97 b&w photographs by Berenice Abbott / introduction by Audrey McMahon / text by Elizabeth McCausland / typography by S. A. Jacobs / printed by The Golden Eagle Press, Mount Vernon

Firehouse, Park Avenue. East 135th Street, Manhattan, December 19, 1935. Built in 1908. Owned by New York City; under the supervision of the Fire Department.

• The dock firehouse for the fireboat Lawrence is only thirty years old; but it resembles an older architecture. Once used for fighting fire on land, it was moved in 1917 from Lexington Avenue and 132nd Street to its present location at the head of Park Avenue, the banks of the Harlem River, and in 1929 subjected to a thoroughgoing alteration.

168

Gus Hill's Minstrels, 1890-1898 Park Avenue, Manhattan; December 19, 1935. Built: About 1869.

● Gus Hill's Minstrels has been used as a vaudeville theater, public dance hall, political club gymnasium, fight arena. Courthouse and jail. Once owned by "Boss" Tweed, it was deeded to his son in 1872 for $1.00. Twenty years ago it housed Lew Dockstadter's Minstrels, and Gus Hill's Minstrels appeared here. Jack Dempsey, Gene Tunney, Chief Meyers, Bill Brennan and Leo Lomski trained and fought underneath its mansard roof.

170

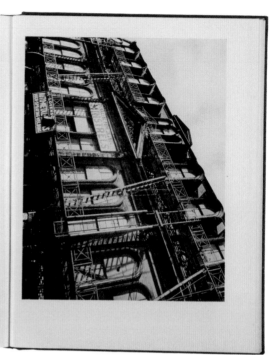

Wheelock House, 661 West 158th Street, Manhattan; November 11, 1937.

● Heart-shaped flower-beds of pinks, lilies-of-the-valley, moss roses, peonies and poppies were the fashion of the day when James Gordon Bennett and other men of property built their mansions north of 155th Street. Of this whole neighborhood, but one Victorian house is still in use, the William A. Wheelock house, built about 1860.

172

**Under Riverside Drive Viaduct at 125th Street
and Twelfth Avenue,** Manhattan; November 10, 1937.
The viaduct extends from St. Clair Place to 135th Street. Completed 1901. Design and construction supervised by Department of Highways: James P. Keating, commissioner of highways; Andrew Ernest Foxé, chief engineer of highways. Owned by City of New York.

● Forty years old, the Riverside Drive Viaduct represents early highway pioneering. For its steel arches and columns lifted a 60-foot-wide roadway 70 feet high over an intervening valley and made an arterial continuity for traffic in a way which proved increasingly necessary for the growing city.

174

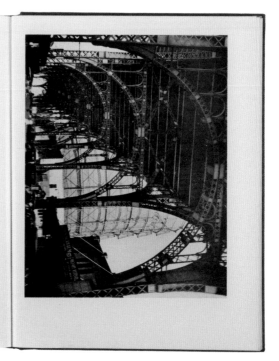

George Washington Bridge, Riverside Drive and 179th Street, Manhattan; January 17, 1936. Completed October 25, 1931. Engineer: O. H. Ammann; chief engineer of design: Allston Dana; architect: Cass Gilbert. Cost $60,000,000. Owned by Port of New York Authority.

● The great cable towers of the bridge rise 335 feet into the air, two and a third times as high as those of Brooklyn Bridge. Thus in 50 years the physical scale of engineering has more than doubled itself, as may be seen also in the relative length of the main river spans of the two bridges, 3500 and 1600 feet.

176

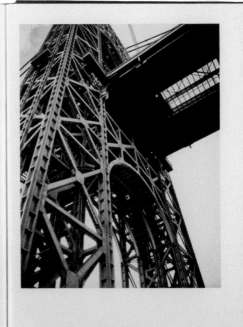

Country Store Interior. "Ye Olde Country Store." 2553 Sage Place. Spuyten Duyvil. Bronx. October 11, 1935. Built about a century ago by P. Tarantino, now owned by J. Tarantino.

● The Cannon Ball stove and wire chairs were characteristic designs of the turn of the century. Distributed throughout the United States, the stove was manufactured from 1904 to 1914 and sold for about $20. Repair parts are still available. Chairs of this type had their heyday before the war. They sold retail for $2.50.

178

Gasoline Station. Tremont Avenue and Dock Street. Bronx. July 2, 1936.

● "Abe's Plaza gas station" is one of the many which sell an aggregate of 20,000,000,000 gallons of gas yearly to the American public at a cost of $3,000,000,000, supporting a petroleum industry with a total capital investment of $13,276,000,000.

180

Tri-Borough Bridge: East 125th Street Approach,
Manhattan; June 29, 1937. Built: 1929-1936. Chief engineer: O. H. Ammann. Cost: $60,000,000, of which two-thirds was made up of PWA loans and direct government grants. Opened by President Roosevelt July 11, 1936.

● The viaducts, ramps, depressed roadways and clover-leaf junction of the Tri-Borough Bridge's 19-mile express highway system link the boroughs of Manhattan, Queens and the Bronx. Long viaducts and four bridge spans, measuring 17,710 feet, comprise the elevated part of the bridge. The bridge proper consists of the Harlem span; the Bronx Kills span, connecting the Bronx with Randall's Island; the concrete arches across Little Hell Gate to Ward's Island; and the span from Ward's Island across the East River to Queens.

182

Jamaica Town Hall, 159-01 Jamaica Avenue, Jamaica, Queens; June 1, 1937. Occupies 141 feet on Jamaica Avenue, 250 feet on Flushing. Built: 1870.

● The Jamaica Town Hall of "Boss" Tweed's day now shelters the Traffic Court, the Small Claims Court, and the Fourth District Municipal Court.

184

Brooklyn Bridge, Water and Dock Streets, Brooklyn; May 22, 1936. Designed and built by engineers John A. Roebling and Col. Washington A. Roebling; opened to public May 24, 1883; construction cost, $15,211,982.92 and land cost, $10,000,000; originally owned by private company, now by New York City under the supervision of the Public Works Department.

● Brooklyn Bridge is the technological ancestor of all the great steel cable suspension bridges which connect Manhattan Island with the world. The Roeblings' success in devising a steel cable strong enough to support the strain of its mighty spans opened the way for the Williamsburg, Manhattan and George Washington Bridges.

186

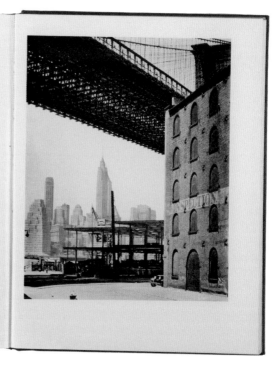

Fourth Avenue, No. 154, Brooklyn; October 29, 1936.

● These Brooklyn old-law tenements stand empty because the present owner prefers to take a loss on taxes and insurance rather than meet the cost of removing violations. Fire escapes and fire retarding of stair wells are the principal requirements.

188

Talman Street, Between Jay and Bridge Streets, Brooklyn; May 22, 1936.

● The condemned old-law tenements of "Irishtown," Brooklyn, have no hot water, no central heating, no bathtubs. Negro families now share the neighborhood with the earlier Irish settlers.

190

Cropsey Avenue, No. 1736, Brooklyn; October 29, 1936.

● Fashionable resort of the eighties, Bath Beach experienced a decline in recent years till this handsome survivor of the General Grant era became a restaurant and cabaret. Progress of the metropolitan highway system overtook it in 1937; and it had to make way for the Shore Road Extension from Dyker Beach Park to Bensonhurst.

192

1945
Weegee **Naked City**

"[...] I keep to myself, belong to no group, like to be left alone with no axe to grind [...]"
Thus does Weegee describe himself in introducing this book, in which voice and image
go hand in hand. By means of both he produces a tribute to the city he loves—that city of
"New Yorkers with their masks off" to whom he dedicates the book—and a monument
to a trade, that of photojournalism, which he claims to have invented and which makes
him the last hero of the world he presents to us. The strongest proof is the photo of an
invoice in the amount of $35.00 for photographing "two murders": the text explains
how in the city prices rise or fall in accordance with the name, neighborhood, and status
of the victims.

Naked City opens with bundles of newspapers waiting to be read by people still
asleep on Sunday morning, observed by the manikins in a display window. The same
people who will later wake up and be curious about the
previous night's events (fires, murders, people run over, but
also a fire hydrant pouring out cool water in the middle of
summer...), the same people who attend the events that
take place (a Sinatra concert, a night at the opera, dance
halls, but also a few drinks at a variety show...) or wander
around the Bowery, Coney Island, or Harlem, experiencing
first-hand a social and racial inequality that no one at any
moment attempts to sugarcoat.

It is a photobook of genuine prose accounts in black-
and-white, lacking in subtlety: photos with no margins and
with humorous captions at the bottom. The anecdotes
oscillate between the surprise of the murderess being
fingerprinted in the precinct to the expert appraisal by the
employee at De Beers, equipped with his loupe, confirming
the authenticity of the diamonds of some ladies Weegee
also portrayed at the opera. Spare images, nocturnal and
sagacious, which avoid virtuosity of any kind and treat
everyone and everything—passersby, neon signs, firemen,
dogs, or babies—equally. Weegee belongs to no group and
has no need to feel superior to anyone.

Naked City appeared in 1945 and has survived the
passage of time. It can be read as the perfect palimpsest that combines the most
universal aspects of American art: expressive pragmatism, a false harshness that
conceals an undeniable moral sense... from a concrete and persistent viewpoint, that of a
photojournalist with his ear to the police frequency of his shortwave radio, always in on
everything, who has converted his car into a mobile darkroom and whose only life is
documenting those of others. Someone who never puts himself above the people whose
pictures he takes and who keeps the lens at street level. Ascetic, aware that he cannot be
part of what he portrays if he wishes to maintain his independence. And, as we said, the
last hero of the first-person account. From Joe Pesci in *The Public Eye* to Jake
Gyllenhaal in *Nightcrawler*, cinema has paid him homage. [I. G. U.]

New York: Essential Books 1945 / 235x160 mm, 246 pages, gray cloth, illustrated dust jacket / 239 b&w
photographs and text by Weegee / introduction by William McCleery, Nancy Newhall / designed by Henry Stahlhut,
Michael Polvere / printed in gravure by The Ullman Company, Brooklyn

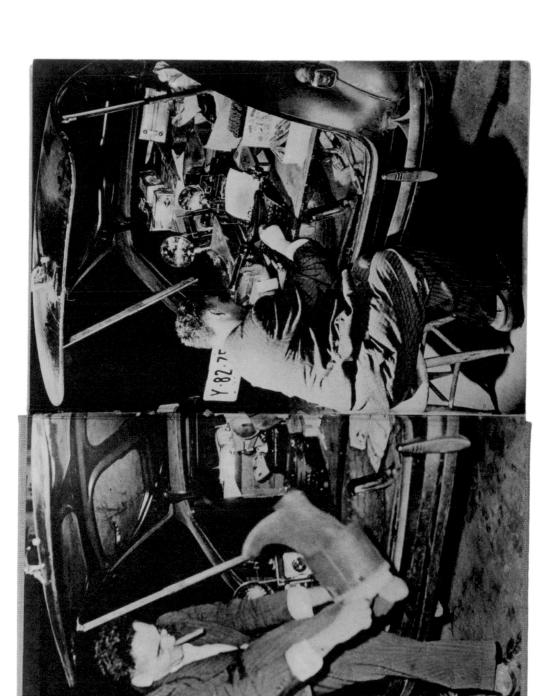

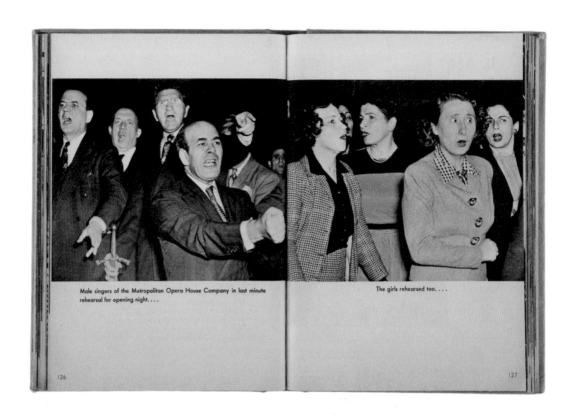

Male singers of the Metropolitan Opera House Company in last minute rehearsal for opening night. . . .

The girls rehearsed too. . . .

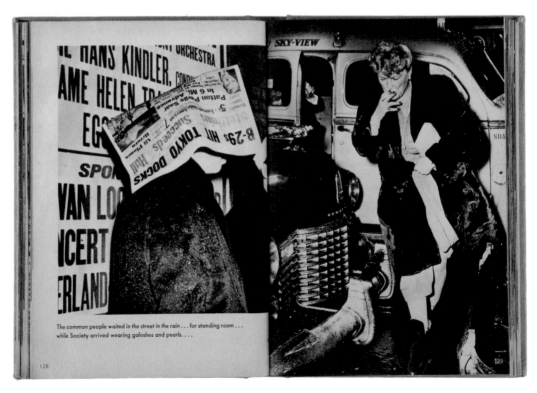

The common people waited in the street in the rain . . . for standing room . . . while Society arrived wearing galoshes and pearls. . . .

The Critic

Music
"Lovers"

134

135

136

The four High Hats are waiting for James and the limousine . . . when the others had gone this dowager was still waiting under the marquee wondering what had become of her chauffeur. A couple passing by picked up a program from the sidewalk. . . END OF FIRST NIGHT.

137

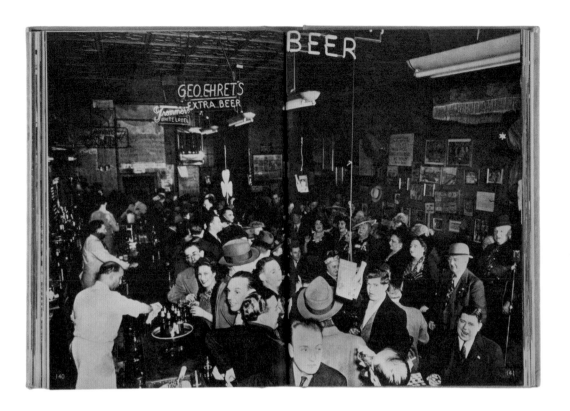

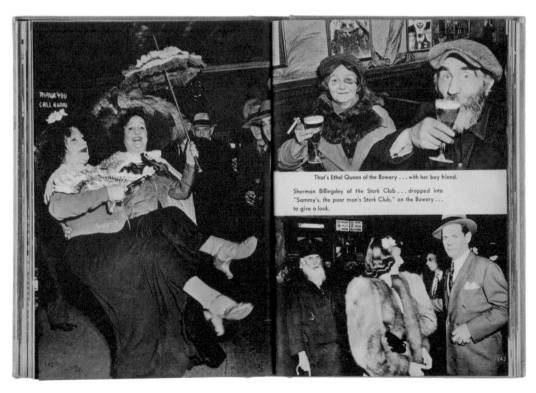

That's Ethel Queen of the Bowery . . . with her boy friend.

Sherman Billingsley of *the* Stork Club . . . dropped into "Sammy's, the poor man's Stork Club," on the Bowery . . . to give a look.

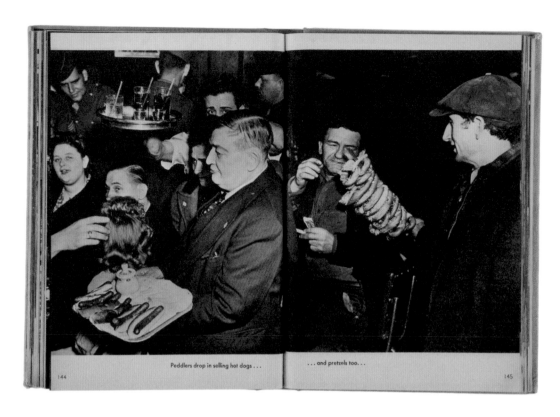

Peddlers drop in selling hot dogs . . .

. . . and pretzels too. . .

144

145

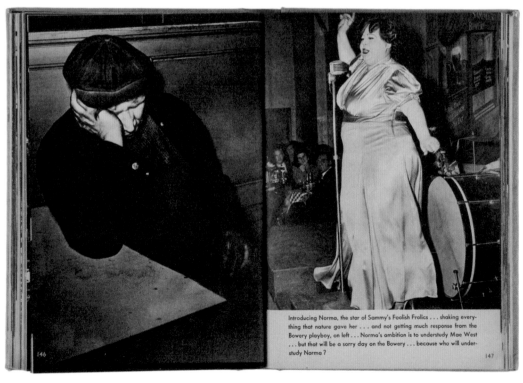

Introducing Norma, the star of Sammy's Foolish Frolics . . . shaking everything that nature gave her . . . and not getting much response from the Bowery playboy, on left . . . Norma's ambition is to understudy Mae West . . . but that will be a sorry day on the Bowery . . . because who will understudy Norma ?

146

147

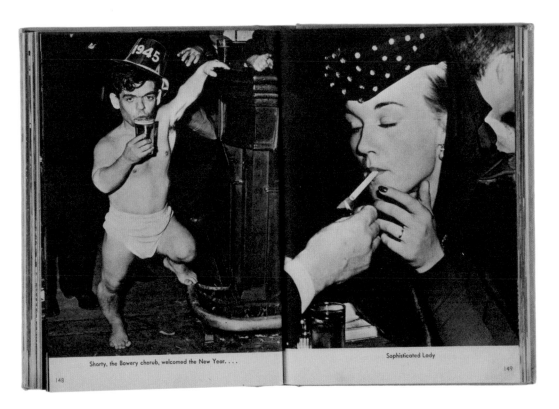

Shorty, the Bowery cherub, welcomed the New Year. . . .

148

Sophisticated Lady

149

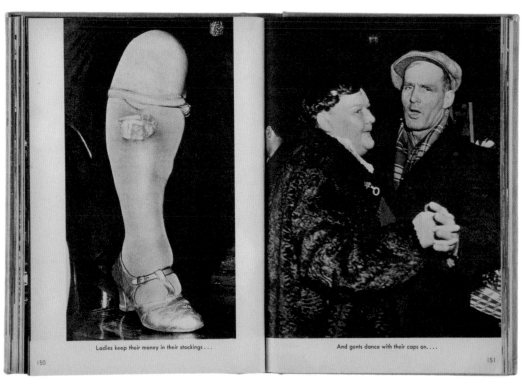

Ladies keep their money in their stockings . . .

150

And gents dance with their caps on. . . .

151

1949
New-York

The Second World War was over and the publishing house of Fernand Nathan was doing its best to forget it. With their amiable, playful tone, the imprint's books had contributed to the education of several generations in France, but following the years of the German occupation, there was little of that left in Europe. Travel was Nathan's best option for restarting the business, and his first destination was New York City. His collection "Marvels of France and of the World" was launched with this book devoted to the Big Apple, as if traces of the energy lost in Paris could still be found there. In his introductory text, Daniel Wronecki, an aspiring young filmmaker, underlines this quality the photographs share with the rhythm of a Parisian *flâneur*. Like instants that the reader threads together, creating his or her own story, the images serve as a guide to a city larger than life: New York waking up in the harbor, shaking off sleep on Wall Street, crossing the Brooklyn Bridge, and, as its streets fill up with people, in the bustle of Chinatown and the Bowery, finally exhausting the day, which ends in the wee hours in Times Square.

The smoke pouring from chimneys suggests it, and the markets replete with merchandise confirm it: it is work that articulates life in New York. Businessmen plan their days, waiters are unable to cope, stevedores eat their lunch amidst the pallets. Leisure time follows work: New Yorkers stroll in Central Park or leave the city for the weekend. What the introduction announces as a geographical tour is thereby transformed into a story of interrelationships, narrated in a series of photos, as Henri Cartier-Bresson conceived of reportage in *The Decisive Moment*: "a progressive operation performed by the head, eye, and heart in order to express a problem, fix an event or impressions." That event is the very vitality of New Yorkers and the impressions are mostly those of the photographer, open to a dialogue between planes and always exposed to something outside the frame that suggests unsuspected relations among the inhabitants of the big city.

Taken in 1946 and 1947, just when the agency Magnum was founded, Cartier-Bresson's photographs, by their number and quality, offer a visual promenade dotted with ironic winks of the eye, for the captions are not always limited to a place: "Children's games and men's games," "To the conquest of the world," "The refuge of fantasy." We also go to Harlem with "The Negro problem," a breach immediately closed by idylls and downpours, a pair of jazz movie stills, and a firm tread in the direction of Columbia University and houses in Riverside. Without a hint of conflict, it is strange perhaps to find as the final photograph the Romanesque cloister brought by Rothschild from France to Inwood Hill Park. Although, in this way, a book about New York ends up effacing the phantasm of war with this final silence. [D. L.]

Paris: Fernand Nathan 1949 / 240x174 mm, 190 pages, softcover, illustrated dust jacket / 127 b&w photographs by Henri Cartier-Bresson (64), J. J. Languepin (12), Fred Stein (5), Wronecki (19) et al. / text by Daniel Wronecki / photogravure printed by Helio-Cachan, Cachan

4. ARRIVÉE PAR AIR

5. DERNIÈRES MINUTES À BORD

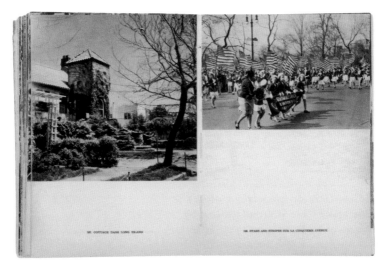

59. COTTAGE DANS LONG ISLAND

104. STARS AND STRIPES SUR LA CINQUIÈME AVENUE

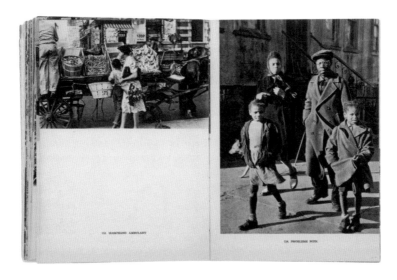

114. MARCHAND AMBULANT

115. PROBLÈME NOIR

Berenice Abbott **Greenwich Village / Today & Yesterday**

Dearest: In the 1940s the Village vibrated so slowly it seemed to stand still. My way of working, so far removed from the snapshot, had trained me in the creation of that nimbus of stillness. Sometimes I felt helpless as I walked through the neighborhood, and then I began to photograph what seemed to me evidence of that neglect: Rhinelander Gardens with its leafless shrubs, a patio once where I found an abandoned doll next to a window from which, if I remember correctly, the ghostly figure of a woman with a baby in her arms looked out. It was a time when a certain degree of neglect implied a certain degree of freedom, which is why belongings seemed to be let go of without too much concern. You will have noticed the car, the half-finished game of checkers in the café on Lafayette. So I was portraying not just a piece of the city but also that absence with which it was imbued. There is something heart-rending about the image of the empty street captured from the entrance hallway of the "Wisteria house": that light accentuated by time, the vines—also leafless—falling over the door frame. Cats used to lie in the sun on the sidewalks or climb up balconies as though they lived in another world. Closed doors and windows seemed to conceal great secrets, whatever the eye could imagine. That is why, I now recall, I decided on just a few singular portraits which, by their strangeness and strong appeal, left that impression of mystery the Village always produced in me.

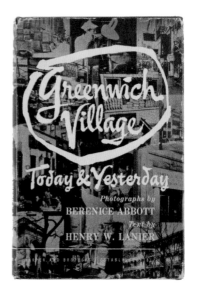

Dearest: On the plane. Six hours ago to go to Madrid. Speed: 1,943 km per hour; outside temperature: 49°F. I don't know why I am noting these facts and not writing about my walk through the Village this morning. Your book *Greenwich Village Today & Yesterday*, the 1949 edition published by Harper & Brothers, with a text by Henry W. Lanier, accompanied me all the way. I walked through the Village looking at the images as if they were a map: sixty-four pages of photographs. I paused exactly where you took the first one, in front of the Washington Square Arch that so recalls the Arc de Triomphe, and I began to look, to walk. I entered the Village as one about to visit a holy city. I didn't read the text, Lanier's very long text: it seemed like a different book to me. It's not that, as they say, a picture is worth a thousand words. What of it? It's just that they seemed to be two books in one, one of them interrupting the other, or both of them tripping each other up. The Village in black-and-white in 1948 won out against the Village in color in 2016. Look at that window: do you see the rag doll? "Looking back at the late 1940s," writes Broyard, "it seems to me now that Americans were confronting their loneliness for the first time." I stopped in Milligan Place. Loneliness was the only thing that still coincided inside and outside the book. [A. S. / C. R.]

New York: Harper & Brothers 1949 / 240x155 mm, 162+[64] pages, cloth, illustrated dust jacket / 72 b&w photographs by Berenice Abbott / text by Henry Wysham Lanier / designed by A. W. Rushmore / photogravure manufactured by The Haddon Craftsmen, Scranton

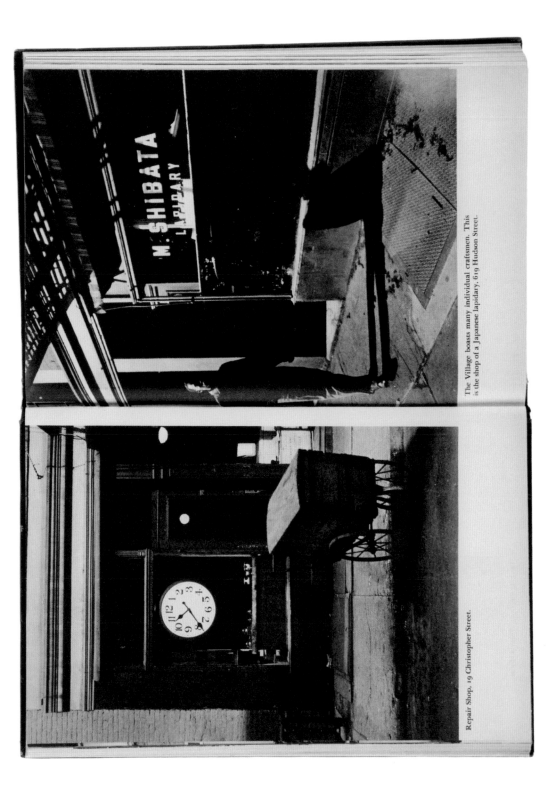

The Village boasts many individual craftsmen. This is the shop of a Japanese lapidary, 619 Hudson Street.

Repair Shop, 19 Christopher Street.

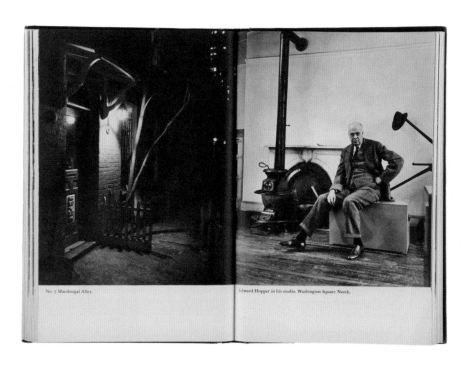

No. 7 Macdougal Alley.

Edward Hopper in his studio, Washington Square North.

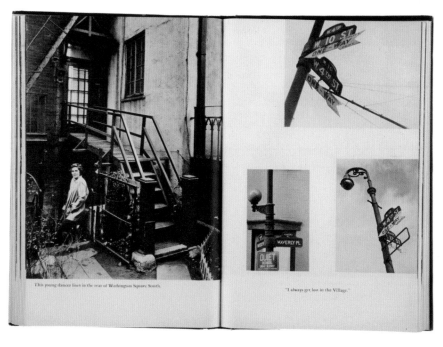

This young dancer lives in the rear of Washington Square South.

"I always get lost in the Village."

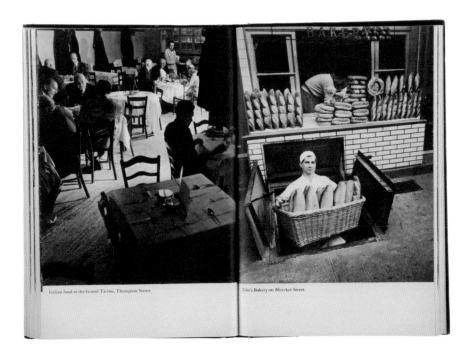

Italian food at the Grand Ticino, Thompson Street.

Zito's Bakery on Bleecker Street.

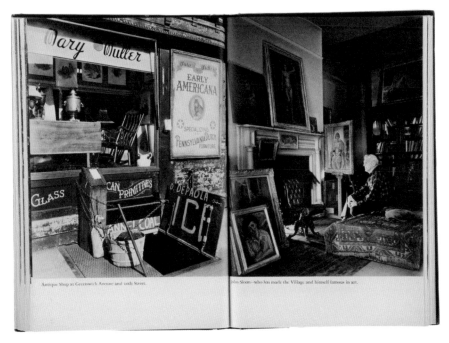

Antique Shop at Greenwich Avenue and 10th Street.

John Sloan—who has made the Village and himself famous in art.

1955
Roy DeCarava **The Sweet Flypaper of Life**

When he wrote the text of *The Sweet Flypaper of Life*, Langston Hughes was already a legend: he had championed jazz poetry and been a leading figure in the Harlem Renaissance, had been involved in the Spanish Civil War, and was beginning to write his autobiographical *I Wonder as I Wander*. His many books had made him the voice *par excellence* of black America and he had received the nickname "the O'Henry of Harlem." The photographer DeCarava, almost twenty years younger than Hughes and known for his portraits of jazz musicians, was the recipient of a Guggenheim fellowship and had been one of the group of photographers who participated in *The Family of Man*, the exhibition organized by Steichen at the Museum of Modern Art.

"In Harlem something is happening all the time." The phrase appears at some point in *The Sweet Flypaper of Life*, coauthored by Hughes and DeCarava in 1955. It is a modest paperback that presents itself as fiction, buttressed by clearly realistic images, which portray that "something" that happens in Harlem: a child saying goodbye to the camera (the book is full of children); a Saturday night party in a little apartment; people looking out the windows; pots and pans in the kitchen; flowerpots on a balcony; another child sitting at the foot of the stairs. Almost nothing, which is to say everything: life goes on, everyday gestures, very often friendly, smiling, or tired after a day's work.

A child's eyes stare out at us from the cover, where the text begins (a daring gesture, though it was nothing new and has continued to be used, from Lorca's *Poema del cante jondo*, whose table of contents Mauricio Amster placed on the cover to a more recent novel by Dave Eggers). The story begins with a simple "Come home" sent by the Lord to Sister Mary Bradley, which serves as a catalyst for a dizzying stampede of memories, whose poetry is underpinned without tricks or grandiloquence by DeCarava's images. Mary Bradley protests: "Come home! [...] I got plenty time to come home when I get to be eighty, ninety, or a hundred and one. Of course, when I wake up some morning and find my own self dead, then I'll come home. But right now, you understand me, Lord, I'm so tangled up in living, I ain't got time to die."

The result is one of the most moving photonovels ever published. Everything is gauged with sobriety, because it starts from a premise that prevails throughout the book: the heroine has to be everyday life, that day-to-day activity whose grandeur is manifest in repetition. No "decisive moments," therefore. Langston Hughes says so himself in a sentence printed on the back cover: "We've had so many books about how bad life is, maybe it's time to have one showing how good it is." [J. B.]

New York: Simon and Schuster 1955 / 180x125 mm, 100 pages, illustrated softcover / 141 b&w photographs by Roy DeCarava / text by Langston Hughes / photogravure printed by R. R. Donnelly & Sons, Chicago

THE TEXT OF THIS BOOK IS ENTIRELY FICTIONAL.
ALL NAMES USED IN THE STORY ARE FICTITIOUS, AND ANY RELATION
TO PERSONS LIVING OR DEAD IS PURELY COINCIDENTAL.

ALL RIGHTS RESERVED
INCLUDING THE RIGHT OF REPRODUCTION
IN WHOLE OR IN PART IN ANY FORM
COPYRIGHT, ©, 1955, BY ROY DECARAVA AND LANGSTON HUGHES
PUBLISHED BY SIMON AND SCHUSTER, INC.
ROCKEFELLER CENTER, 630 FIFTH AVENUE
NEW YORK 20, N. Y.
FIRST PRINTING
LIBRARY OF CONGRESS CATALOG CARD NUMBER: 55-10048
MANUFACTURED IN THE UNITED STATES OF AMERICA
PRINTED BY R. R. DONNELLEY & SONS, INC., CHICAGO, ILLINOIS
BOUND BY H. WOLFF BOOK MFG. CO., INC., NEW YORK

her glasses to sign the slip.

"For one thing," said Sister Mary, "I want to stay here and see what this integration the Supreme Court has done decreed is going to be like."

Since integration has been, ages without end, a permanently established custom in heaven, the messenger boy replied that her curiosity could be satisfied quite easily above. But Sister Mary said she wanted to find out how integration was going to work on *earth* first, particularly in South Carolina which she was planning to visit once more before she died. So the messenger boy put his wire back in his pocket and departed.

"Come home!" said Sister Mary. "I got plenty time to come home when I get to be eighty, ninety, or a hundred and one. Of course, when I wake up some morning and find my own self dead, then I'll come home. But right now, you understand me, Lord, I'm so tangled up in living, I ain't got time to die. I got to look after Ronnie Belle:

3

And that baby that's sleeping in yonder which is my tenth grandchild:

And I sure got to look after Louetta, who is just starting to school:

4

And then there's Rodney. Now, you take Rodney:

That Rodney! The street's done got Rodney! How his father and his mother can wash their hands of Rodney, I do not know, when he is the spitting image of them both. But they done put him out, so's they can keep on good-timing themselves, I reckon:

6

So I told him, "Come here and live with your grandma." And he come.

Now, Lord, I don't know—why did I want to take Rodney? But since I did, do you reckon my prayers will reach down in all them king-kong basements, and sing with the juke boxes, and walk in the midnight streets with Rodney? Do you reckon, Lord? Because there's something in that boy: You know and I know there's something in Rodney. If he got lost in his youth-hood, it just might not be his fault. Lord, I were wild myself when I were young—and to tell the truth, ever so once in a while, I still feels the urge. But sometimes, I wonder why the only time that boy moves fast is when he's dancing. When there's music playing, girls have to just keep looking to see where he's at, he dances so fast. *Where's he at? Where's he at?*

7

But when he's talking, or listening, or lounging, he just looks sleepy—drinking beer down in the basement with them boys:

And Rodney has to come upstairs here to me to borrow subway fare to take her. He never moves fast—not even to reach out his hand for a dollar—except when he's dancing. And crazy about music. Can tell you every horn that ever blowed on every juke-box record in the neighborhood:

Now, you take that Joe, older than Rodney, thinks he's wiser—ties a big rope of words all around Rodney, ties a rope of dreams with Cadillac headlights, and bebop horns, and girls saying, "Gimme a ride." Rodney ain't got no car. But he's got a girl, nice girl, too—at least, she's got him. She comes down there in the super's basement when she's ready to go to a party all dressed up looking for Rodney:

8

Young folks nowadays, I don't understand them. They gets their hair all done up:

just to go and set:

and listen to a juke box . . .

in a candy store, restaurant, bar, speak-easy cellar—anywhere. Sometimes maybe they dance.

10 11

But who can dance to this bopping music? In the old days we used to like blues. And I still do:

But now the kids don't lean on the piano no more unless the piano is playing off-time. When I was young we used to play "hot" but now they play "cool." But they get just as excited as I did:

12

Leastwise, that's what Rodney tells me. And cars:

All the young ones nowadays is just crazy about cars:

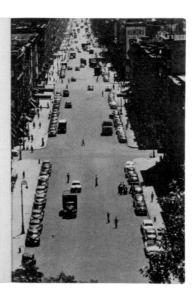

And no wonder, because the streets is just full of cars:

14

In Harlem lots of roomers have got cars bigger than the room they live in. But ain't nobody in our family got a car. I wonder how come? But my oldest daughter, Mae, Chick's mother:

says they're gonna get a car. And Chickasaw, which is my most up-and-coming grandchild, declares soon as he gets married, he's gonna get one, too, so he won't have to ride the bus to work:

16

He always goes to work dressed up. Chick's as different from Rodney as day from night. Could dress his self when he was three years old. Gets up early in time to take the bus all the way downtown to work, don't like subways. But Rodney don't hardly get to work at all no kind of way, says daylight hurts his eyes. Never will be integrated with neither white nor colored, nor work, just won't. Now, you take Chick's girl:

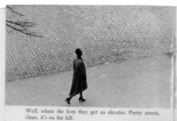

Well, where she lives they got an elevator. Pretty streets, clean, it's on the hill.

How come one grandchild can get a girl from a nice family like that and another one can't? One can grow up bright—all rect, all right, as the kids say? How come two boys is so different that-a-way? Lord, help me just a little bit with that Rodney. He was always the first to turn on the hydrant in the street in the summer . . .

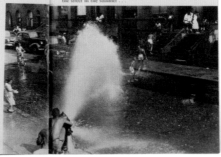

18

Life is Good & Good for You in New York William Klein **Trance Witness Revels**

New York is William Klein's first work as a photographer. Klein had studied painting with Fernand Léger in Paris, and a visit to an exhibition of Klein's abstract compositions led Alexander Liberman, the art editor of *Vogue* at the time, to commission a book of photographs. The result was *New York*, which Liberman, however, considered unsuitable for publication. It finally appeared under the Éditions du Seuil imprint, through the mediation of filmmaker Chris Marker.

The full title is *Life is Good & Good for You in New York*. It recalls those advertisements that offer facile solutions for everything and anything, an idea also to found on the cover of the brochure containing the photo captions written by Klein, full of similar slogans: *Remember there is only one: NEW YORK*. Thus, right from the dust jacket—on which several luminous signs repeat, in different directions, sizes, and color, the name of New York—the book presents itself as a commentary on or parody of the advertising esthetic.

The eleven chapters ("Album de famille," "Extase," "A vital message," Dream"...) follow no clear order. What predominates is street photography. "I was a make believe ethnographer: treating New Yorkers like an explorer would treat Zulus," Klein would write. The photos are full of spontaneity, of people laughing at the camera or being turned into phantasmagoric presences by lack of focus. These techniques clearly reveal the presence of the photographer, who has also written the captions in the first person, like a subjective, personal diary. In those year the filmmaker Jean Rouch would coin the term *ciné-transe* to describe his ethnographic films, in which chance played an important role. As it does in *New York*, which bears an eloquent subtitle: *Trance Witness Revels*.

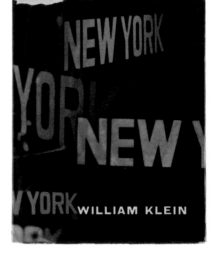

This gestural quality led Ben Lifson (*Village Voice*, December 1980) to compare Klein's work to Pollock's or de Kooning's action painting. The similarity is clear, though *New York* is not just a manifestation of the author's "subconscious" (as Pollock would have it). It is also a reaction to a city full of references: Klein speaks of the "lettrist poems" and the typographical variety of the city's signs, of motion pictures and newspapers... This is why Max Kozloff (*Artforum*, May 1981) prefers to speak of Pop Art: *New York* is an artificial world of advertising, tabloids, gossip, crime, and sensationalism, presented by Klein with a mixture of tenderness, black humor, and irony.

The confused and contradictory sensations produced by the book are underscored by the layout, done by Klein himself: some images are enlarged and reproduced without borders, while other are arranged in sequences to create brief narratives or mark contrasts. There are ample blank spaces (black or white), which render the content more expressive still. It is a book "about graphic design," as Klein acknowledged. And indeed the layout accounts for a large part of the sensation of frenetic, syncopated rhythms produced by *New York*. [J. O.-E.]

Milan: Feltrinelli Editore 1956 / 285x225 mm, 194 pages, black cloth, illustrated dust jacket / loose illustrated brochure 276x230 mm, [16] pages / 188 b&w photographs, edition, text, and design by William Klein / photogravure printed by Roto-Sadag, Genève

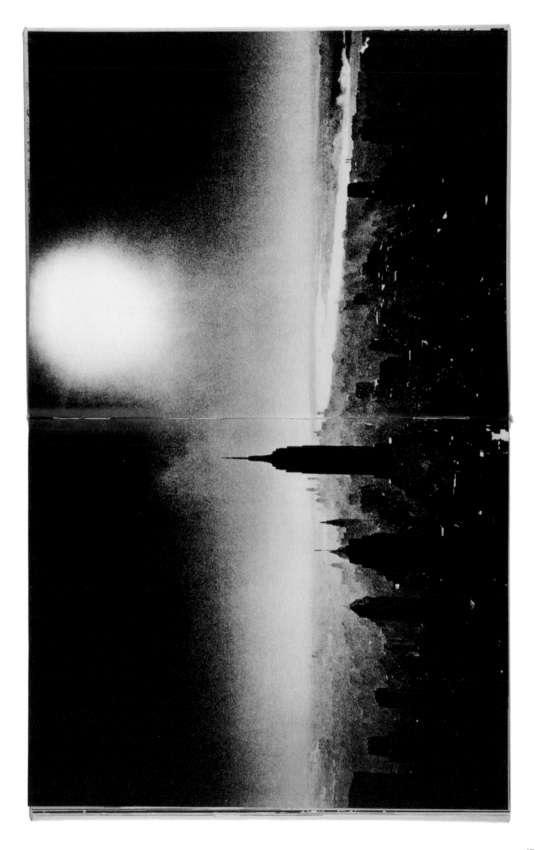

97

103

105

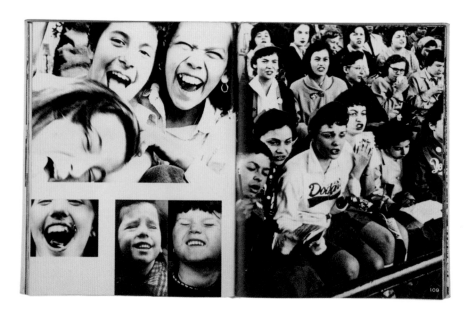

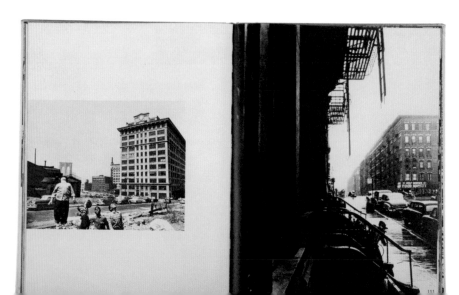

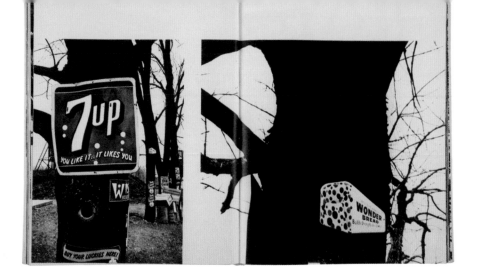

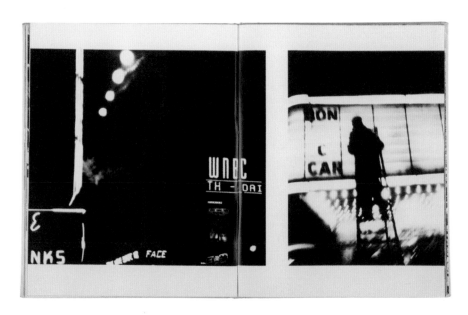

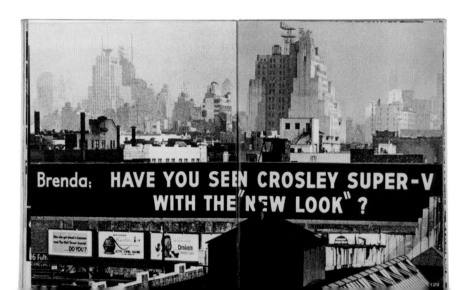

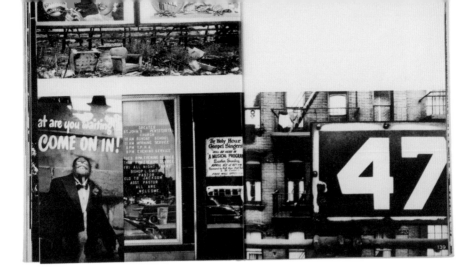

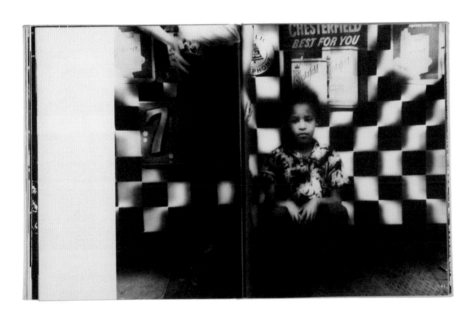

1956
New York

In 1955, the US edition of *Bonjour, Tristesse* (1954), by Françoise Sagan, rose to first place on *The New York Times* bestseller list. Given the success of the book, the magazine *Elle* organized a promotional tour for the author and gave it ample coverage. Sagan asked her friend Florence Malraux—who worked in the photography department of Gallimard—to accompany her. This was to be seed of the present photobook, conceived and edited by Malraux.

New York was published in 1956 in Paris by Éditions Tel, an imprint affiliated with Gallimard. It contains 91 photographs and a text by Sagan. The cover highlights the name of the writer, while the photojournalists are mentioned only on the last page. Not all of the photos were recent: Roger Parry had been in New York in 1945 and Cartier-Bresson a year later. More recent were the photographs of Auro Roselli, who was moreover credited with the largest number of them.

The book begins and ends with a nineteenth-century engraving of Manhattan, when only boats crossed the East River and the Hudson. The city's insular nature is also evoked by the first and last photographs in the book, and by the images of bridges and piers. A city built on top of itself, in a ceaseless process of tearing down and rebuilding that multiplied the skyscrapers: "marvelous stone dandies," as Sagan calls them. Different atmospheres are captured, from dawn to night: images enveloped in fog, which almost seem aquatints, like the double page of Bischof skyscrapers; luminous photos of the statue garden of the MoMA by Boubat; dense interiors with sharp contrasts of light in Gjon Mili's images of Harlem nightclubs.

The city is voracious, with a heart that beats faster than those of its inhabitants. Which is why, as Sagan writes, there is no place for the *flâneur*. But in fact, the bars, display windows, advertising, bustling sidewalks, variety of small trades, varied commercial alphabets, and animated scenes of street life give the lie to this perhaps rather Parisian condemnation. "What street corner does America begin on?" asks Sagan, commenting on the colors, smells, and accents of Harlem, Chinatown, and the Lower East Side. And there is the omnipresent electricity, which makes it impossible to tell day from night, a contrast resolved on the appealing dotted dust jacket, an effective optical illusion halfway between the rows of windows on a skyscraper and the ceaseless blinking of neon signs.

In 1956 Sagan also published her second novel, *Un certain sourire* (A Certain Smile), dedicated to Florence Malraux. In New York, there is also a concealed dedication to someone who was perhaps more than just a friend. Malraux was well aware of the plots of Sagan's books: two people fall in love, while a third looks on in silence and suffers. The situation may well be evoked by the beautiful double-page spread (pp. 38-39) with the photos of the New Year in Times Square by Ernst Haas and a young man alone at night by Cartier-Bresson.

New York has been a scarce, inaccessible photobook, the text of which was reprinted in 2007 under the title *Bonjour New York*. It deserves a closer look. [S. A.]

Paris: Éditions Tel 1956 / 305x240 mm, 112 pages, softcover, illustrated dust jacket / 91 b&w photographs by Werner Bischof (12), Édouard Boubat (13), Henri Cartier-Bresson (10), Jean-Pierre Darnat (4), Ernst Haas (4), Gjon Mili (2), Roger Parry (6), Auro Roselli (34) et al. / text by Françoise Sagan / designed by Jean-Pierre Rosier / photogravure printed by SAPHO

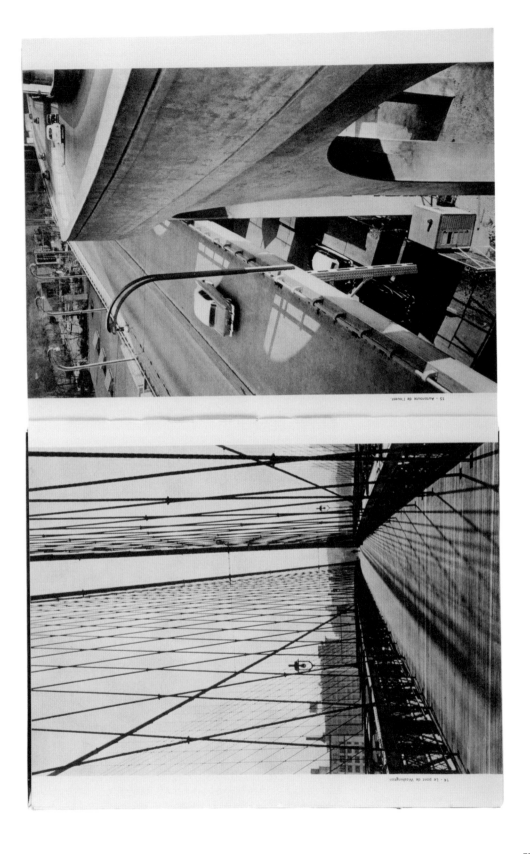

15 - Autoroute de l'ouest

14 - Le pont de Washington

75

1960 (1968)
Suzanne Szasz **Young Folks' New York**

Susan Elizabeth Lyman (1905-1976) worked in the education department of the Museum of the City of New York (where she developed the "Please Touch" room) and was a chronicler and popularizer of New York history.

In 1954 Lyman published *The Face of New York*, with photographs by Andreas Feininger, under the Crown Publishers imprint. The positive reception of the book encouraged her to return to the same subject, but this time adapting it to a new market niche. In 1960 cities were not yet understood as family tourist destinations, but the Czech author and illustrator Miroslav Šašek had just created his innovative children's travel guides under the generic title *This Is...* (Paris and London in 1959, Rome and New York in 1960). Crown Publishers decided to replace illustrations with photographs and enlisted the services of Suzanne Szasz. An émigré to the United States after the Second World War, had begun doing children's photography while working at a summer camp and was known for her images of children (indeed, Steichen had included her in the *Family of Man* exhibition in the section entitled "The Magic of Childhood").

The first edition of *Young Folks' New York* came out in 1960. Eight years later a revised and expanded edition would appear. While she was preparing it, Lyman discovered that New York is not really a city in constant change, for it contains places consecrated by time. It is that "timeless" city that is presented to us in the book: different from the noisy, dirty, bustling metropolis of adults; a window onto a friendly, sentimental place, closer to fairy tale than to film noir. The narrative may sound old-fashioned, but it by no means diminishes the charm of the book. The same can be said of the photos. With their sensitivity to all social classes, the authors manage to capture the rhythm, variety, and vitality of New York.

The book is divided into ten sections: "Introducing New York," "Glimpses into History," "Nature in the Big City," "A Variety of Nations," "Holidays in New York," "In Central Park," "Enjoying the Arts," "All around the Town," "Fun for Everyone," and "At Coney Island." Apart from their qualities of composition and scale, the photos stand out by the naturalness of the human subjects, present in almost all the images. They look at everything, they play with everything. They enjoy themselves. It is a spontaneous atmosphere, owing both to the complicity of the participants and to the simplicity of the sessions. They never trespass on zones forbidden to children, and the photographer carries no showy baggage. Some of the shots show the children full-face, absorbed in their thoughts. Particularly moving is the similarity of the children's gestures with those recorded twenty-five years before during the Second Spanish Republic by the Patronato de las Misiones Pedagógicas, in another world altogether.

Worth noting among the photographer's later work is *The Silent Miaow* (Crown Publishers, 1964), with a text by Paul Gallico: a guide written by a cat (a female cat, not a male, like Hoffmann's Murr) to explain to her fellow felines the way to captivate and dominate a human family. The book soon became a classic among cat lovers. The National Gallery of Hungary organized a retrospective of Szasz's work in 1982. [F. B.]

Revised edition / New York: Crown 1968 / 283x216 mm, 144 pages, hardcover, illustrated dust jacket / 181 b&w photographs and design by Suzanne Szasz / text by Susan E. Lyman / jacket designed by Anthony Congello

CENTRAL PARK PLAYGROUND

Playgrounds in the city are getting better and better. Now you don't have to settle for plain old swings and seesaws and knee-skinning pavements. Try the Central Park Playground at 67th Street and Central Park West (that is, if you are not older than fourteen). Instead of a hard surface, sand carpets the ground—this must be the largest sand pile in captivity. Kick off your shoes if you wish, lots of others do.

Busy, busy, busy. This is the place of perpetual motion, for there is so much to do. Walk along the curving wall, wade in the long "stream," capture the fort, shimmy up the flagpole, clamber into the treehouses, climb up the steps of the stone pyramid—then slide down the chute. Or crawl through the tunnel into the stone igloo and go up the inside ladder. It's just like coming up a submarine turret.

Good news. More and more exciting playgrounds are continually opening up in the city.

What better place for storytelling than the statue of Hans Christian Andersen in Central Park? Here he sits, larger than life, his book open, the ugly duckling at his feet, while Miss Lydia Perera tells the children, "He was no longer a clumsy, dark gray bird, ugly and ungainly—he was himself a swan."

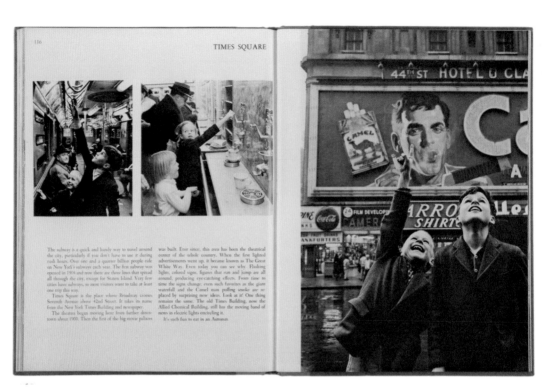

The subway is a quick and handy way to travel around the city, particularly if you don't have to use it during rush hours. Over one and a quarter billion people ride on New York's subways each year. The first subway was opened in 1904 and now there are three lines that spread all through the city, except for Staten Island. Very few cities have subways, so most visitors want to take at least one trip this way.

Times Square is the place where Broadway crosses Seventh Avenue above 42nd Street. It takes its name from the New York Times Building and newspaper.

The theaters began moving here from farther downtown about 1900. Then the first of the big movie palaces was built. Ever since, this area has been the theatrical center of the whole country. When the first lighted advertisements went up, it became known as The Great White Way. Even today you can see why. Flashing lights, colored signs, figures that run and jump are all around, producing eye-catching effects. From time to time the signs change; even such favorites as the giant waterfall and the Camel man puffing smoke are replaced by surprising new ideas. Look at it! One thing remains the same. The old Times Building, now the Allied Chemical Building, still has the moving band of news in electric lights encircling it.

It's such fun to eat in an Automat.

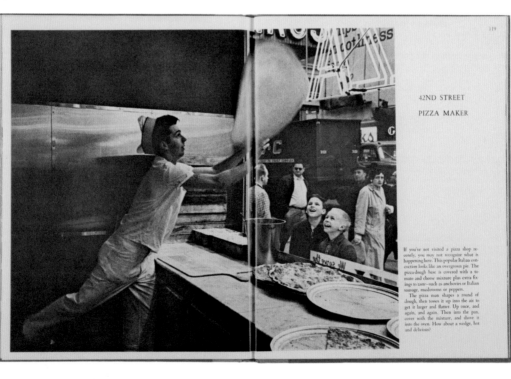

119

42ND STREET
PIZZA MAKER

If you've not visited a pizza shop recently, you may not recognize what is happening here. This popular Italian confection looks like an overgrown pie. The pizza-dough base is covered with a tomato and cheese mixture plus extra fixings to taste—such as anchovies or Italian sausage, mushrooms or peppers.

The pizza man shapes a round of dough, then tosses it up into the air to get it larger and flatter. Up once, and again, and again. Then into the pan, cover with the mixture, and shove it into the oven. How about a wedge, hot and delicious?

TIMES SQUARE ARCADE

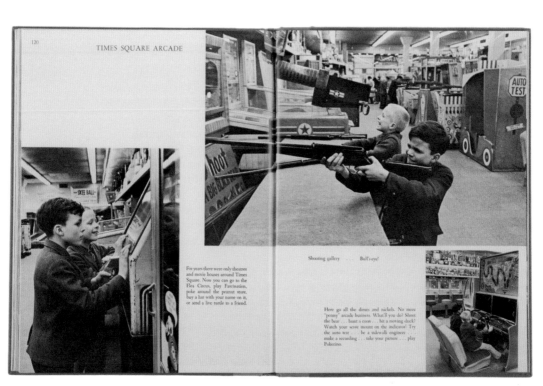

For years there were only theatres and movie houses around Times Square. Now you can go to the Flea Circus, play Fascination, poke around the peanut store, buy a hat with your name on it, or send a live turtle to a friend.

Shooting gallery . . . Bull's-eye!

Here go all the dimes and nickels. No more "penny" arcade business. What'll you do? Shoot the bear . . . hunt a coon . . . hit a moving duck? Watch your score mount on the indicator! Try the auto test . . . be a sidewalk engineer . . . make a recording . . . take your picture . . . play Pokerino.

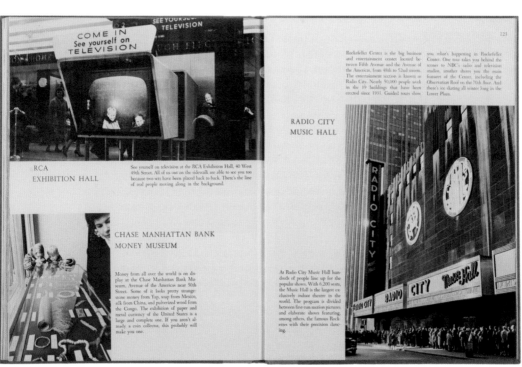

COME IN
See yourself on
TELEVISION

RCA
EXHIBITION HALL

See yourself on television at the RCA Exhibition Hall, 40 West 49th Street. All of us out on the sidewalk are able to see you too because two sets have been placed back to back. There's the line of real people moving along in the background.

CHASE MANHATTAN BANK
MONEY MUSEUM

Money from all over the world is on display at the Chase Manhattan Bank Museum, Avenue of the Americas near 50th Street. Some of it looks pretty strange: stone money from Yap, soap from Mexico, silk from China, and pulverized wood from the Congo. The exhibition of paper and metal currency of the United States is a large and complete one. If you aren't already a coin collector, this probably will make you one.

RADIO CITY
MUSIC HALL

Rockefeller Center is the big business and entertainment center located between Fifth Avenue and the Avenue of the Americas, from 48th to 52nd streets. The entertainment section is known as Radio City. Nearly 30,000 people work in the 19 buildings that have been erected since 1931. Guided tours show you what's happening in Rockefeller Center. One tour takes you behind the scenes to NBC's radio and television studios, another shows you the main features of the Center, including the Observation Roof on the 70th floor. And there's ice skating all winter long in the Lower Plaza.

At Radio City Music Hall hundreds of people line up for the popular shows. With 6,200 seats, the Music Hall is the largest exclusively indoor theatre in the world. The program is divided between first-run motion pictures and elaborate shows featuring, among others, the famous Rockettes with their precision dancing.

1960
Kees Scherer **Hier is New-York**

Kees Scherer (1920-1993) began his career as a photojournalist in 1945. His spectacular reportages on flooding in Amsterdam in 1953 and the Hungarian uprising in 1956 made him one of Holland's best-known photographers. For thirty years he contributed to Dutch magazines such as *Margriet* and *Avenue*, while at the same time producing dozens of photobooks. *Hier is New-York* is the second of a collection of fourteen photobooks published in the 1960s by A. W. Bruna & Zoon. The cover of the first in the series, a book about Princess Beatrix, reproduces a photo taken by Scherer in New York in September 1959, when he was working on his own photobook.

The format of *Hier is New-York* is rather uncommon among photobooks, which are generally expensive, with limited print runs, and aimed at a small audience. It is a pocketbook, a model created during the 1930s and characterized by large print runs, low prices, and sales to the general public. An inexpensive book, therefore, bound in soft covers, but printed in high-quality photogravure, with a carefully arranged visual sequence: an outstanding example of a photobook made for mass consumption.

The text was signed by Max Tak, a musician and journalist almost thirty years older than Scherer, who had been living in New York since 1943. His words lead the eye of the photographer and the reader along the streets of the metropolis by means of the images, almost all of them laid out in dialectical fashion, showing the contrasts of the Big Apple: rich and poor, classical statues at the feet of modern skyscrapers, an old man playing chess in the park and a child cooling off in a fountain. Without breaking the thread of Tak's text, rich in details and statistics, but also full of ironic nods in other directions, Scherer introduces more classic visual metaphors, perfectly suited to making a coherent photographic essay that begins with images bathed in morning light to show a typical day in New York City and ends with the lights on Broadway in the city that never sleeps. Both worlds are present in the photo captions, that of the word and that of the image. They provide information about what can be seen in the photos, but try above all to make explicit the visual interplay, as for example in the double-page spread that shows, on the left, a dead pigeon lying on the sidewalk and, on the right, a man seated in a doorway, head bowed and shoulders hunched: "The pigeon, which just a minute before was circling the highest skyscrapers in daring flight, has come to a sad end on the sidewalk... and not only the pigeon."

Hier is New-York was a commercial success. It was reprinted in Hamburg and London a year later, also in photogravure, with the same efficient design placed at the service of the main message of the book: New York is a city unique in richness, diversity, spirit, and, above all, contrasts. [M. N.]

Utrecht: A.W. Bruna & Zoon 1960 / 175x115 mm, 80+[122] pages, illustrated softcover / 122 b&w photographs by Kees Scherer / text by Max Tak / photogravure

8. De duif die een wiener geleden nog zo zwierig van de hoogere verkeerskabler omlaag kwam glijden eindigt triest in de goot ...
9. ... maar niet alleen de duif

10 / 11. Een ieder zoekt hier zijn plaatsje onder de zon, maar alleen de baby zal bruin worden

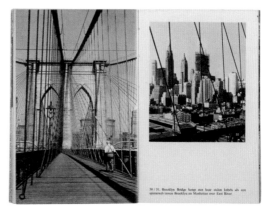
30 / 31. Brooklyn Bridge hangt met haar stalen kabels als een spinneweb tussen Brooklyn en Manhattan over East River

48 / 49. 'Geen T.V., net als vroeger', zo lokt deze bar haar klanten, maar ... er zijn er die er mooi genoeg van krijgen!

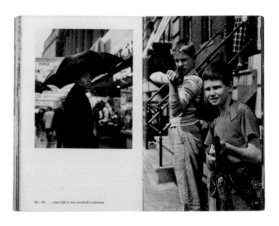
48 / 49. ... soms kijk je wat verschrikt achterom

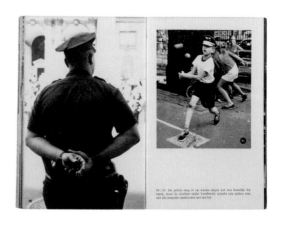
50 / 51. De politie mag er op warme dagen wel wat bonkig bij-lopen, maar de overbuur vindt handhaving spoorelt een ander tint, met alle jongetjes spelen met met een bal

1964
Victor Laredo **New York / People & Places**

Commissioned by his publishers, Victor Laredo (b. 1910 in Pergamon, d. 2003 in New York) devoted months to photographing the city that had welcomed him. In principle, the idea was to capture the city's architecture (streetscapes, buildings, details...) and only later, as he reviewed the photos he had been taking at the same time, was it decided that the book would deal with places... and people.

Laredo was a well-known photographer at the time. He had been trained at the National Academy of Art and Design, where he began to study in 1929. The Museum of Modern Art had acquired work by him in 1948. As a commercial photographer, he had contributed to *Harper's Bazaar* and *Charm* until the 1950s. A frequent contributor to *Life* magazine as well, he was also a professor in a school for disadvantaged young people that he himself had established in East Harlem.

One has only to glance at the first section of the book to see that human figures appear in the overwhelming majority of the images. And if we pause to look at the few photographs in which there is no direct human presence, we shall see that even the loftiest skyscrapers are portrayed in a light that renders them familiar, graspable, endowed with personality, and therefore legitimate neighbors to those ramshackle houses, those stairs and windows about to tell us a story, happy or sad, but always moving.

Laredo was extraordinarily sensitive to the specifically human note, the atmosphere of everyday life, the mute eloquence of gestures and signs that allow us to imagine and enter into the lives of others. Especially the lives of ordinary people: fishermen, shoeshine boys, secretaries, machine operators, tailors, seamstresses, charlatans... Human lives, impossible to dissociate from the discipline of photography.

Those who knew him, such as the gallery owner Marta Cervera and the photographer Corina Arranz, recall his generosity and warmth. The latter told me on the telephone: "We were introduced by Joaquín Cervera. I was just beginning to take photographs and his advice and opinions were fundamental. He had great technical skill, but what he insisted on valuing was the photographer's *gaze*. He also spoke perfect Spanish. In his neighborhood he frequented the old Catalan anarchists... From his childhood, he remembered with special emotion the codfish in garlic and tomato sauce that his mother used to prepare."

In Asia Minor, in the early twentieth century, codfish was prepared in Sephardic families almost as it had been in the middle ages. Perhaps it is not inappropriate, in attempting to gauge the sensibility transmitted by these photographs, to take into account the photographer's biographical background. Laredo arrived in New Jersey as a child, when the implosion of the Ottoman empire following the First World War led his family to seek again—four hundred years after a previous expulsion!—another place in the world. He was young, but, like any good Sephardic Jew, by no means forgetful: in the 1960s, apart from taking the photographs in this book, he traveled to Spain in search of his roots and compiled another priceless volume, *Sephardic Spain*.

From the very beginning, the critics discerned a clear rejection of the academic manner in his technique. And it might be said that he also understood his art as a rejection of that other cold, hard, universal rule we call forgetfulness. [A. C.]

New York: Reinhold 1964 / 266x210 mm, 192 pages, cloth, illustrated dust jacket / 161 b&w photographs by Victor Laredo / text by Percy Seitlin / designed by Myron Hall III / photogravure printed by Joh. Enschedé en Zonen, Harleem

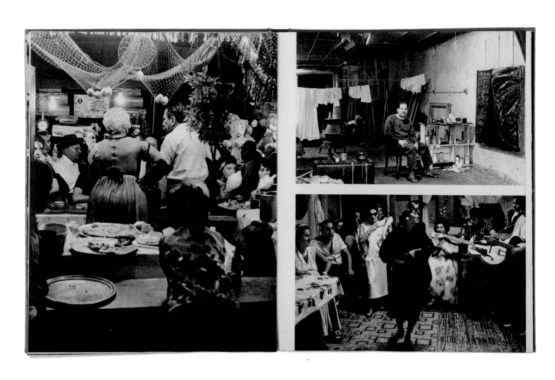

Sam Falk **New York: True North**

New York: True North is a choral book: a group of "I"s seeking to form a "we." It gathers the many voices of a metropolis which, in its several introductions, is defined in 1964 as the new Rome, the *Urbs* with a capital U, the city that serves as the essential reflection of an entire age. The center of the universe or, as the cover blurb reads, "the most desirable and most difficult of cities in which to live ... the endless celebration of everything."

The compilation of the different voices was the work of Gilbert Millstein, a veteran journalist who had worked for the most famous publications in the city, from the *Herald Tribune* and *The New Yorker*, to *The New York Times* and the *Saturday Evening Post*. His work is spectacular: in the pages of the book we come across surgeons and prostitutes, anthropologists and housewives, musicians and columnists, Blacks and homosexuals, theater producers and African diplomats. This multiplicity prevails right from the four introductions that open *New York: True North*, with their four "witnesses" who describe the city: a novelist, a real estate contractor, a poet, and a psychoanalyst. Of all of them, it is only the poet, Gregory Corso, who dares to doubt that anyone can be fully intelligent if he or she has not visited the Big Apple.

In contrast to this multiplicity, the photographs belong to a single pair of eyes: those of Sam Falk (1901-1991), who participated in *The Family of Man* and was a photographer for the *Times* for more than forty years. A pioneer of the use of 35mm cameras in the printed press, Falk was always effective: nothing escaped him, and he dominated everything. Like a studio musician able to blend in with others, he had a talent for imitating any style, day or night, in architecture (from the inside of the Guggenheim Museum to an alleyway in the financial district) and in portraits (of children, of pretty girls in Greenwich Village, of old immigrant women).

There is a third name that needs to be mentioned: that of typographer, calligrapher, and cartographer Joseph P. Ascherl, who was working at the time as senior designer at Doubleday, the publisher of the book. The polished, classic design—serif typeface and sober black-and-white—lends the photobook as much personality as the images it contains, starting from the panoramic views of the metropolis, at dawn and dusk, ever alert, on the flyleaves. Or the dust jacket with the cross atop a church peeking out between two skyscrapers.

The result is a faithful reflection of a city that is sure of itself, able to present itself as the center of the world and to assume or sugarcoat its contradictions. And of a time, the mid-1960s, forceful, confident, optimistic... still oblivious of the changes and upheavals waiting just around the corner. [I. G. U.]

Garden City: Doubleday 1964 / 285x215 mm, 288 pages, black cloth, illustrated dust jacket / 197 b&w photographs by Sam Falk / text by Gilbert Millstein / designed by Joseph P. Ascherl

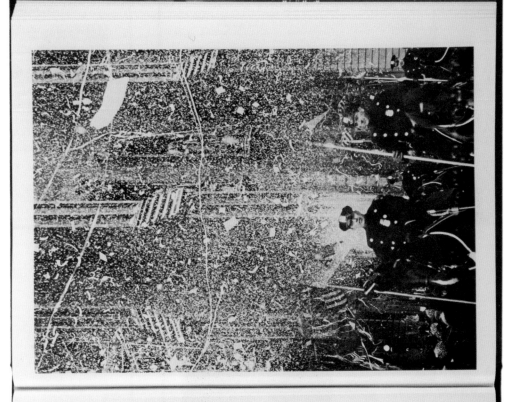

Lower Broadway, an official reception.
New York is the endless celebration of everything.

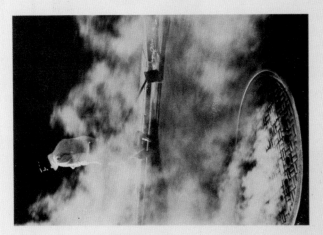

White wing in the mist of
Manhattan. Cold air vaporizes
on the outside of livestream
mains below the street; the
Mephistopheles with the broom
materializes in it.

142

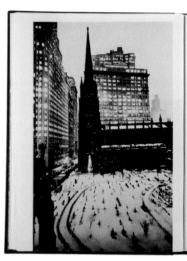

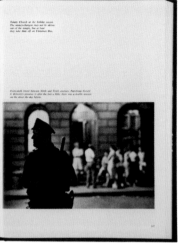

Trinity Church at the holiday season.
The snow-whangers may not be driven
out of the temple, but at least
they take time off at Christmas Day.

Forty-sixth Street between Sixth and Tenth avenues. Patrolman Gerald
V. Helenski's presence is after the law a little. Here was a double service
on the street the day before.

Fifth Avenue and Fifty-ninth Street, the Pulitzer Fountain. The lush, quiet
breathes of Abundance.

Columbia University, steps of the Low Library. You are aware of its full name: Columbia
University in the City of New York.

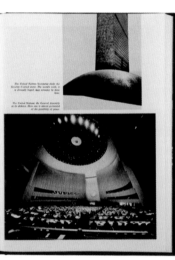

The United Nations Secretariat shaft, the
Security Council dome. The world's work, it
is devoutly hoped, may someday be done
here.

The United Nations the General Assembly
at its debate. Here one is almost persuaded
of the possibility of peace.

General Sherman touches distant Central Park eternally, but the horseback rides in
winter time.

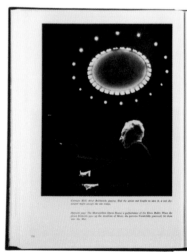

Carnegie Hall, Artur Rubinstein playing. Had the artist not fought to save it, a red slice
tongue night occupy the site today.

Opposite page: The Metropolitan Opera House a performance of the Elves Ballet. When the
grand Bohemia goes up the Academy of Music, the patrons Vanderbilts generally let them
into the Met.

Central Park at night.
The worldly and shining much is that it is not safe after dark.

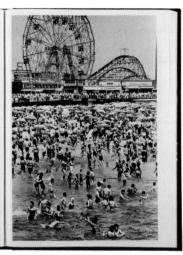

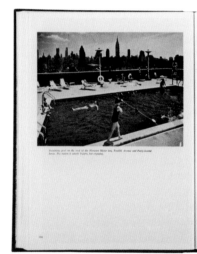

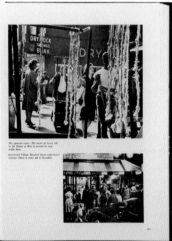

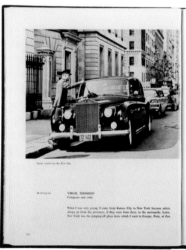

1965 (1981)
Helen Levitt **A Way of Seeing**

When *A Way of Seeing* was published in 1965, almost twenty years had passed since Helen Levitt portrayed the daily life of her hometown, in the streets of Yorkville, Harlem, and the Lower East Side. An heir to the European tradition, Levitt translated the new vocabulary developed by Henri Cartier-Bresson and the incisive gaze of her friend and mentor Walker Evans into a language of her own. Equipped with her Leica, she produced her sophisticated, poetical compositions of everyday life with a combination of intuition and intelligence.

Blending the static beauty that Evans extracted from day-to-day events with Cartier-Bresson's sense of movement, Levitt created a genuine portrait of street life. She isolates the brightest and most spontaneous moments with a vision that includes a clear dose of emotion and that betrays an admiration, even a perplexity, in the face of neighborhood life. She lingers over the most pleasant moments of people's lives, over their expressions, interrelations, gestures, which are captured with grace and subtlety, as if the entire neighborhood were a stage and the people a cast of actors. In her work there is a sort of unconscious theatricality, an implicit dance, a continuous evolution of movement. Levitt never sought to produce a social document, as other photographers of the time. She recreated, in those neighborhoods so active in social relations and so visually rich, a sort of celebration of community.

The first edition of *A Way of Seeing* was planned in the late 1940s, when James Agee was working on the short documentary film *In the Street* (1952), but Viking Press did not publish the book until 1965, by which time the writer had died. Nevertheless, Agee clearly put his stamp on the editing of the book, the selection of photographs, and their arrangement. The images, it might be said, are at the service of the text, which comments on more than half of them. Although Evans had also associated Levitt's work with dance and poetry, Agee's essay described it as something "as beautiful, perceptive, satisfying, and enduring as any lyrical work that I know." These somewhat arbitrary reflections, however accurate, contributed to the pigeonholing of Levitt's work for decades.

The Horizon Press edition (1981) recovers a classic representation of Levitt's photography. In a larger format, completely redesigned by Marvin Hoshino, it maintains James Agee's essay, now complete, and increases the number of photographs to sixty-eight. The original sequence is altered, and Levitt, now with greater freedom, was able to restore the original format of the many of the photographs, which had been cut back in the first edition. The 1981 edition is elegant, however, and a sort of narrative sequence is given to the images by combining them in pairs or grouping them together according to action, gesture, or age, or by highlighting certain images. Neither the front or back of the jacket nor the clothbound hard covers bear any images, only typeface. Along with this expanded second edition, a deluxe edition, this time with ninety images, was also printed, limited to two hundred and fifty signed copies. [C. G. C.]

Revised edition / New York: Horizon Press, 1981 / 245x275 mm, xv + [77] pages, blue cloth, dust jacket / 68 b&w photographs by Helen Levitt / text by James Agee / designed by Marvin Hoshino / printed in halftone by Richard Benson and Meriden Gravure Company

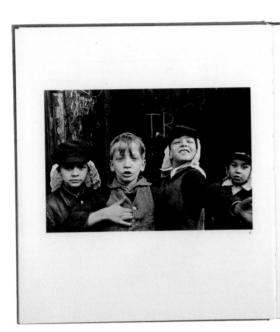

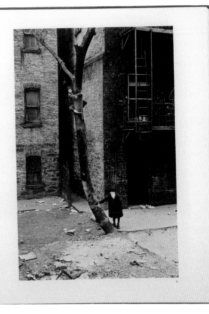

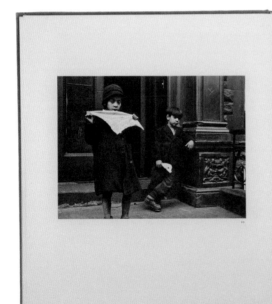

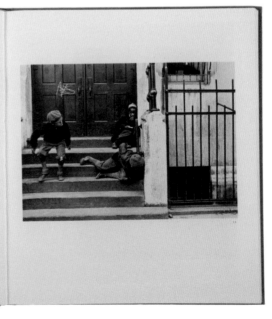

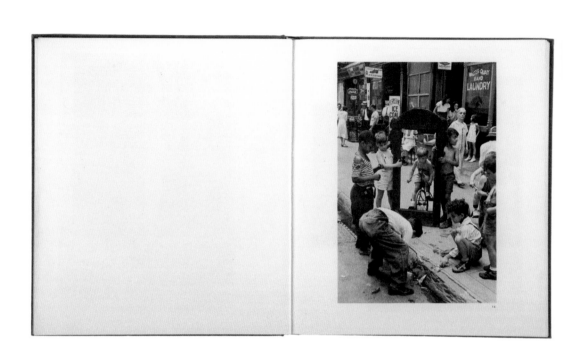

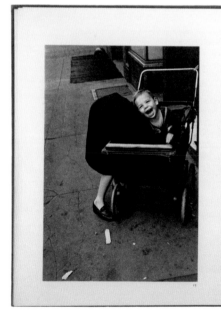

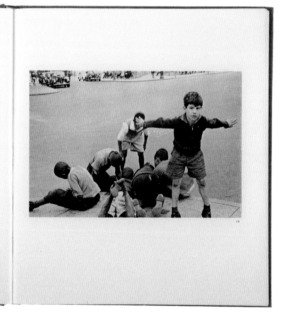

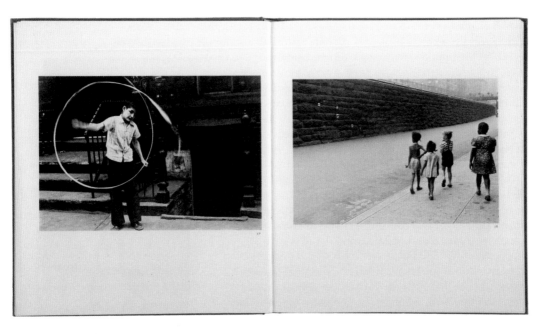

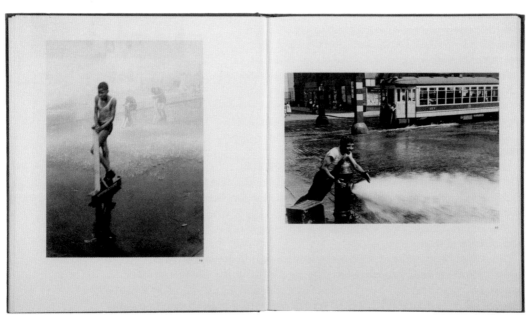

95

1965
Jan Yoors **Only One New York / The Unknown Worlds of the Great City**

As a photobook, *Only One New York* stands out. Not only for its impeccable design, which recalls the perfectionism of W. Eugene Smith, but also for the care lavished on the texts by both authors and editors: from the subtitle ("The Unknown Worlds of the Great City") to the narrative structure, ordered by chapters, a literary and visual immersion that culminates in the epilogue "Change and Decay." The stance described in his preface by Charles Samuels, the author of the texts, fits perfectly with the photography of the nomadic and multifaceted artist Jan Yoors (1922-1977): "[...] there are, within the city, a thousand, a hundred thousand, private worlds, where a life goes on that remains, closed, private and unique, screened from us either by fear, by pride or by our own indifference."

The images representing New York City are imbued with the life of their author, born in Flanders into a family with Romani roots. As a teenager, Yoors was taken into a Roma family and lived a nomadic existence, being condemned to death by the Nazis and exiled in London during the Second World War. In a metaphorical rebellion against the imposition of a eugenicist and racist vision of society, he discovered the art of tapestry in the English capital and ended up settling permanently in the 1950s in New York, the most polychromatic capital of the mestizo New World, which would be both his salvation and the favored setting of his career as an artist.

Photographs by Jan Yoors / Text by Charles Samuels

Samuels describes the book as "a collection of photographs designed not so much to show what life is like among the poor or the dispossessed ... but to record the immense and exotic beauty of a city that has no common culture, no dominant character." In contrast to the modern tendency towards decontextualizing the photograph, at the cost of the viewer's understanding of the image, Samuels and Yoors invite the spectator to read—and almost to listen to— the voices of the protagonists, as individuals and as members of the dynamic and infra-represented collectivity.

The narrative is organized around both individual and shared experiences—community festivals, weddings, celebrations, solitude and old age, childhood, religious ceremonies—which avoid all distinctions between the individual and the community into which he or she is inserted. The visual *tempo* is fragmented. The association of images seeks to humanize and connect the inhabitants of the city, stripping them of their anonymity.

The extraordinary value of this book resides not only in the solidity of its representations and the originality of its vision and esthetic, but also in how it has succeeded in presenting the best of documentary photography outside of the limitations of the printed press. The result is a photographic essay that recalls the "encyclopedic" effort of Edward Steichen and his project *The Family of Man*, albeit on a New York scale. [J. P.]

New York: Simon & Schuster 1965 / 310x 235 mm, 136 pages, hardcover, illustrated dust jacket / 116 b&w photographs by Jan Yoors / text by Charles Samuels / designed by Eve Metz (book) and Janet Halverson (jacket) / photogravure printed by Murray Printing Co., Forge Village

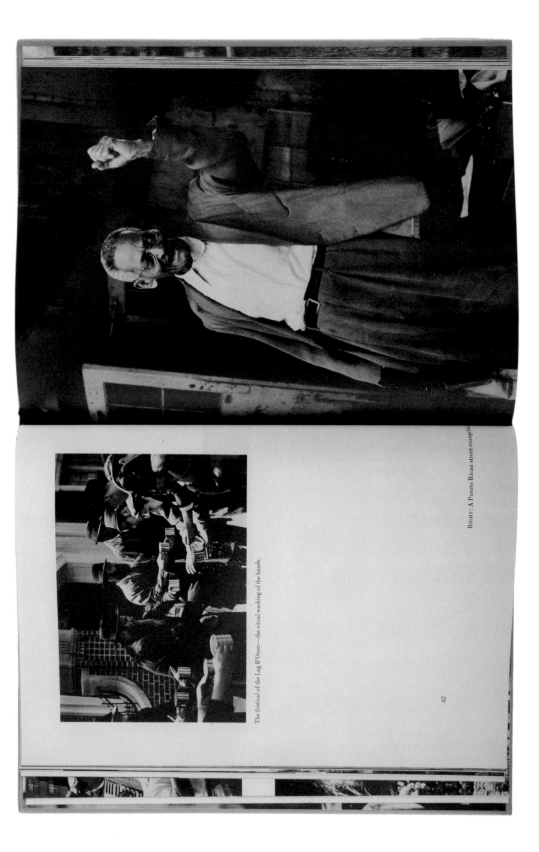

The festival of the Lag B'Omer—the ritual washing of the hands.

RIGHT: A Puerto Rican street evangelist.

42

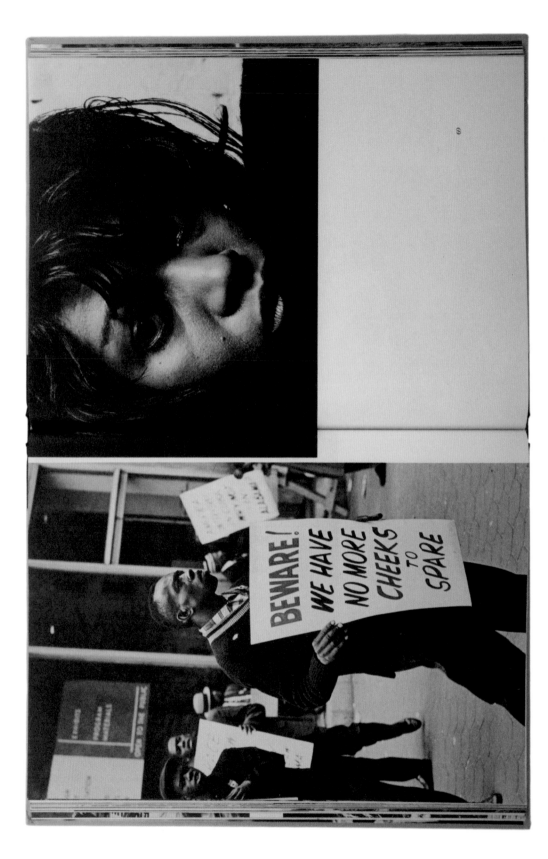

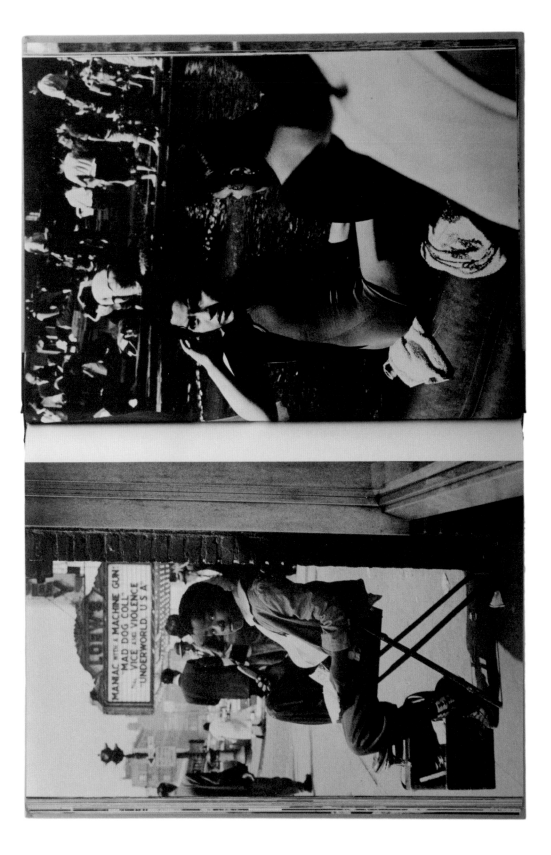

1965
Evelyn Hofer **New York Proclaimed**

Evelyn Hofer (1922-2009) was essentially a portraitist. She established herself in New York as a commercial photographer in 1946 and her career is associated with magazines and books about cities, produced in collaboration with writers such as Mary McCarthy, who commissioned her to take the photographs for *The Stones of Florence* (1959). Over the next forty years she would also collaborate with Jan (James) Morris on *The Presence of Spain* (1964) and especially with her friend V. S. Pritchett on *London Perceived* (1962), *Dublin: A Portrait* (1967), and *New York Proclaimed*. Travel books in which the words are as important as the images.

"New York, horrible," noted Hofer on just arriving in the city. Two decades later, her vision was different. Pritchett presents a New York of "stereoscopic hardness," full of hostile skyscrapers. This sinister side is neutralized by the always effervescent urban activity. In fact, Pritchett finds the beauty the New York in this constant juxtaposition. An insightful, ironical text, with "visual and aural keenness," according to a contemporary critic, attentive to the European essence of the city and its status as an island. A young city, always in the present, raised up by waves of foreigners and by a love of money that derives from its Dutch founders.

Hofer's photographs seek to distil the essence of the city. In panoramic views and urban scenes, Hofer pays homage to the beauty and diversity of its architecture, in line with the optimistic prewar vision of Berenice Abbott. Apart from the typical skyscrapers, Hofer also captures the horizontal arteries (highways, bridges, tunnels) and the details (cast-iron structures, fire escapes, rooftops with water tanks, posters, display windows). Photographs of a particular age that nevertheless possess a timeless classicism, also reflected in the interior views (such as the VIP dining room of the Chase Manhattan Bank or Andy Warhol's studio).

Hofer had a talent for connecting with her subjects, including the lion at the zoo. This capacity for empathy, the result of much observation, links her work to that of August Sander. Her subjects know they are being photographed and have both dignity and pride, in a complicity generated by means of long exposure times, studies of the relation between figure and background, and a handling of light worthy of Ingres. With a keen gaze, Hofer portrays typical urban types and trades: from the doorman of the Picasso building to passersby, stevedores, street vendors, fortune-tellers, bankers, pastors, and dilettantes. All together they make up a choral portrait of the city and the activities that characterize it.

Hofer's compositions possess painstaking balance. According to Hilton Kramer, her work conveyed a "serene indifference to the accidental, the sordid, the trashy and the vulgar." She herself said she like to keep her work as simple as possible. In technical terms, she had mastered the handling of proportion, light, form, and color. She was one of the first professional photographers to adopt color. The editing of the this book is magnificent, both in its circular structure and the rhythm of the text and photographs. The splendid printing, which alternates black-and-white and color on the same page, was unusual at the time. [M. R.]

London: Chatto & Windus and William Heinemann 1965 / 283x220 mm, 116+[128] pages, cloth, dust jacket, cardboard slipcase / 90 b&w and 22 color photographs by Evelyn Hofer / text by V. S. Pritchett / jacket designed by Miriam Woods / photogravure printed by Conzett & Huber, Zurich

are not free, they say, as young Europeans are free. They are all disciples of Carlyle and, indeed, one of the features of Bellamy's Utopia was that, in view of Utopia's (and Manhattan's) shortage of servants, the students would wait on their elders in the glorious cafeterias of the future. They would "work their way." In a very different social climate, this becomes true of modern life in all advanced countries, though not with the American sense of self-conscious moral necessity. Yet what the young people are escaping from when they get a footing in the Village, or come down in thousands from the Bronx and Brooklyn to see it over the weekend, turning what was once the hiding place of serious artists into a carnival—what the young come for now is the short burst of freedom, the freedom to do nothing, to have no purpose, no status, to keep no hours, to get up late, to pass the days and nights drinking coffee and talking. It is Montparnasse, circa 1925, at the height of the American invasion. Poetry is recited, folk songs are sung, jazz pulses, race differences vanish, the cops are out in force in MacDougal Street, the theaters are packed. It is charming; it is sometimes sinister: the Italians loathe the tourist. But tourism—even to the extent of no more than half an hour on the subway—is in the blood. You could sell a tour to the next station down the line.

And once the weekend teen-agers have gone back to their respectable homes, the Village recovers its early-American charm. Its small houses bloom, its alleys, its mews and unexpected gardens are quiet. The local families stroll from the delicatessen to the bookshop and everybody knows everybody. People get up late—at ten or eleven in the morning curtains are often still drawn, shops scarcely open, perhaps the only non-early-American trait. I think of the little houses in Vandam Street or St. Luke's Place, of winding streets, of thriving cafes, and of the local pride: the expert fight the dedicated Villagers put up against the impersonal engineers and speculators. There is all the pleasure of being among trees in an oasis. In short, the Village is everything that Manhattan is not—except, of course, expensive. One has to be really successful to live there now and the hangers-on of the artists have usually so much more money than the artists. These indeed move out to the slummier quarters; the painters go into warehouse lofts; the writers into places where the bath is unspeakable and the water heater broken, where the poor Poles shout from the windows, and where the poorest Italians run little restaurants that are in no gourmet's guide.

When I had the time I had not the money to live in the Village and later I had not the time. I could get more done on the West Side or in the East Nineties. Besides, one becomes *un corrompu*. But one cannot but be sentimental about

Times Square

86

NEW YORK PROCLAIMED

BY V. S. PRITCHETT

Photographs by Evelyn Hofer

CHATTO & WINDUS AND WILLIAM HEINEMANN LTD

walking. At the corners of the cross streets in the winter you put your head down, button up, and feel your chest wither as the wind gets at your miserable nakedness. I can see myself dodging from doorway to doorway on Forty-third Street and wondering whether I should be alive by the time I got to Lexington. I commiserated with my shirt. I talked to my coat collar. All the people I passed looked isolated from the human race. You walk, in these extreme seasons, from hot to cold, from cold to hot in a yard or two. In the summer you walk out of a freezer into the fire. One day, the Greek at the grocer's in our neighborhood popped out of his doorway into the fire and put up his hands in self-defense as the flame struck him. "Oh God," he said and stepped back inside. Such changes would be enough to create a life basically nervous even if there were no other cause, and the tightness of New York's nerve strings is famous. They emit sharp arpeggios which break out of the relaxed tones of New York speech. To Europeans, especially the British, the New York air in the main seems dry to the point, as I have said, of being electric, for we are used to damp air and also to what New York lacks entirely: damp rising from the ground and entering the soul. But when the great if erratic summer heat comes on we suddenly understand the New Yorker's concern with humidity. After all, this is a subtropical city: its fellow is not Paris but Seville or Rio. He knows to a degree the amount of wet air that can turn New York harbor into a choking tropical lagoon and the city into a place where one is reduced to a state of desuetude. One is an ominous collection of sweat glands and guts, a subhuman blob in the jungle of morose thoughts. The buildings slam back the heat at each other. As you walk past the little air-conditioning boxes on the street level, you feel hot air shoot out at you; the glass buildings seem to have been madly constructed to create refraction—iced people inside heating the hot ones outside.

The New York heat waves of August or September are hard to endure and you look at the inhabitants with wonder during them. They do not look cool, but they are far from being overcome. The women do not give up their care in dressing. The crowds are still pretty brisk. Where Seville or Athens closes down from one to four, New York insists on going on. The crowd appears not to be distressingly damp or particularly burned. The leisure of utterance is the same in all seasons and has nothing to do with the weather. People sleep on the benches, but these are the people who always sleep on benches. People go to the Long Island beaches, but they are the people who always go there. Back in your room you walk about more or less naked, as a relief from sticking to your chair. You listen to the trickling of your body. Their minds seem to be going on, but yours has almost stopped, for

Right
Lower Lexington Avenue

Next two pages
From Brooklyn Heights

18

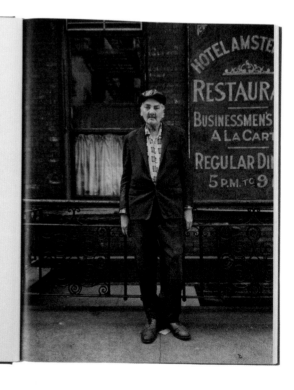

they allow one to see large blocks of sky, whereas off Fifth and Madison one sees little more than slits and jigsaws.

The vistas are the thing. The ego—for which New York is so good—steps out at the prospect. I doubt whether the most inured New Yorker, one to whom the place is a treadmill, a dirty machine, a perpetual grunt of computation, or one so stuck to his neighborhood, confined to what, without a more than rudimentary sense of place, he calls "a couple of blocks," would say these vistas do not tone him up. Waiting for his stinking green bus, he will look down an avenue and gather his notions of the weather, guess at the dry clearness of the air, the humidity, the yellowing smog of the remote distance, the vapors round the waists or the shoulders of the skyscrapers, the density of the blizzard in the winter, the ferocity of the wind, or the weight of heat or freezing. On a rainy night a Londoner will look gratefully at the lights dabbled for straight miles in the black streets even if, on some torrential Sunday when the streets are empty, he is appalled by the sight of a city so violently available to sheets of water.

And to three tastes of New York life the avenues are a godsend—I mean the taste for police cars, fire engines, and parades. The police and the firemen have the best chasing runs in the world and, God knows, they make the most of them, ripping up and down all day and night and keeping the place keyed up to the nervous pitch it loves. As for the parades, the avenues may even have created the habit. Unless you have a parade of trained soldiers, there is nothing worse than a winding street for the amateur exhibitionists. They want three or four miles clear before them, so as to put the light of glory in their eyes. And when you look at the history of New York you see that the New Yorker has been a marching animal. He marches to convince himself. In other cities people congregate when they feel the need to assert their public personality. In New York they do not congregate: they process. In 1824, Lozier and DeVoe, two practical jokers, convinced the public that the southern tip of Manhattan was liable to break off because the Battery was too heavy and proposed that the peninsula, as it then was, should be sawn through at Kingsbridge and the island reversed. Five hundred men and fifty hogs met at the Bowery for the great march with fife and drum to the appointed spot. This story confirms the belief in marching and the fancy was a great compliment to New York's innate belief that everything, in the engineering line, is possible.

The cross streets of the grid, the joints in the bed of the machine, are less ambitious, though there are wide ones at intervals. I find them stirring when they swoosh down from Washington Heights where the sky is wide or when they fall

Doorman: Picasso apartment house

15

gentlemen and dramatic cartoons of the police letting the dogs loose on the crowd at Birmingham, Alabama. Behind a curtain a long chat was going on about a split among the Nationalists. The dusty smell of old books, the way bits of news flew in from outside, the long conversations, brought to mind the scenes of conspiracy in old Russian novels—conspiracy in which nothing happens. I had bought a book in one shop and B was very much concerned that I should hide it in my pocket before we went into the second one, because he thought the bookseller would be upset to see I had patronized a competitor! This struck me as an intrusion on my personal rights, so, indelicately, I refused, for I am dead to the charms of competition. Harlem is evidently as competitive and pushing in the matter of a deal as the rest of New York is. When you read the accounts of the agitation against the British in the Revolutionary period, the meetings in shops, taverns, and clubs, and then consider these scenes in the bookshops, you realize that what once went on in the name of freedom is being repeated in Harlem.

B and his friends are great talkers and hangers about. This raises a curious point. There is plenty of intellectual conversation and gossip in New York, but outside of this agreeable crackle the New Yorker shares in the general American tradition of monologue and anecdote. He is continuing, in other surroundings and other accents, the tradition of vernacular literature which emerges also in the nonstop patter of a Mort Sahl. It is very impolite to interrupt the monologue. If interrupted it, wait for silence, and then go on from precisely the word, the very semicolon at which the break was rudely made. He is therefore not a conversationalist, for conversation depends on interruption, digression, exchange, capping, and repudiation; and I have many times heard conversation described as something like sin, certainly a waste of time, an opportunity for the fluent and superficial to show off their ridiculous graces. Henry James, for example, said that the English talked fast about nothing and never listened. Now monologue, often of a crackpot and moralistic kind, is popular in Harlem, but there is no doubt that the Negro has a taste for a chat and for passing the time of day. One can settle down to it anywhere in Harlem—in shops, even at street corners—to a degree that is quite impossible in the passing life of New York, except in a taxi. And there, unless you fight back, it is mainly ad-libbing declamation. There is a great love of language for its own sake in Harlem. The Negro is above all a man of the world. He revels in utterance and usually speaks with loving clarity. In the voice of an Oxford don, a Negro taxi driver told us it would be "phenomenal" if—as we had feared—a

Entrance to subway: Broadway

100

103

1966
Walker Evans **Many Are Called**

By the time *Many Are Called* came off the press, its eighty-nine photographs—all taken
by Walker Evans in underground train cars between 1938 and 1941—were no longer
documents of contemporary life. And yet, half a century after this small, austerely-
designed photobook was first published, flipping through its pages still evokes the
timeless experience of riding the subway in New York.

All but the last of the book's images show just one or two riders, surreptitiously
photographed by Evans at close range as he sat across them in subway cars. Except for
an epigraph, a page of acknowledgments, and a brief essay by the American writer
James Agee, there is no text to provide context or to frame our reading of Evan's black-
and-white pictures, each one reproduced alone and uncaptioned on the center of the
recto page, with its corresponding plate number discreetly printed on the preceding
verso.

Evans began working on a series of subway photographs in
1938, after his dismissal from the Farm Security Administration,
for which he had photographed life in rural communities during
the Great Depression. The publication of the celebrated book *Let
Us Now Praise Famous Men* (1941)—a collaboration with Agee
depicting the harsh living conditions of three sharecropping
families in Alabama—slowed down Evan's progress on a book of
his subway photographs, later interrupted by years of work for
magazines such as *Time* and *Fortune*.

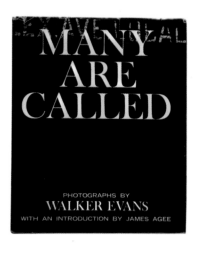

Evans did not resume work on this venture until the late 1950s,
when he produced a maquette and likely tried to interest potential
publishers. He eventually managed to secure a deal with
Houghton Mifflin. In spite of a vigorous promotional campaign,
when *Many Are Called* was finally released in 1966 it received little
attention from the public and critics, perhaps a reflection of its
stark design or the fact that, by then, its photographs pertained to
a bygone era.

As a project of urban portraiture, *Many Are Called* reflects the disposition of Evans,
who did not relish interacting with his subjects as he photographed them. Indeed, he
took most of his subway pictures on cold days, so that his medium-format camera could
remain concealed underneath his winter coat. Inspired by physiognomic curiosity and a
voyeuristic impulse, *Many Are Called* adds up to a cross-sectional study of urban types: a
compendium, in Agee's words, of people "of all ages, of all temperaments, of all classes,
of almost every imaginable occupation."

The sober uniformity of the book's design encourages brisk browsing through its
pages. The viewer moves quickly from one portrait to the next, not unlike the hurried
glimpses of fellow passengers in a subway car. This survey of commuting city-dwellers,
portrayed with their guard down, as Evans once put it, concludes with the sole group
portrait in the book: that of a man playing his accordion, enraptured, to a largely
ignoring crowd of New Yorkers absorbed in their own thoughts and doings—a most
familiar sight to anyone riding the city's subway today. [M. O.]

Boston: Houghton Mifflin, Cambridge: The Riverside Press 1966 / 220x180 mm, [14]+178 pages, cloth, dust jacket
/ 89 b&w photographs by Walker Evans / introduction by James Agee

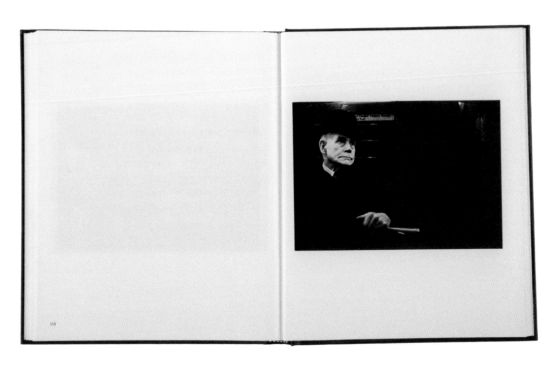

158

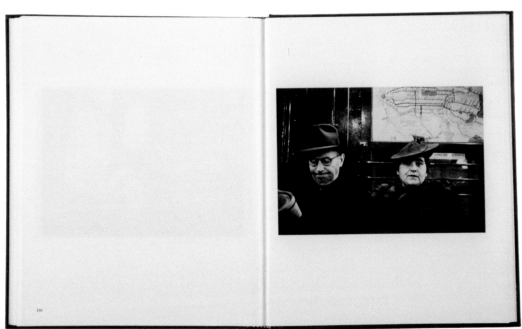

160

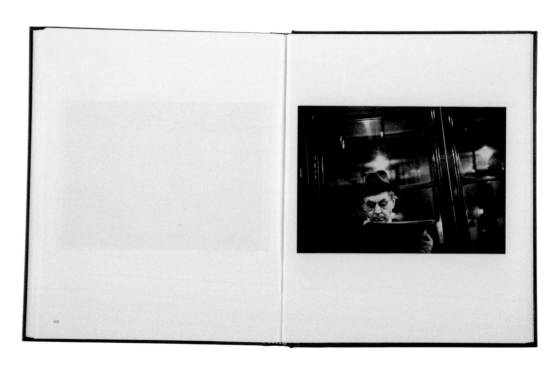

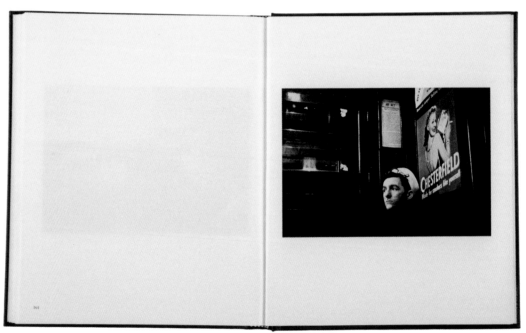

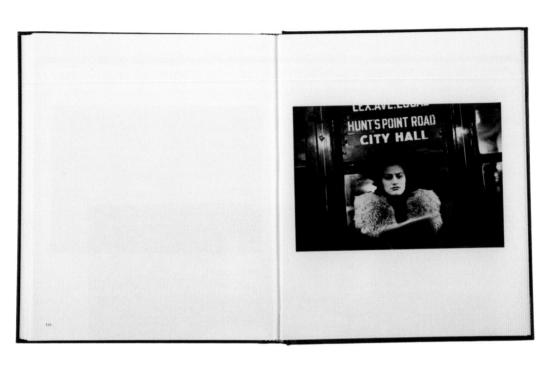

166

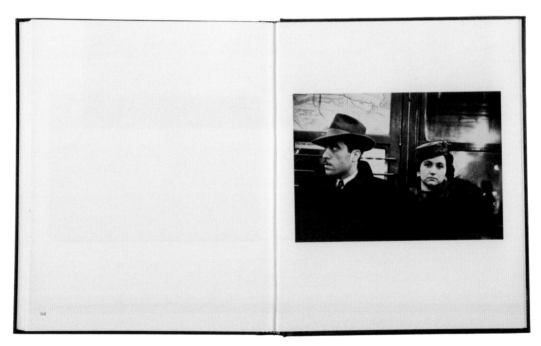

168

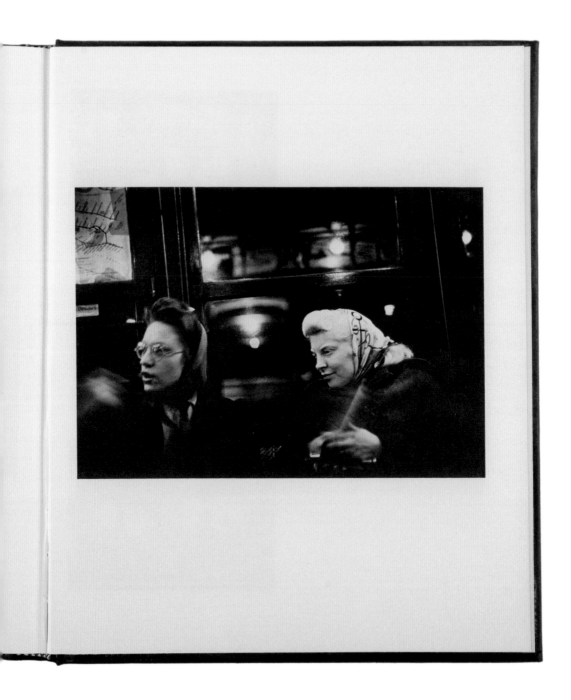

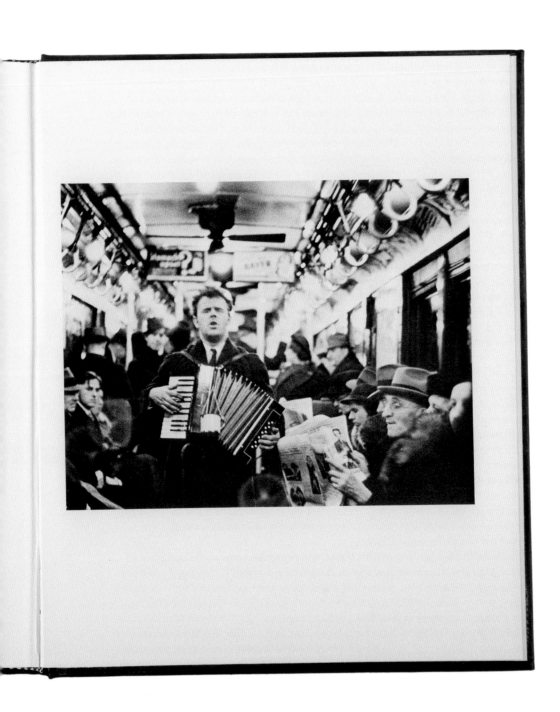

1966
Anthony Aviles, Don Charles **Harlem Stirs**

We can understand *Harlem Stirs* (1966) as a sort of patchwork of different genres, a homage to critical rereading and reappropriation. It is true that agitprop has always made use of archetypes in order to subvert them, parody them, or redirect them toward other meanings. This photobook, however, was also seminal in its use of media and political slogans, in its neutral listing of data, and its collages of descriptive information drawn from government bulletins. Because of all this, because, that is, it confronts images dense with ideological meaning with highly eloquent texts from the grammar of power, we can affirm that *Harlem Stirs* anticipated the counter-information discourse that was all the rage in the 1970s, also making it a work of conceptual art *avant la lettre*.

Published by Carl Marzani, a member of the US Communist Party, a veteran of the Spanish Civil War, and the founder of Union Films—a producer of subversive documentaries such as *Deadline for Action* (1946) and *The Great Swindle* (1948), for which Marzani spent three years in prison—the texts of *Harlem Stirs* are the work of Fred Halstead, the most prominent voice of the Socialist Workers Party in the 1960s and a candidate for president in 1968. Scattered through the book there are also excerpts from the public speeches of James Baldwin, a central figure in African-American culture and a leading defender of civil rights for homosexuals.

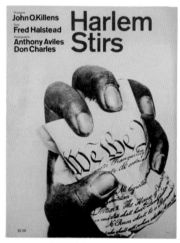

The foreword is by John O. Killens, another novelist crucial to understanding the imaginaries of New York's Black proletarian community at the time. In 1950, together with Rosa Guy and some other literary figures, Killens created the Harlem Writers Guild. Finally, as we pointed out, there is an abundance here and there of fragments of official information, reams of figures and residues of memorandums that provide a certain socioeconomic horizon, a certain dose of hard reality, to the more propagandistic aspects of the book.

This anthology of dissident pens is replicated in the photographs of Anthony Aviles and Don Charles, whose images illustrate the economic disparities and racial conflicts, the "stirring" of the inhabitants of Harlem—organizing their discontent though acts of protest and community assemblies—and also the realities poverty and marginalization.

From the front cover to the final climax, which pays homage to the thought and figure of Malcolm X, assassinated a short time before, without forgetting the famous rent strikes of 1963 and 1964, which mobilized community leaders and various show business personalities on behalf of African-American activism, *Harlem Stirs* barely steps down from its incendiary pulpit. Thus, unlike a book such as *A Seventh Man: Migrant Workers in Europe* (1975), by John Berger and Jean Mohr—with which it nevertheless shares certain ideological similarities—this chronicle of citizen unrest not only moves away from poetic or humanistic reporting on the lives of the poor, but also maintains the prospect of revolutionary violence and class struggle on its horizon of action. [V. R.]

New York: Marzani & Munsell 1966 / 280x215 mm, 128 pages, illustrated softcover / 126 b&w photographs and design by Anthony Aviles and Don Charles / introduction by John O. Killens / text by Fred Halstead

New York
is a nice place
to visit...

14 million visitors spend
$1,000,000,000 a year.

It's not
too bad a place
to live...

**even
for those in
lower income
groups,
if they have
had the luck
or connections
to get into
one of
the better
public housing
projects
such as this
one in
Harlem.**

There are some 140,000 public housing units in New York City. But there is a shortage of at least 200,000 units. In recent years, additional public housing units have been built at the rate of about 3,500 a year. At this rate, it will take three-quarters of a century to replace the present slums in New York City, and by that time, of course, deterioration of present buildings would create more slums.

There is no hope to slum clearance from private enterprise—it does not build low-cost apartments in New York City. Slum clearance must be a public function, yet President Johnson's Public Housing Bill calls for only 35,000 new units nationally, of which New York City would have a mere 3,000 annually. In previous years, the number of units built has reached 9,500, which has proven inadequate.

Occasionally private owners renovate a slum building, replacing everything but the basic structure. But then rent controls no longer apply, and the former tenant cannot afford the rents. As a typical example, take a building with five-room apartments which had an average rent of $71 a month. After renovation, the apartments are cut down to two- or three-room units and rent for $100-$125 per month.

Between 1950 and 1960, nearly three-quarters (71%) of units renting for less than $50 have disappeared, while the number of units renting for more than $100 have increased by five times. The median over-all city gross rent has been increased 50% in the decade. In substandard housing, the rent increase has been 65%.

This rise must be seen against the income of the minority groups who are, to a large extent, the slum dwellers. In New York City, Negroes and Puerto Ricans have a median income of $3,500 compared to a median income for others of $5,500, or about half. About a third (34%) Puerto Ricans and 27% Negroes) have incomes of less than $3000 a year, while only 14% of white families fall that low. This income of $60 a week for a family must be seen against the estimate of the Community Council of Greater New York for what a family of four needs for a "modest but adequate" standard of living. The estimate is $125 per week in 1964, or more than double what 320,000 families get.

Not only is the income of Negroes and Puerto Ricans much lower, but they pay a high proportion of that income for rent: 25% compared to only 20% for non-Puerto Rican whites. In Harlem, absentee landlords get from $50-$74 a month for a one-room flat that would rent from $30-$49 in white slums.
CERGE

At least 350,000 dwelling units in New York City are structures constructed to building standards outlawed since 1901. In Harlem, 90 percent of the buildings are over 33 years old.
N.Y.C. Dept. of City Planning

20% of all housing in N.Y.C. is unfit to live in.
U.S. Census, 1960

Better housing, while it heightens morale, does not affect the more fundamental variables of economic status, broken homes, and lowered aspirations. Merely to move the residents of Harlem into low-income housing projects without changing the pattern of their lives—menial jobs, low incomes, inadequate education for their children—does not remove them from the total tangle of the community and personal pathology.
Youth in the Ghetto

There is one aspect of urban renewal which is often overlooked, and that is the impact of middle-income housing on the slum problem. It often makes it worse by removing the low-rent units.

For example, a low-rent area in Manhattan was cleared to make room for a famous cooperative sponsored by an influential union. In spite of the fact that the former residents of the area had first claim on the new apartments, less than 5% of the former residents were able to move into the new project. The others simply couldn't afford the several thousand dollar down payment which was required.
A Citizens' Survey of Available Land, Metropolitan Council on Housing

For most relocated families the situation is worse, not better. Hence the bitter comment often heard in Harlem. Urban renewal is Negro removal.

16

17

6

111

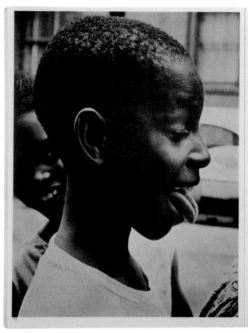

Behind the riots, We want justice!

Because my mouth
Is wide with laughter,
And my throat
Is deep with song,
You do not think
I suffer after
I have held my pain
So long?

Because my mouth
Is wide with laughter,
You do not hear
My inner cry?
Because my feet
Are gay with dancing,
You do not know
I die?

Langston Hughes

The frustration finally overflowed in July. The immediate cause of the outbreak was the killing on July 16 of a fifteen-year-old Negro boy, James Powell, by a white police lieutenant wearing civilian clothes. Harlem children attending a summer school in the Yorkville section of Manhattan that day had been sprayed with a water hose held by a white building superintendent who, the children say, had yelled racist slurs at them.

School children, eyewitnesses report that James Powell, who they do not believe was directly involved in the dispute with the janitor, ran into the building. Upon emerging, he was shot twice by Police Lieutenant Thomas R. Gilligan, a man who holds over twenty citations, including some for disarming grown men who had firearms. He was off duty at the time he encountered Powell.

Gilligan claims the boy came at him with a knife. Eyewitnesses dispute this. School children at the scene burst into tears and screamed at police: "Come on, kill another nigger!"

A protest demonstration was organized by CORE on Saturday night, July 18, in front of a police station in Harlem. Police charged the demonstrators and arrested the CORE spokesmen on the spot.

The police then ran throughout the district, attempting to break up groups of people on street corners, but the people wouldn't disperse. The police fired 2,000 rounds of ammunition, using all they had with them, thus provoking a riot which lasted until early morning. There were scores of injuries and some stores were smashed and looted. The police killed a man named Jay Jenkins, who, they claimed, was hurling bricks from a rooftop.

James Farmer, national director of CORE, reported seeing a policeman shoot a woman in cold blood. The woman, in panic, had approached the police for help in getting out of the area.

Farmer also said he saw police emerge from a patrol car yelling: "Let's get those niggers!" and wade into a group of Negro youth walking down 125th Street. Police fired bullets into windows of tenements and into the 8th floor of the Theresa Hotel. The next day, Sunday, Harlem looked like an occupied country with helmeted riot police stationed at all strategic corners, and walking in groups down the streets.

Harlem residents filed quietly past the casket of young Powell all day Sunday at a funeral parlor on Seventh Avenue, near 132nd Street. As the time for the funeral approached people began to assemble there. Riot police appeared in force, irritating the people by their presence. The police began pushing people off corners and off the island in the middle of the avenue. But after a few small-scale fights, people began to stand their ground and then talk back to the police. In panic, the police drew their pistols and began firing. Bricks and bottles rained down on them from all directions.

The police forced people into doorways and bars along the street, swinging nightsticks and shooting down the avenue and into side streets. But as the police moved, the unarmed crowds grew larger and reoccupied the streets behind the police.

By Monday night groups of Harlem youth were engaging the police in arguments and battle fights, running the police from place to place and wearing on their nerves. On Monday evening, Negro youths paraded in defiance through the streets of central Harlem. Every corner taken over by police was soon re-occupied as the police were diverted elsewhere. By 11 p.m. that night, a spontaneous demonstration of over 1,000 Negroes marched down 125th Street chanting "We Want Justice!"

The police fired over the heads of the marchers, but could not disperse them. The police finally stopped shooting, pulled their men back to reserve areas, and the crowds dispersed.

White cop triggers riot: Negro jailed for it

The Harlem riots were triggered by the killing of a 15-year-old Negro boy by police lieutenant Gilligan who was later exonerated by white justice. The leaflet on the opposite page reflects the feelings of Harlem, for giving voice to these feelings

William Epton, a 33-year-old Negro fighter for his people, was framed and received three one-year sentences to run concurrently. Sentenced under an archaic law of criminal anarchy passed in 1901, it is the first time the law has been applied in 46 years, in effect, Epton is being blamed for the Harlem riots, being made the scapegoat for the conditions shown in this book, which are the real reasons for the riots and for which the white landlords, white cops, white business, and white politicians are responsible.

Epton, at his sentencing January 27, 1966, said, "I've agitated against the system my people have been forced to live under. I've fought police brutality . . . exploitation . . . the war in Vietnam. I agitated for a

better way of life." Justice Markewich says the *New York Times*, "appeared bored" as Epton spoke and ordered the courtroom cleared when Epton was applauded. But in the court of world public opinion there was little boredom. At the Tri-Continental conference of Asia, Africa and Latin America in Havana, the case of William Epton was brought to the notice of the delegates by Robert Williams, himself under a police frame-up for organizing a Negro self-defense unit in Monroe, S.C. (See his book, Negroes With Guns, Marzani & Munsell.) Epton won unanimous support. He will be remembered when Markewich is long forgotten.

photographs Robert L. Haggins

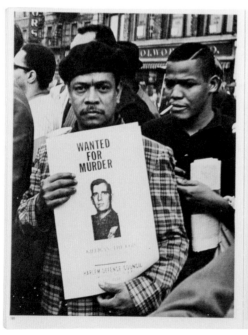

WANTED
FOR
MURDER

HARLEM DEFENSE COUNCIL

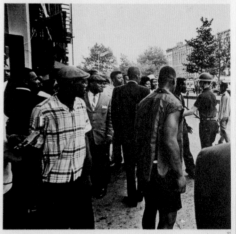

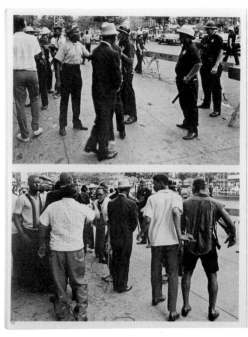

Malcolm could articulate the heartbreak

The street in front of the Nationalist Memorial Bookstore at 7th Ave. and 125th St., across from the Hotel Theresa, has been the scene of many Harlem meetings, and no speaker ever got the response that Malcolm X did. He is seen here speaking at a rally in support of Mississippi Negroes on March 23, 1963. Among the other speakers on this occasion were Dick Gregory and Congressman Adam Clayton Powell, whose villa in Puerto Rico was then in the news.

Malcolm X delivered an address on religion in which he criticized the preaching of some Christian ministers that the black masses should expect their reward in Heaven. The people should fight to improve their condition on this earth, said Malcolm. And he concluded: "If you want to know what Heaven is, ask Rev. Powell. He's got a piece of it down in Puerto Rico."

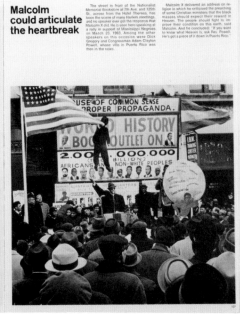

113

1966
New York

Prague, 1964. Thirty or so Czech artists travel to New York City to visit the World's Fair. Among them, three photographers—Eva Fuková (1927-2015), Miloň Novotný (1930-1992), Marie Šechtlová (1928-2008)—along with the scientist and poet Miroslav Holub (1923-1998). Two years later they would spill their impressions into an extraordinary book that begins thus: "New York is supposed to be an American city, a fact the Americans categorically deny... An American city is Cleveland or Buffalo or Tucson; in the end, San Francisco or Miami (not to mention Minneapolis or Seattle, and passing over Fort Worth). When all is said, New York is not an American city."

While Holub describes, praises, and imagines "the giant" in writing, his three eager companions take visual notes, snatch snapshots. If this book conveys anything (with its unusual square format, which almost fits in the palm of your hand), it is fascination and astonishment in the face of a discovered universe. Although the jacket does not do justice to the insides, it anticipates its curiosity for the new, its respect for what is about to be explored. Stripped of its jacket and conceived to make an immediate effect, the typographic cover, designed by Jaroslav Fišer (1919-2003), introduces the use of the colors and graphic elements of the Stars and Stripes that will accompany the reader throughout the book.

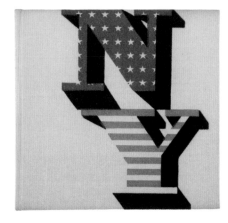

The design is yet another protagonist and acts on behalf of the book. Container and content reflect dynamism and a desire to experiment: they cause the reader to undergo an experience that recalls the authors' own strolls through Manhattan and Brooklyn, Harlem and the Bronx. Museum tickets, newspaper clippings, soft drink labels, and coins found on the street are just some of the souvenirs that Fuková, Novotný, Šechtlová, and Fišer share with us.

A nocturnal landscape, blurred and in color, confronted with the black-and-white foreground of an old man defeated by life (or by rum); a little foldout story that draws a smile from us, a sequence of snapshots of a young man on Seventh Avenue told in cinematic language; collages, sandwiches, and other darkroom interventions into the images, like surrealist traces of the Czech avant-garde movements of the 1930s... all this forms the portrait of a single city that in fact is many.

Bewildered by the dizzying whirl of life in the Big Apple, the trio of authors offer snapshots of its broad gamut of spaces, of the people who inhabit it or simply pass through it. Dazzled by the crowd, but also attracted by the individual in his or her paradoxical solitude, we know a little of that blend of flavors that Miroslav Holub describes as "a Babylonian and magical city. One of the summits of the world."

Published with a large print run in 1966 by Mladá fronta, the foremost Czech publishing house, which produced other beautiful urban photobooks in those same years, *New York* is a collective work that has stood the test of time. [L. Ty.]

Prague: Mladá fronta 1966. 195x210 mm, 172 pages, cloth, illustrated dust jacket / 143 b&w and color photographs by Eva Fuková (39), Miloň Novotný (25) Marie Šechtlová (42) et al. / text by Miroslav Holub / designed by Jaroslav Fišer / edited by Václav Kocourek / photogravure / 10,000 copies

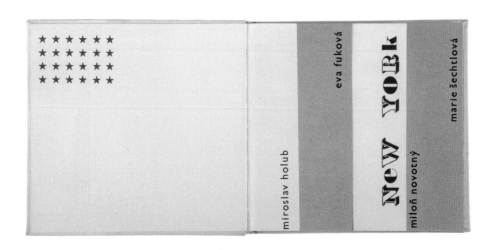

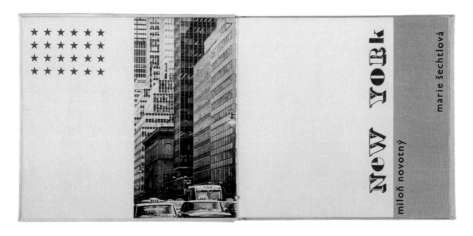

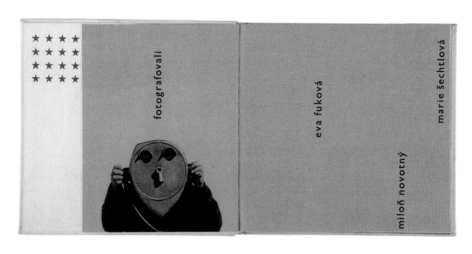

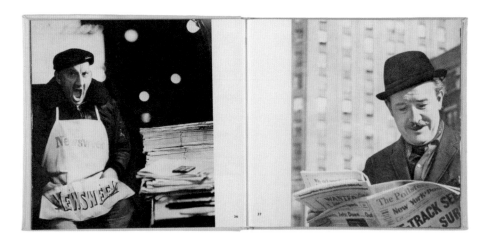

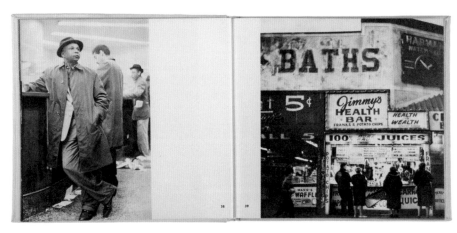

116

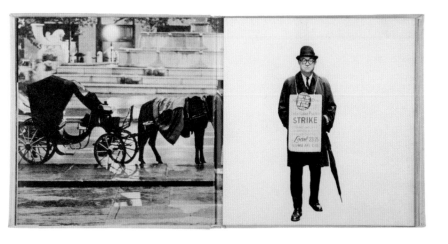

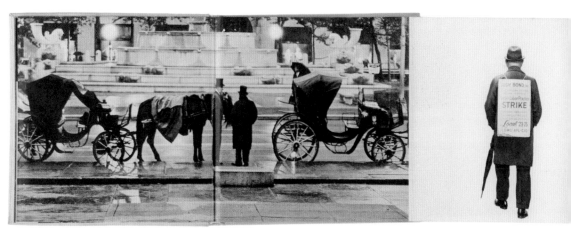

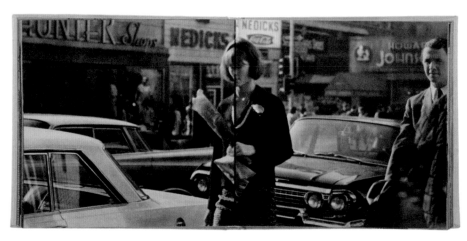

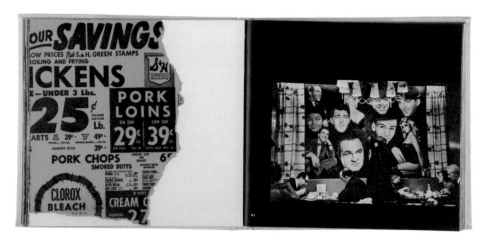

118

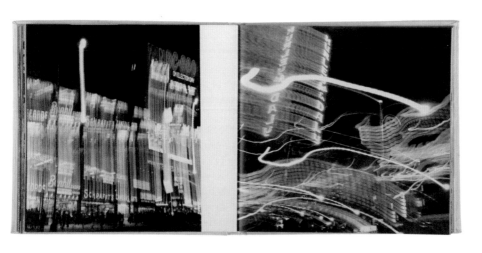

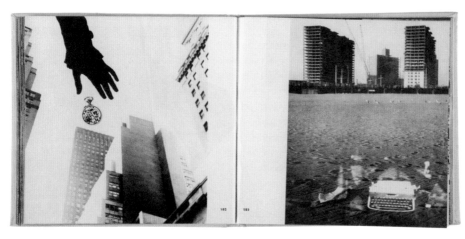

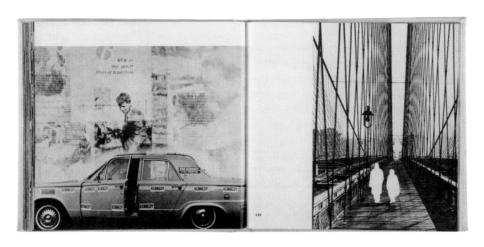

1966
Maspons+Ubiña **Poeta en Nueva York**

In a lecture in 1930 Federico García Lorca warned that his book of poems was not intended to "explain New York from the outside." *Poeta en Nueva York*, he explained, was a "lyrical reaction" to the "extrahuman architecture and furious rhythm" of the city, to the geometry of its skyscrapers, blind to all mystery, and to the anguish and fear of the cruelest crimes of capitalism, among which Lorca gave racism a prominent place. The book is so tortured that Neruda suggested the title *Introduction to Death* when it was first published.

It seems impossible to use photography—a highly objective medium—to illustrate what a critic of the time described, without much empathy, as "surrealist finger exercises," exaggerating the concentration of dreamlike images in the poems. Lorca was not fantasizing, he was portraying a "city without sleep" by stretching his consciousness and sharpening his vision. He was expressing the Dalí images of *Un perro andaluz*—cow's eyes, ants, and putrefaction—which cinema had turned into hallucinations in order to weave the plot of a screenplay, whereas in the poem they are shown with the force of the "demonic value of the present," which sweeps away the spirit with a stroke of the pen and places those images in the reality of a modern Protestant city. Perhaps that is why Lorca wanted to illustrate his book with photographs: a volume of modern poems required the descriptive literality of photography, as can be deduced from the list he submitted to his publisher in 1936. Thus, just as he renounced automatic writing in order to shape images based on a painful observation of his surroundings, he chose photography for its automatism in capturing chance elements.

Thirty-five years later, the Lumen publishing house decided that the ideal complement to the poems would be a documentary reportage, and they sent Maspons + Ubiña, vital contributors to the collection Palabra e Imagen, to New York City. The photographers read and underlined the book of poems, and on arriving in New York they went to the places mentioned in it to record their updated state. Foreigners in a foreign land, like Lorca himself, they reacted with astonishment to the "hurricanes of black doves," "the putrid waters," "the buried light," "the people who wander unsleeping," or "only this: the river's mouth." Although their mood was not darkened by the indifference and humiliation that had driven the poet to flee Spain, they transmit a sensation of fear and anguish in each one of their contrasting and oppressive frames, replete with architectural pieces like models to be assembled.

It is not the photos nor the photographers, but the poet himself who instills in us his vision as we look at this apparently innocent series. Like the music that accompanies a cinematic sequence, the photographs accurately capture that sense of horror and panic, objective nevertheless, that echoes in the poems. It was one of Lorca's achievements to imagine this marriage of surrealist poetry and photographic objectivity, inspired perhaps by the ideas of his friend Salvador Dalí, who in 1927 had defined photography as "objective glass. The lens of authentic poetry." [L. Te.]

Barcelona: Lumen 1966 / 220x210 mm, [124] pages, illustrated hardcover / 49 b&w photographs by Oriol Maspons and Julio Ubiña / text by Federico García Lorca / designed by Oscar Tusquets

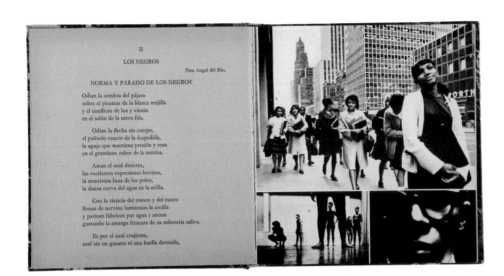

II
LOS NEGROS

Para Angel del Río.

NORMA Y PARAISO DE LOS NEGROS

Odian la sombra del pájaro
sobre el pleamar de la blanca mejilla
y el conflicto de luz y viento
en el salón de la nieve fría.

Odian la flecha sin cuerpo,
el pañuelo exacto de la despedida,
la aguja que mantiene presión y rosa
en el gramíneo rubor de la sonrisa.

Aman el azul desierto,
las vacilantes expresiones bovinas,
la mentirosa luna de los polos,
la danza curva del agua en la orilla.

Con la ciencia del tronco y del rastro
llenan de nervios luminosos la arcilla
y patinan lúbricos por agua y arenas
gustando la amarga frescura de su milenaria saliva.

Es por el azul crujiente,
azul sin un gusano ni una huella dormida,

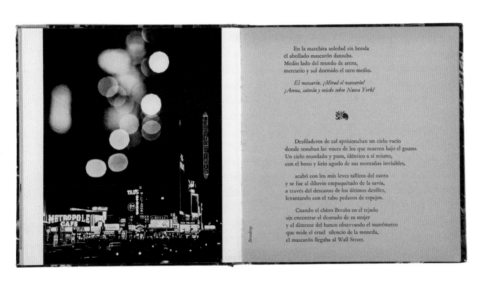

En la marchita soledad sin honda
el abollado mascarón danzaba.
Medio lado del mundo de arena,
mercurio y sol dormido el otro medio.

El mascarón. ¡Mirad el mascarón!
¡Arena, caimán y miedo sobre Nueva York!

Desfiladeros de cal aprisionaban un cielo vacío
donde sonaban las voces de los que mueren bajo el guano.
Un cielo mondado y puro, idéntico a sí mismo,
con el bozo y lirio agudo de sus montañas invisibles,

acabó con los más leves tallitos del canto
y se fue al diluvio empaquetado de la savia,
a través del descanso de los últimos desfiles,
levantando con el rabo pedazos de espejos.

Cuando el chino lloraba en el tejado
sin encontrar el desnudo de su mujer
y el director del banco observando el manómetro
que mide el cruel silencio de la moneda,
el mascarón llegaba al Wall Street.

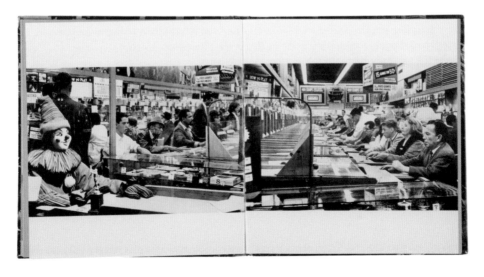

121

1967
Karol Kállay **New York / Die explodierende Metropole**

This book about the "exploding metropolis" is one of the most critical publications about a failed, inequitable, dirty New York, in the style of Arno Fischer's *New York Ansichten*, published by the same state-owned East German publishing house twenty years later.

The text begins with a plane landing on a "rather distant runway" at Kennedy airport and a slow approach to the city by the Czech scientist and writer Miroslav Holub, who assures the reader that "in a way we came in through the back door." His aloof style does not allow us to sympathize with the city and its inhabitants. He describes life in the suburbs, his rides on the subway, work in a laboratory, and the everyday anecdotes of someone we would now call an "expat." Meanwhile, advertisements, articles and reports, and vernacular—sometimes almost surrealist—news flashes, like a classified ad on the "front page, second column of *The New York Times*," looking for "'dead' human brains for subsequent resuscitation in the future." And there are his own verses about Rockefeller Center, the East River, and the freeways.

The images of the Slovakian photographer Karol Kállay (1926-2012) are arranged in thirteen sections whose titles evoke the darkest aspects of the capital city of capitalism: "In the Machinery of Consumerism," "Supply and Demand," "The Color of Monotony." New York is a city saturated with lights, cars, and smoke, full of advertising billboards, enormous architectural works, and anonymous crowds.

Kállay generates playful visual effects, as for example portraits of highly dignified African Americans in counterpoint with vulgar white office workers. His work draws on the humanistic photography of Magnum, but also on the tradition of the direct, "dehumanized" images of Robert Frank or William Klein. The typefaces of the advertisements and the traffic signs recall Walker Evans, but in fact they serve to underline the urban hostility, with all their warnings of DO NOT ENTER, DON'T WALK, and DANGER. Lothar Reher's design emphasizes the unfriendly nature of the city that Karol Kállay

seeks to portray. With several photographs on a single page, there are double-page spreads in which all of the photographs dialogue with one another, and it is difficult sometimes to tell where one image begins and another ends, as also in the photobook *Mexiko: Tage einer Stadt* (1968) by the same photographer, designer, and publisher.

The book ends with an epilogue signed by a clinical psychologist from the East German Academy of Sciences. His aim is to focus the reading of the book from the official viewpoint of socialist East Germany: the motor that propels American society is insecurity; the media are manipulated; racial segregation may be "less direct," but no less efficient than that of the Nazis. Perhaps it is the text on the flap that best synthesizes the project: "In this book two Europeans try to show how they have seen New York... They are two artists who give their subjective impressions and opinions spontaneously. The advantages for the reader are immediacy, freshness, and adventurous personal discoveries." [M. N.]

Berlin: Verlag Volk und Welt 1967 / 305x250 mm, 124+[64] pages, cloth, illustrated dust jacket / 130 b&w and color photographs by Karol Kállay / text by Miroslav Holub / epilogue by Alfred Katzenstein / designed by Lothar Reher

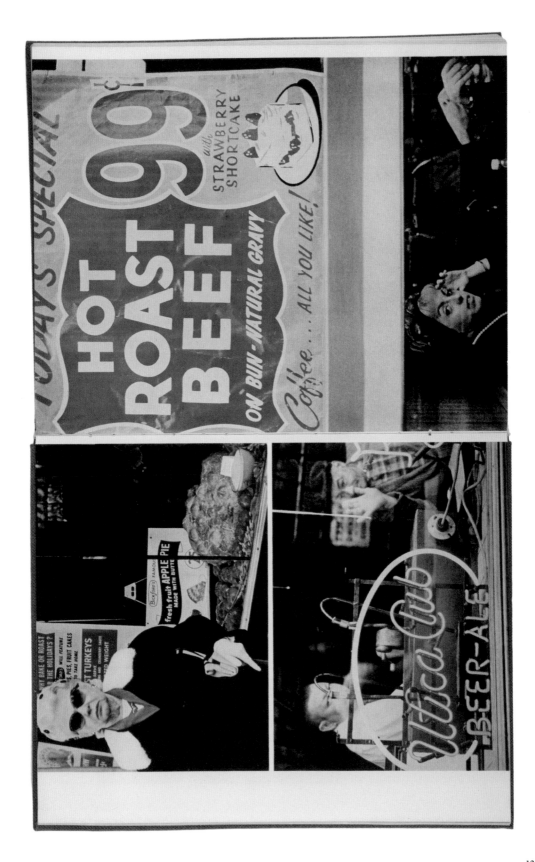

123

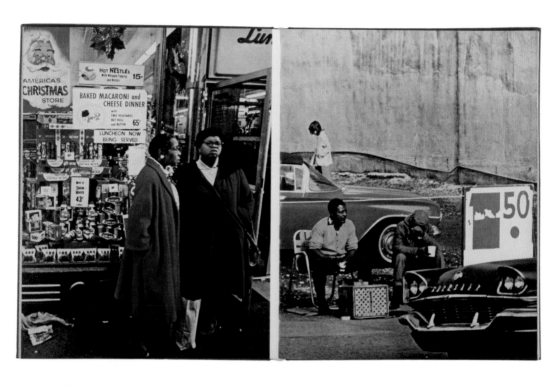

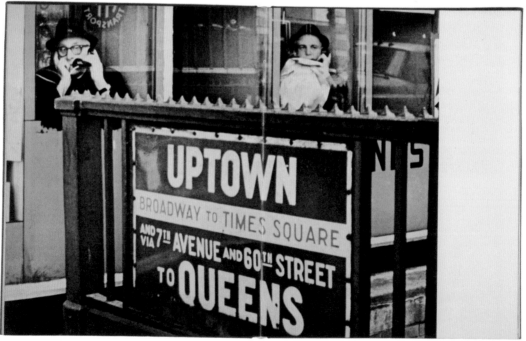

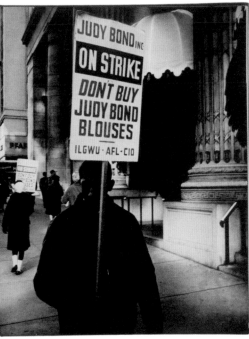

Ugo Mulas **New York: The New Art Scene**

This book by Ugo Mulas (1928-1973) opens abruptly with a photograph of some unmistakably New York façades and a large, unmistakably American poster showing the upper part of the Statue of Liberty. At a right angle to the arm holding up the torch, the words "KEEP AMERICA STRONG" can be seen.

The following page is its contrast: a photo of Deborah Hay dancing in *Map Room II*—a performance piece by Robert Rauschenberg—in a dress whose front part is a torso-length cylindrical cage. Three doves are fluttering about inside the cage.

The book has only just begun, but the first decisions have already marked it significantly. Without flagging, Mulas manages to maintain a sort of almost chemically pure balance between two apparently opposing reagents: something powerful, even hard, that seems to kept America "strong" and something difficult to grasp, like doves fluttering about in a cage, which moves itself with the body of a woman dancing on the stage in accordance with the storyboard of an artist.

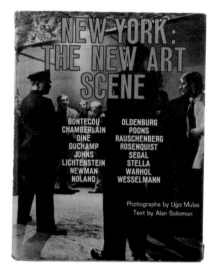

The first of these two reagents is the art produced in the United States in the 1950s; the second is New York City and twenty or so artists "making the scene." True, the book is "a photographic record of a long moment in the history of contemporary American art," but it is also a formidable answer to a question about which Friedrich Kiesler knew a great deal: What is a scene, that intermediate element between actors and audience, which we now commonly call a "stage" in English? Since we are speaking of photographs, a scene is nothing not revealed by transforming instants into snapshots and then enclosing these in a sort of beneficent cage in order to condense and concentrate them so they can be looked at.

On his visits to New York, with the "uncanny quickness of eye" attributed to him by Solomon, Mulas took his camera to artists' workshops and homes, to parties in galleries and apartments, and through the streets of cinematic New York, just as Deborah Hay moved the cage sewn onto her dress across the stage. With this difference, that Hay's task was defined by Rauschenberg's instructions, whereas that of Mulas consisted of nothing less than capturing a gigantic metropolis (which he had never before visited) within whose grid there moved (and how!) twenty or so "well-established artists" whom he did not know, whose language he did not speak, and in whose studios and homes he had never been.

As Solomon points out, Mulas captured everything as it happened: his magical black box managed to fix the city and some of its inhabitants in order to make them dance in a cage of images that is this whole book (Provinciali's sober design often consists of just a sort of narrow bar of text centered on each page): the "new" art "scene" of New York in the 1960s, which still dances with readers of his photobook today. [M. F. J.]

New York: Holt, Rinehart and Winston 1967 / 325x240 mm, 344 pages, cloth, illustrated dust jacket / 292 b&w photographs by Ugo Mulas / text by Alan Solomon / designed by Michele Provinciali / photogravure printed by Alfieri & Lacroix, Milano

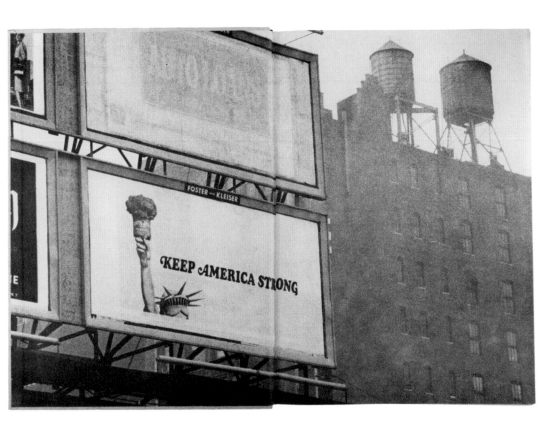

A Pesca, frutto di mare, giummini d'Aprile.

Deborah Hay in Rauschenberg's theater piece Maproom II, at the Cinematheque, December, 1965.

127

JOHNS

Jasper Johns was born in Allendale, South Carolina, in 1930, and educated at the University of South Carolina. He has lived in New York since 1952, but in the past several years he has divided his time between a penthouse overlooking the Hudson River in New York, and a house and studio at Edisto, South Carolina, a remote beach town on an island in the Atlantic. The house and its contents were totally destroyed by a recent fire while Johns was traveling in Japan; consequently, the pictures of Edisto in this book comprise what is virtually the only record of the place where Johns did much of his work of the past few years.

Another younger American with an impressive exhibition record, Johns has been shown in many museums, including one-man exhibitions at the Jewish Museum, New York, in 1964, and the Whitechapel Art Gallery in London and the Pasadena Art Museum, in 1965. He has been represented at the Venice Biennale in 1958 and 1964, and the Kassel Documenta in 1964. In that year he also won the International Prize at the Instituto Torcuato di Tella, in Buenos Aires.

Like Rauschenberg, Johns has been an important influence for the younger generation of Americans, except that his impact has been more extensive in a certain way. His early paintings of flags and targets and his use of objects opened up the iconography of American Pop Art. However, at the same time, his cool attitude toward the content of his pictures was suggestive not only to Pop painters, but also to the new group of geometric abstract artists. His detachment from expressionism has therefore been an important factor in the development of the new American esthetic.

An elegant and charming fellow, Johns at the same time is rather quiet and withdrawn. His particular qualities of intellect, the clarity and persistence of his thought, make him one of the artists most respected by his contemporaries. With his friends John Cage and Merce Cunningham, he has been a moving force in a foundation to encourage advanced activity in the performing arts.

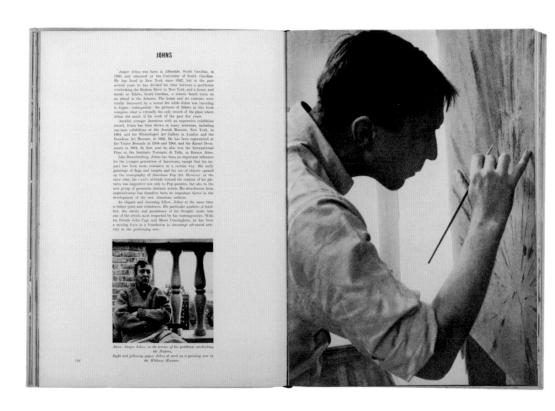

Above: Jasper Johns, on the terrace of his penthouse overlooking the Hudson.
Right and following pages: Johns at work on a painting now in the Whitney Museum.

124

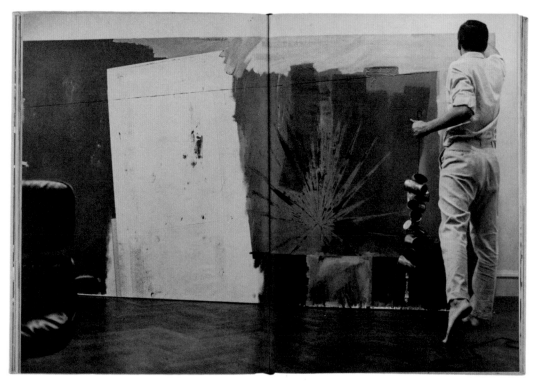

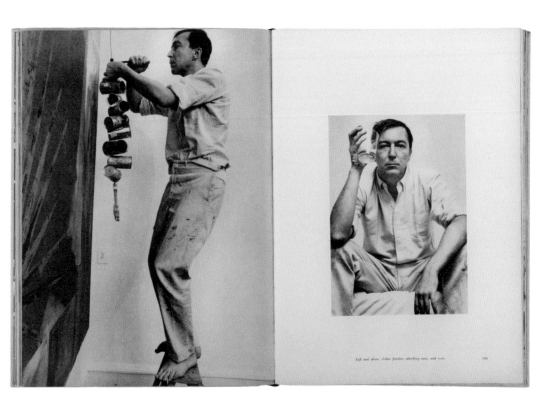

Left and above: Johns finishes attaching rope, and coin. 141

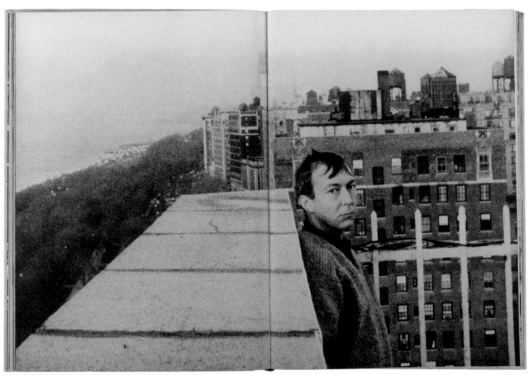

WARHOL

Born in Philadelphia in 1930, Warhol studied at the Carnegie Institute of Technology in Pittsburgh. He has lived in New York since 1952. He has had one-man shows at the Ferus Gallery in Los Angeles, the Stable Gallery in New York, and, more recently, at the Leo Castelli Gallery. He has been given major retrospective exhibitions at the Institute of Contemporary Art in Philadelphia in 1965, and the Institute of Contemporary Art in Boston in 1966.

Warhol's studio, which is called the *Factory*, has become the center for all kinds of activities which have nothing to do with Warhol's painting. Although he silk-screens his pictures there, principally with the help of his assistant and friend, poet Gerard Malanga, the Factory also doubles as a film studio and an exhibition hall for miscellaneous eccentrics, many of whom appear at all hours, uninvited.

Much of the ceiling is covered with aluminum foil, and the furniture and floor are painted silver. The confusion and the serious business go on to the sound of a hi-fi set at peak volume. More recently, since Warhol has become involved with the Velvet Underground, an advanced Rock and Roll group, the factory has also become a rehearsal hall. Life in the Factory picks up in the late afternoon. Later Andy goes out with an entourage of his latest super-stars and various attendants. The group is a familiar sight in the parts of the city where the scene night life goes on.

Warhol's paintings of soup cans and Brillo boxes, of flowers and movie stars, anticipated much of the present spirit of detachment in American art. Their impersonal execution and the absence of comment on the subjects speak for the new cool spirit of the younger generation. At the same time, his films, which at first were static and passive, and are now more elaborate, including color and sound, have energized the underground cinema movement in New York.

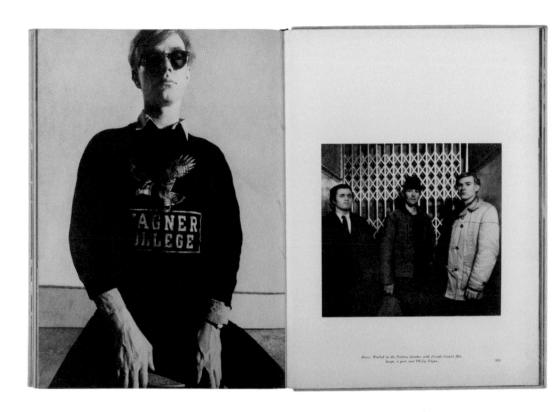

Above: Andy Warhol.
Right: A quiet moment in the Factory.

306

Above: Warhol in the Factory elevator, with friends Gerard Malanga, a poet, and Philip Fagan.

305

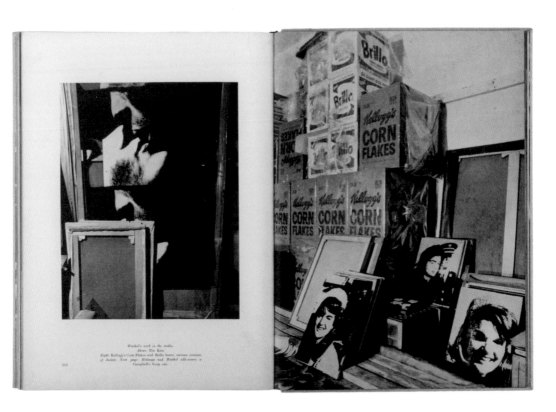

Warhol's work in the studio.
Above: The Kiss.
Right: Kellogg's Corn Flakes and Brillo boxes; various versions
of Jackie. Next page: Holmqya and Warhol silk-screen a
Campbell's Soup can.

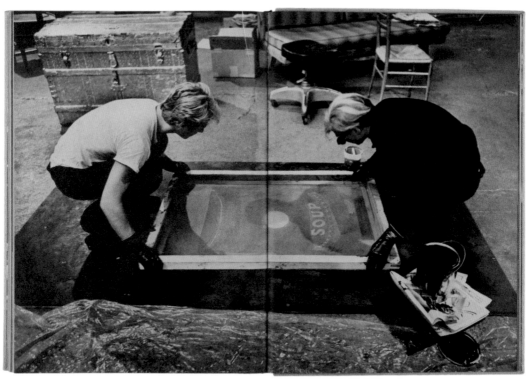

"To bring New York down to date, a man would have to be published with the speed of light," wrote E. B. White, and Hasse Persson's photobook seeks to do just that: to take the pulse of the most dynamic city in the world. It was at a moment (the late 1960s) when life itself seemed to be a performance, something ephemeral that just happened, even if no one was there to photograph it: actors and actresses on the stage of the city, interacting and barely noticing the presence of the photographer. The city has always been the realm of surprise, of chance, of the unexpected find and the encounter with strangers: a vital space to share with others. The young Persson captured that New York with enormous vitality, mixing color and black-and-white without prejudice and creating sequences of images that speed up and slow down the rhythm of the book. In this way, the camera of a Swede who had recently arrived in the city, fascinated, like everyone else, by that motor that never slowed down, managed to reflect the spirit of those times that were a-changing.

The design of the book (structured in chapters, but with great continuity, even when the pages are printed black) has a great variety of page types, conceived to offer an explosive blend of horizontal and vertical images, taken with different lenses and films. Freedom seems to have been another of the keys to Persson's work in the streets of the Big Apple. The structure of the book attempts to order the urban chaos, starting from a wide plane, more aerial and distant, in the first chapter, "City," with its images of skyscrapers, monuments, cemeteries, and practically empty spaces, before eventually turning its attention to a narrower, nearer, more private plane, which takes in the faces and live of the residents of the "Poor Neighborhoods." In between, there are four parts whose titles themselves are revealing: "Street" is an exercise in street shooting, in the true tradition of the photographic hunt; "Park" maintains the same photographic approach, but in more natural surroundings, which seem to offer a liberating nudity; "Man" brings the humanistic postwar photograph, with its taste for *The Family of Man*, its anecdotes, and its optimistic message, up to date; and "Politics" is an inventory of the burning issues and conflicts of the 1960s in the United States, through images of election posters, meetings, banners, parades, demonstrations, trials, and arrests.

New York and Hasse Persson continued to change together. The Swedish photographer continued to live in the city for decades and made some more photobooks, the last one about the legendary nights in the now vanished discotheque Studio 54. Today, many of the streets in Hasse Persson's photobook have become shopping areas or theme parks for tourists. In New York there is no time for nostalgia, a sentiment which, in any case, is not even the shadow of what it once was. [J. V.]

Halmstad: Bokförlaget Spektra 1969 / 285x215 mm, [156] pages, hardcover, illustrated dust jacket / 149 b&w and color photographs and text by Hasse Persson / designed by Jan Bohman

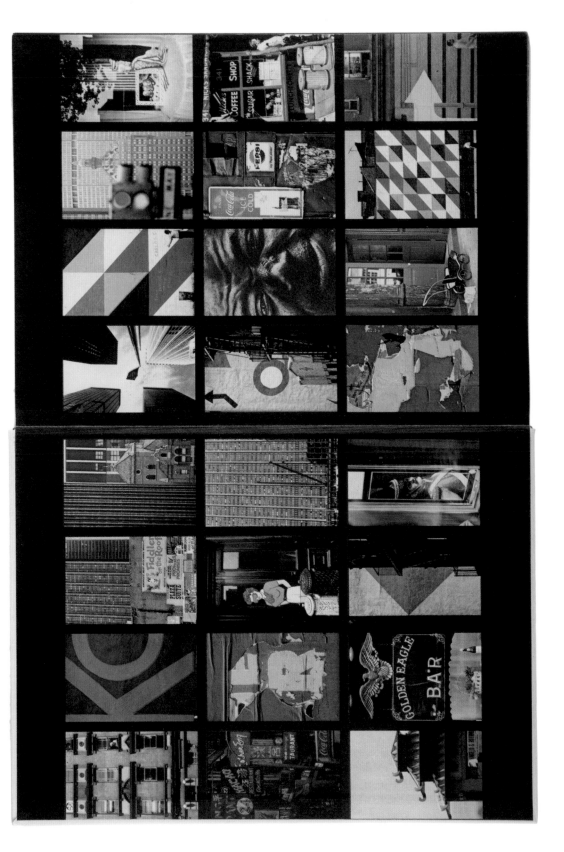

133

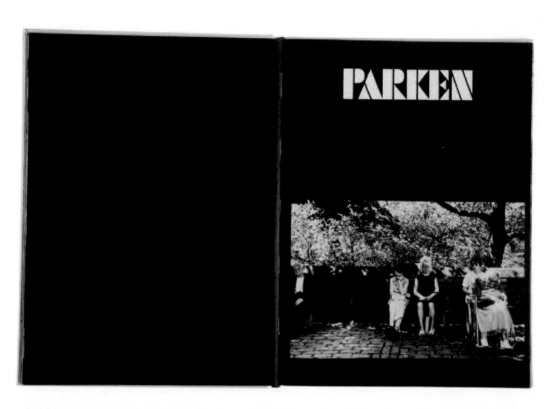

PARKEN

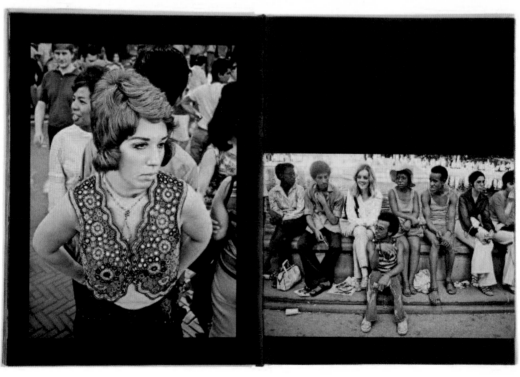

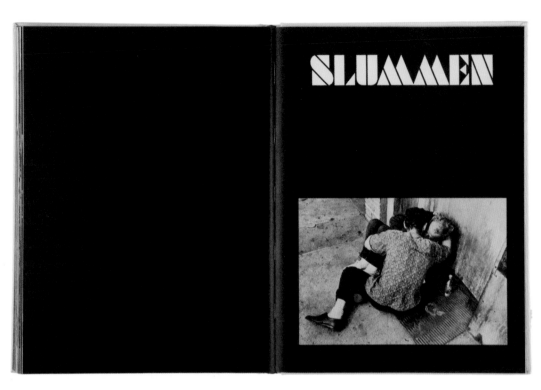

SLUMMEN

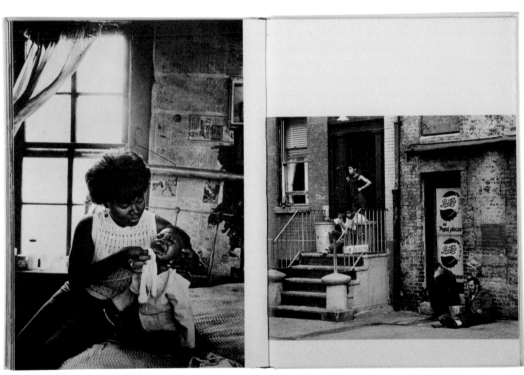

1969 (2005)
Danny Lyon **The Destruction of Lower Manhattan**

In 1966 Danny Lyon returned to New York after having lived for several years in Chicago, where he studied ancient history, became involved in the social and political movements of the time, worked at the university newspaper, and learned about publishing and taking photographs. Back in his hometown and in search of solitude, Lyon settled in an isolated part of Lower Manhattan with his friend the sculptor Mark di Suvero. The downtown area was caught up in a violent process of urban renovation, which included the demolition of more than twenty-four buildings. From his attic window, the photographer observed one of the demolition sites and, concerned by the imminent disappearance of some of the oldest buildings in the city and, indeed, of an entire neighborhood, he began to record the demolitions, which also entailed progressive dislodgement. In order to carry out the project, which involved tracing images on a map of Lower Manhattan, he solicited financing from the New York State Council on the Arts. The result was the photobook *The Destruction of Lower Manhattan*, published in 1969.

Out-of-print and considered a collector's item just a few years later, the book was reprinted in 2005. It contains black-and-white images accompanied by texts written by the artist himself, mostly excerpts from the diary he began to keep at the time, in a notebook he had found in one of the abandoned buildings. The diary contained experiences and anecdotes, impressions of the buildings, and notes on the few residents who remained in them. Lyon did not avoid social criticism: he addressed the situation of the workers entrusted with the demolitions and the lack of sensitivity of the municipal authorities to the nineteenth-century architectural heritage that was disappearing.

The photographs of the buildings in desolate, deserted surroundings are composed with a classic sense of beauty and placid light, influenced by the work of Walker Evans. The book also contains images of the last residents of Lower Manhattan, especially of the workers whom Lyon considered in a certain way the original settlers of the place, taken in full frontal view that recalls the signature portraits in *The Bikeriders* (1968) or *Conversations with the Dead* (1971). Thanks to his closeness to his subjects, Lyon's images manifest an empathy with the poor and marginalized. The book also contains photographs of interiors in buildings that have been abandoned or are in the process of being demolished, as well as details and objects from the spaces that evoke their fragility and tragic fate. It is the record of a past in the process of disappearing, where the nostalgia, solitude, and silence concealed within the images suggest all the violence implicit in the imminent and aggressive demolition, which is seldom portrayed directly. [E. G.]

Revised edition / New York: powerHouse Books 2005 / 275x245 mm, [160] pages, cloth, illustrated dust jacket / 73 b&w photographs and text by Danny Lyon / designed by Kiki Bager

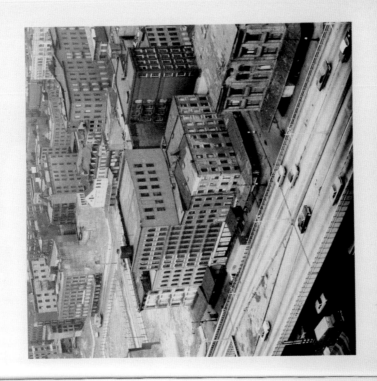

THE WEST SIDE: WASHINGTON MARKET AND WEST STREET

"June 18. The project seems to be going well. I've begun work on the west side, and in Washington Market I have somewhat of a jump on the demo men. The Trade Center site is practically impossible to work in. PATH has the ruins guarded, and the wrecking is going so fast that buildings disappear overnight. As I see it now I might weave a kind of song of destruction. The base of it would be a documentary record of buildings and blocks soon to be demolished, and a record of demolition work. There will be portraits of housewreckers, and anyone left in the neighborhood. In a way the entire project is sad; except for the demolition men and their work."

The Washington Street Urban Renewal Project brought down twenty-four and a half blocks of mostly 19th-century buildings on the west side of Lower Manhattan. Many of the buildings had been in continuous commercial use since before the Civil War as part of the Washington Street produce market. The market, located in the area since the War of 1812, was moved one day to new quarters in Hunts Point, the Bronx. The silence left in the streets was startling. As one wanderer put it, everyone left one night, even the dogs and the rats.

12] West Street and the West Side Highway, just north of the Trade Center site.

32] Steelworker, Beekman Street.

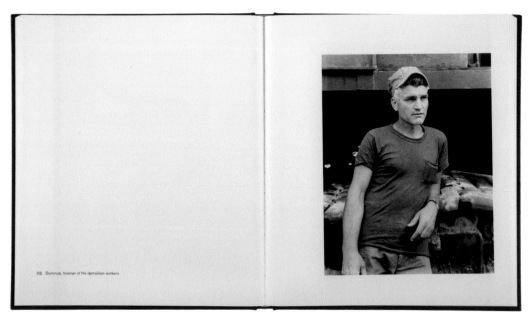

33] Dominick, foreman of the demolition workers.

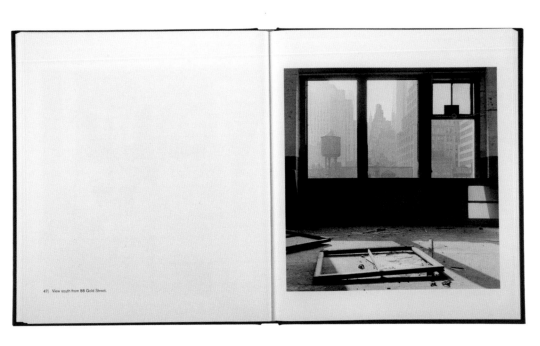

47] View south from 88 Gold Street.

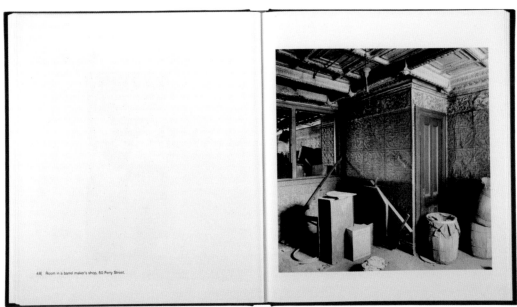

48] Room in a barrel maker's shop, 50 Ferry Street.

HOUSEWRECKING

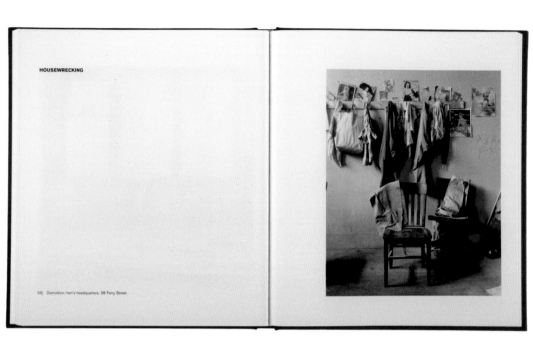

55] Demolition men's headquarters, 38 Ferry Street.

Through the many days I spent with the demolition men, watching them level Beekman Street, my respect for them grew tremendously. They do a difficult and dangerous job very well and it's a mistake to think that they feel anything but pride for their work.

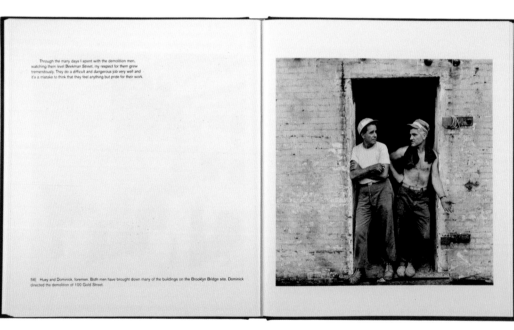

56] Huey and Dominick, foremen. Both men have brought down many of the buildings on the Brooklyn Bridge site. Dominick directed the demolition of 100 Gold Street.

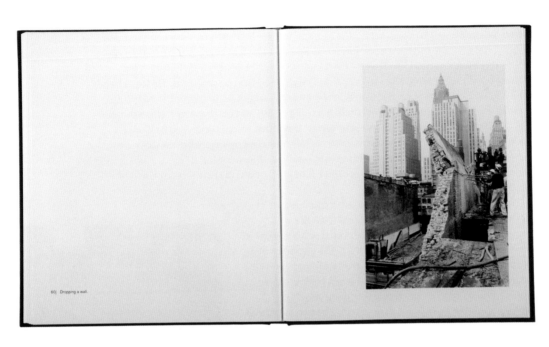

60] Dropping a wall.

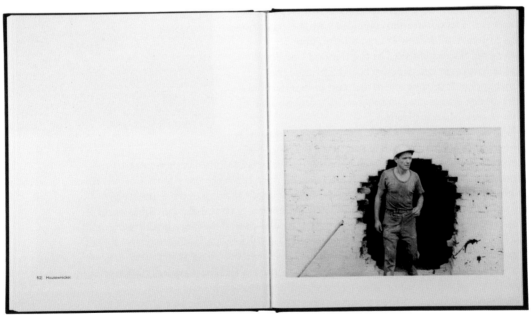

62] Housewrecker.

1969
Bruce Davidson **New York - 100th Street**

In 1966, when Bruce Davidson set up his camera on East 100th Street, between First and Second Avenues—the blighted zone known as Spanish Harlem there was no longer any trace of the friendly street life Helen Levitt had portrayed twenty years before. The neighborhood had become a ghetto and that is how Davidson portrayed it. He was already a well-known photographer, published in the most prestigious photography magazines, where his series on gang members (*Brooklyn Gang*, 1959) and on the civil rights struggle (1961-1965) had appeared. In the present series, Davidson, who considered himself a humanist photographer, had become more socially engaged: his working method consisted of identifying a theme that affected him emotionally and developing it freely... which in this case meant leading them (him and his camera) to participate in the everyday life of the neighborhood.

The series was a success from the very beginning. International recognition, however, came from the prestigious Swiss monthly *du*, which devoted a monographic issue to Davidson and brought his work to the attention of a European public. The magazine was brilliantly and carefully designed by Peter Jenny and included seven foldout pages printed in extraordinary photogravure, deep and dry, perfectly suited to Davidson's dark prints. The text consisted of an acute interview with Davidson conducted by Barney Simon, in both English and German.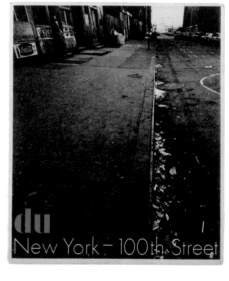

The book came almost two years later: it was the first of his career and its publication coincided with the exhibition at the Museum of Modern Art, curated by John Szarkowski. It was published by the Harvard University Press in hardcover and paperback, and reprinted the following year. It became one of the most influential books of the decade among photographers with a commitment to issues of social marginalization.

The book contains 121 images, one per page, with ample white margins and no captions or page numbers. They are reproduced in rich, warm duotones, dense blacks that were softened in the St. Ann's Press edition (2003), to which more than twenty new photographs were also added. The only text is a brief introduction by Davidson himself: a daring stroke that leaves the entire weight of the book to the images, which offer a detailed and intense portrayal of an invisible world of blacks and Latinos. The sequence begins with a general view of the block before going on to examine the community through individual examples. A barely noticeable narrative thread leads from exterior spaces into the interiors of people's homes. There are no value judgments. The gaze is not moralizing, but it is penetrating, and the images reinforce one another through juxtaposition, making the storyline more complex and denser.

For this book Davidson changed his usual strategy and used a large-format camera that guaranteed personal interaction and a more performative attitude, reflected in the surprising naturalness of the images, halfway between snapshots and posed portraits. [C. G. C.]

du kulturelle Monatsschrift 337 / Zurich: Conzett & Huber March 1969 / 305x255 mm, illustrated softcover / 58 b&w photographs by Bruce Davidson in 54 pages + 7 fold-outs / text by Bruce Davidson with Barney Simon / designed by Peter Jenny / photogravure printed by Conzett & Huber, Zurich

Wer ist Bruce Davidson? Bruce Davidson wurde 1934 in Oak Park, Illinois, geboren. 1959 trat er der Arbeitsgemeinschaft Magnum bei. Unseren Lesern ist er durch den Bildbericht «Die Jokers» bekannt, den wir im September 1960 veröffentlichten. – *Was hat es mit der East 100th Street auf sich?* Die East 100th Street führt vom Central Park – genauer: vom Mount Sinai Hospital – zum East River. Zur Hauptsache besteht sie aus fünf- bis sechsstöckigen Mietshäusern mit russgeschwärzten Backsteinmauern, deren Fassaden von Feuerleitern übersponnen sind. In den Erdgeschossen sind kleine Ladengeschäfte untergebracht, aus deren Inhaberschildern und Auslagen hervorgeht, dass ein Grossteil der Strassenbewohner aus den spanischsprechenden Territorien stammt. Es gibt dort auch ein paar Schankwirtschaften und ebenso viele Kirchen und Sektenkapellen, die in Ladenlokalen und Wohnungen untergebracht sind. In der unteren Hälfte der Strasse wurden die alten Mietskasernen zum Teil abgetragen und durch vierzehnstöckige Hochhäuser ersetzt. Zwischen ihnen wurden Grünanlagen und kleine Spiel- und Sportplätze für die Jungen angelegt. In der Verlängerung der Strasse erscheint das Stahlgerippe der East River-Brücke, das nachts von zahllosen Glühbirnen erleuchtet ist. Als Ganzes macht die East 100th Street einen ärmlichen, düsteren, aber nicht eigentlich verkommenen Eindruck. – *Warum widmet «du» diesem Thema ein ganzes Heft?* Weil wir überzeugt sind, dass Bruce Davidson mit East 100th Street das bedeutendste photographische Dokument des zu Ende gehenden Jahrzehnts geschaffen hat. Weil wir glauben, dass damit ein wesentlicher Beitrag zum Verständnis des brennendsten Problems der Vereinigten Staaten, der Rassenfrage, erbracht wurde. Und nicht zuletzt, weil «du» die einzige Zeitschrift ist, die seine Arbeit in dieser Vollständigkeit zu veröffentlichen die Möglichkeit besitzt. – *Warum wurden den Aufnahmen keine Legenden beigegeben?* Weil der Titel, mit denen der Photograph seine Bilder versehen hat, nicht mehr besagen, als was dem Betrachter von selber dazu einfällt. – *Warum erscheint der Bildbericht ohne redaktionellen Kommentar?* Weil jede Ausdeutung, und wäre sie noch so wohlmeinend, die Absichten des Photographen verfälschen müsste. Es lag Bruce Davidson daran, das Leben in einer beliebigen Strasse des «schwarzen» New York ohne Voreingenommenheit zu schildern. Also nicht als eiliger Reporter, der aus dem Hinterhalt ein paar effektvolle Aufnahmen «schiesst», sondern als einer, der von den Bewohnern der Hundertsten Strasse während vieler Monate als täglicher Gast gesehen und akzeptiert wurde. Auf diese Weise entstand ein tendenzloser Augenzeugenbericht, der so, wie er ist, weitergegeben werden soll.
Die Red.

Bruce Davidson
New York
East 100th Street

aufgenommen werden. Ich werde es Ihnen sagen, wenn ich aufgenommen werden will: wenn ich mich wohl fühle... wenn ich mich wohl fühle. Er hat Arthritis und Rheumatismus. Er kann kaum gehen, kann kaum einen Bleistift in der Hand halten. Er war Hausmeister während wohl dreissig Jahren. Einmal warf jemand einen alten Kühlschrank oder Ofen aus dem Fenster und zerschlug damit das Zementpflaster im Hof. Er schaffte die Trümmer weg und säte Gras. Das wächst nun dort zwischen den Sprüngen im Zement, weil er es begiesst und pflegt.
Und dann ist da der Mann, der das Restaurant führt. Er liess sich einmal photographieren, aber das Bild geriet zu dunkel, und er wollte nie mehr photographiert werden, ich weiss. Sie sind voreingenommen, sagte er. Deshalb haben Sie das Bild zu dunkel gemacht. Sie machen alle Leute hier herum zu dunkel. Wenn Sie helle Bilder machen, dann will ich Ihre Bilder an die Wand hängen. Aber ich weiss, er hat mich gern. Er gestattet mir, die Toilette in seinem Restaurant zu benutzen. Er gestattet mir das nicht jedem.
Und da war ein Junge, der mir viel an die Hand ging. Er trug mir meine Kamera-Taschen nach. Er wusste, wer mich überfallen und meine Kameras stehlen wollte. Er kannte viele von den Leuten, die mich in ihre Wohnungen einliessen, damit ich sie photographiere. Ich konnte mich auf ihn verlassen. Dann, eines Tages, sagte er zu mir: Ich kann heute nicht für Sie arbeiten, denn ich kann mehr verdienen, wenn ich in New Jersey «Stoff» verkaufe. Warum sollte ich für Sie für zwei Dollar die Stunde arbeiten, wenn ich Geld auf meine Art machen kann? Ich verstand: Es ist nicht besonders fein, das Gepäck eines Fremden in seiner eigenen Nachbarschaft herumzutragen.

Es war ihm nicht wohl dabei.
Anderseits gibt es in der Strasse recht viele junge Leute, die am Photographieren interessiert sind. Ich lieh einem Burschen, der mir geholfen hatte, meine Kamera und mein Entwicklungsgerät. Ich gab ihm ein paar Filme und zeigte ihm, wie man's macht. Die Jungen, die Leute, die photographieren ihre Freunde. Du weisst, dieser Junge, der jenes Mädchen küsst... alles mögliche, ohne Sentimentalität. Sie photographieren das Leben, das sie kennen, nicht sein Elend. Und Elend gibt es, und es gibt auch Leute, die nichts davon spüren. Leute, denen die Häuser gehören und die wenig für uns tun. Wir kämpfen einen Krieg in Vietnam und tun vergleichsweise nichts für unsere zerfallenden Städte. Aber die Leute in der Strasse unternehmen etwas. Da gibt es das «Metro North», ein gemeinnütziges Komitee. Es hat Dutzende von Häusern repariert, hat Anlagen erstellt, Fortbildungsschulen eingerichtet. Und vieles wird noch gemacht werden...
Wie ich schon sagte: Ich glaube nicht, dass es wichtig ist, warum und wie ich in die East 100th Street kam; wichtig ist, dass ich dorthin kam mit dem Bedürfnis, wieder Beziehung zu lebendigen Dingen zu haben. Und es war mir erlaubt, an einem Leben teilzuhaben, das ich vorher nicht gekannt hatte. Erfahrungen daraus zu ziehen und etwas dort zu machen, etwas daraus zu machen mit meiner Kamera. Und ich ging fort und nahm mehr mit als Aufnahmen.
Das Leben in der East 100th Street ist dort das beste aller Leben, aber es lebt. Ich glaube, manchmal ist es besser, lebendig zu sein, als das beste aller Leben zu haben. Das «gute Leben» scheint mir tot. Aus dieser Distanz scheint es mir tot.
B. D.

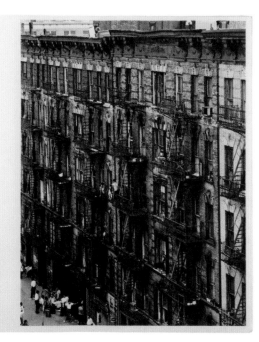

158

143

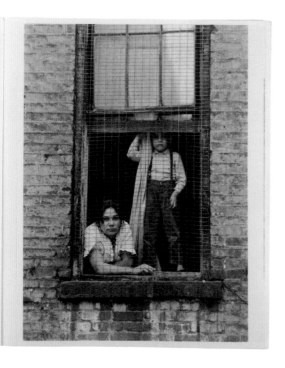

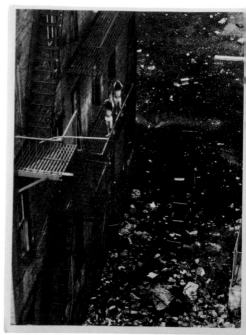

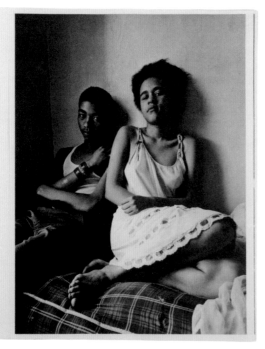

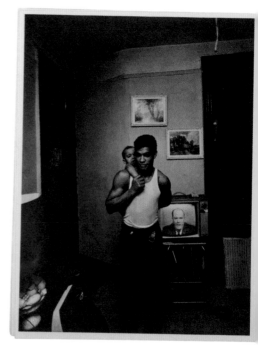

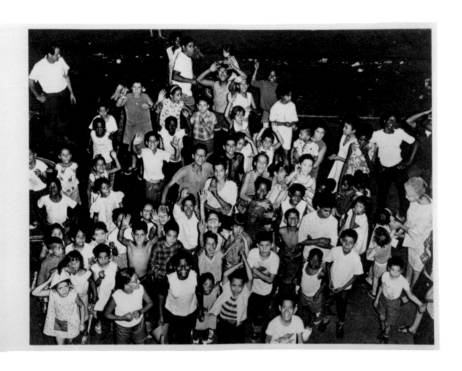

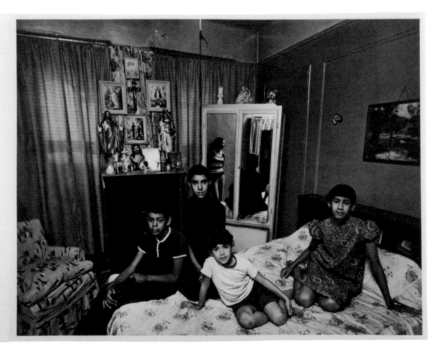

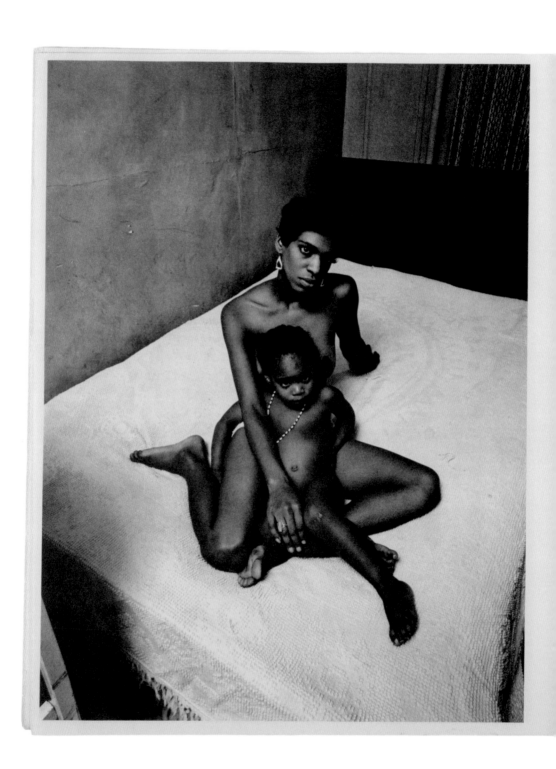

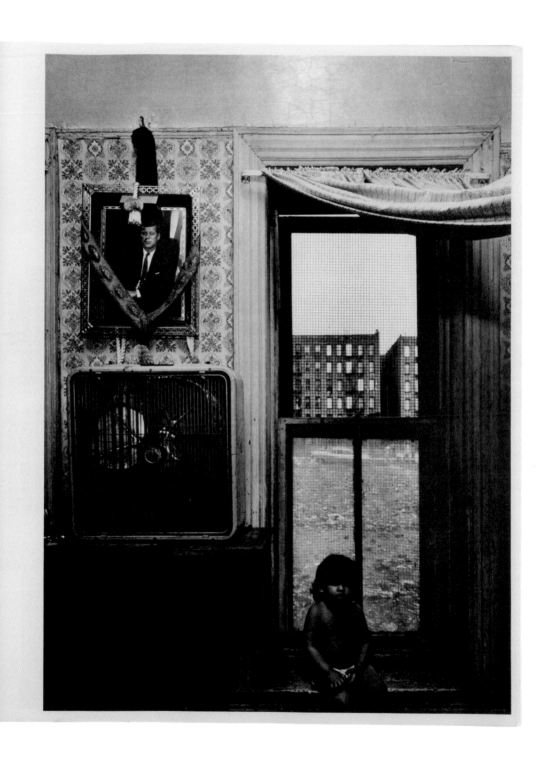

1972
Lőrinczy György **New York, New York**

The snow looks real in the rapid images stored away here and there in *New York, New York*. It's because of the textures: you would think you could run your finger over the page and feel the frozen clumps, but it is an esthetic impression. Some figures are seen from the back, as if we were making our way into a demonstration from the side; the heat must be greater there, towards the middle, where the faces are turned. Where are they looking? Here? Clear traces of solarization: the figures turn—as if offering the back of something—and give notice: there is always more; and give notice: there is always less. The buildings waver, distorted, unsubstantial, in the mist, mere electricity. Of course they don't weigh much, as Hungarian photographer Lőrinczy points out in the brief text that accompanies the book, which is not about NYC but about the people and places that interested him when he was there in '68. That is why the landscapes are flown over rapidly and the gaze has to run after them, drunkenly follow the twists and deformations: where meaning loses, life gains. The montage of the eye and then the manual montage, the masts of the ships compete with the vertical lines of the building; there is a little plane up there, and now another; and there goes a bird, two of them, solarized; the texture of the water can also be felt with the touch of the eye, avid, drugged; the windows are *elooooongated*; the openings, like vowels, allow that; they are like architectural skulls defibrillating and I faint. Seen from above, that little block of garbage bags tied up amidst colorful graffiti, next to the little block of piled-up buildings, or next to the little block of parked cars, all look the same! Lőrinczy is speaking of capitalism now, of residual metaphors, of border desire, and soon the montages are saturated—it's ironic—look how he puts the policeman there next to the cockroach crawling along the edge of the little box of black pepper, and yes, there are also disturbances. The textures approach; the overexposures with inked vegetable paper also approach; they are metonymic procedures, something like cinema, more similar than any other narrative. Lőrinczy's montages conceptualize. Jewels trinkets garbage, instruments among smiling people, fading light, reflecting, turning its back, losing its shape. A city could be any shadow, a city could be any shadow of life, sickness, collapsing falling printing showing naming: *The Age of Imperialism* is blurry on the left, on the right a black child looks directly at the camera, here? Children. Greenwich Village. Richard Lindner. Allen Ginsberg. Dionysius in '69. Look how the children run, how they dance, how they all kiss, as if there were nothing else in the world but New York. As if there were nothing else in the world in '72, when this book was hurriedly published, without even taking the time to properly dry the photomontages. Bleeding black. She sighs, her hair bleeding black. A printed pattern of visual pleasure. [A. S.]

Budapest: Magyar Helikon 1972 / 250x210 mm, 130 pages, index, hardcover, illustrated dust jacket / 96 b&w photographs and introduction by Lőrinczy György / 5,200 copies

9

10

13

14

42

43

44

1973
Le New York d'Arrabal

Echoes of recent May '68 can be heard in these lines that accompany the photograph of four children running toward the camera: *À Harlem / un dimanche matin / même les pavés / deviennent hirondelles* (In Harlem / on Sunday morning / even the paving stones / become swallows). In his most engaged, most nonconformist mode, Fernando Arrabal (b. 1932) observes the world with a curious, human gaze that embraces all aspects of life, walking the streets of New York with his Yashica and taking photographs like free verse. Meanwhile, he is preparing the reprise of his play *... y pondrán esposas a las flores* in the nave of an deconsecrated church.

Arrabal's stylistic eclecticism extends to photography in this book, the work of an avowed amateur. On the strength of his controversial, transgressive, experimental plays, this multidisciplinary artist is one of our great contemporary playwrights. He also wrote a long poem about New York in French to serve as a prelude to this book of black-and-white photographs published by Balland in Paris in 1973. A softcover with a fully contemporary design by Atelier SMK: a striking cover and a refined layout of text and images. The back cover bears a brief text by Roland Topor.

Le New York d'Arrabal is conceived as a total work in which verses and photographs combine in fragments to configure an absolutely subjective, diverse, even interchangeable narrative. There is a protagonist—the photographer himself—who walks the city counting off urban icons. With his words and with a lucid gaze, amidst the actors and extras of the urban stage, people who claim his attention out of the foreground. Opening the book is a single poem, whose verbal sparks are struck off from verses that compose a kaleidoscopic narrative, descriptive of a multicultural, contradictory, insomniac Babel. Many references allude to life in New York in the early 1970s: Beckett and Allen Ginsberg; Nureyev and Mario Montes; Che Guevara, El Cordobés, and Jodorowsky; baseball at Shea Stadium and the prophets of Harlem; a party in Central Park and graffiti in the subway; street porn, chess, and beggars. And theater.

Alongside the images, yes, there is poetry, but also dialogues, aphorisms, quotations, and micro-stories. They succeed one another in an accumulation of urban landscapes and anecdotes that combine to offer surprising meanings, tinged with irony, with condemnation, at times genuine plastic discoveries; the photographs are visual darts as unconventional as Arrabal's own writings. Part of this erratic tour is charted on a map of Manhattan, in an attempt to systemize the impossible that is rejected by his own verses: *Ne cherchez pas d'ordre ni dans la métropole / ni dans ce livre, même / pas une règle capricieuse ou lunatique* (Don't look for order in the metropolis / or in this book, or / for even a capricious or lunatic rule). For Arrabal, confusion is the clearest representation of modernity. [M. G.]

Paris: Balland 1973 / 205x200 mm, 112 pages, softcover / 58 b&w photographs and text by Fernando Arrabal / designed by atelier smk / photogravure by Abéxpress, Paris

Who ? Beckett lui-même au coin d'une rue ! Oui, New York est merveilleux !

A qui, dire ni les "Richures"
ne s'appellent ainsi eux-mêmes
ni les gratte-ciel
ne cataloguent les souvenirs
de l'exactitude

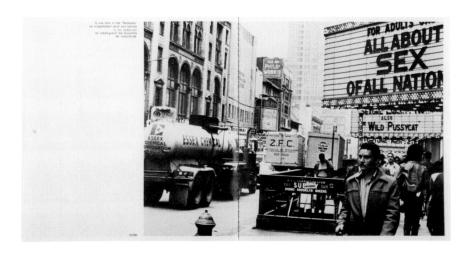

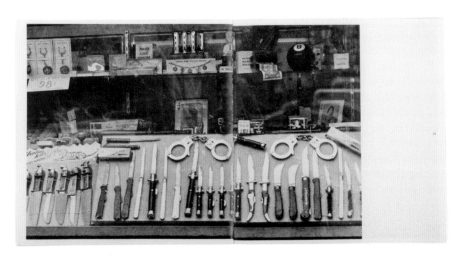

1974 (2013)
Daido Moriyama **Mo Kuni New York / Another Country in New York**

Another Country in New York is the legendary privately published book that Daido Moriyama brought out in 1974, after having already published *Japanese Theater* (1968), *Farewell Photography* (1972), and *A Hunter* (1972). Moriyama (born in 1938 in Ikeda, Osaka) moved to Tokyo in 1961, where he first joint the collective VIVO (of which Shomei Tomatsu, among others, was a member) and then worked as an assistant to Eikoh Hosoe. In 1969 he contributed to the second issue of *Provoke*, the ephemeral magazine created by Takuma Nakahira and Taki Koji.

In the winter of 1971, Moriyama left Japan for the first time, accompanied for a month by his friend the artist and designer Tadanori Yokoo. The following year he contributed a small selection of images to the Japanese photography magazine *Asahi Camera*.

The present book was produced in improvisatory fashion in 1974, with the help of a photocopier Moriyama rented for two weeks, from the images he had taken on that trip. He also rented a small commercial space in which to produce and sell the book on demand: a simple publication with photocopied pages, stapled together, and a serigraph cover. The sequence of the almost fifty images changed slightly from day to day, as did the cover, of which there were two versions. This means there are different versions of the approximately one hundred copies of the book that Moriyama sold.

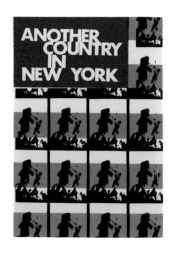

It is not surprising that in 1974 he ventured to hold his first "printing show" to further explore the forms of publication known to him, since the arts in Japan were assimilating many ideas from contemporary performance, theater, literature, cinema, and music at the time. Moriyama was the photographer of Shuji Terayama, a poet, filmmaker, writer, and photographer himself, who had a deep influence on him. For photographers like him and like Araki, the book also became a place for experimentation.

In those years of booming economic growth, and also of energetic protests and sharp political conflicts around the US occupation, Moriyama proved to be one of the least politicized photographers of his generation. He has always been more interested in the development of photographic language. He was influenced by everything happening in New York, and by the photographers he admired, such as Weegee, Klein, and Warhol, as can be seen in the silkscreen of the flag on the cover of this book. The title is also an allusion with an American connection, namely to African-American James Baldwin's novel *Another Country* (1962), which tells the story of the unhappy life and suicide of a black jazz drummer in New York City.

With its unmistakable *provoke* esthetic of contrasting blacks and whites, grainy textures, and uneven tones that make the images fade away at certain points, Moriyama presents in *Another Country in New York* a vital and dynamic city, as if he were seeking the same chaotic pattern he had so far pursued in photographing his native land. [S. B.]

Reprint / Tokyo: Akio Nagasawa 2013 / 315x215 mm, 44 photocopied pages, 1 loose page, illustrated silkscreen-printed softcover (two variants), stapled / 80 b&w photographs and text by Daido Moriyama / limited edition 250+250 copies

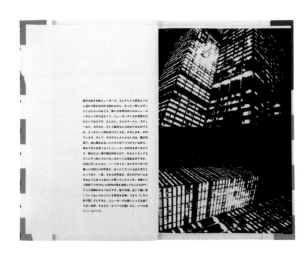

僕の大好きな街ニューヨーク、もしかしたら東京よりか
ばかり好きなのかを知れません。たっか一度しか行っ
たことないいわけども、僕には世界中のどこにあるニュー
ヨークというわけではなくて、もしかし、コンクリートと、スティ
ールと、ガラスと、そして誰かさんの中のやさるのです
が、どこまにいい別れのやさしさ、かなしみ、ひか
でいます。そして、その中のしささくしるは、窓の内
変て、窓に腐れあないわたしで今もつつけているもので
、特わりない人を思うようにことニューヨークの街を思うわけで
す、僕はひさい別れをわけないのがとても残念なのですが、
日前に行ったように、ハーフサイズ・カメラでパチパチ
撮った内ばたの時の写真で、ほとんどどこにも出かずに
しまっており、一度、それらの写真を、恋人のアルバムを
作るように作ってみたいと思っていたところ、今度なら
大阪駅下でのフレーム制作の電を提案してくるからです。
やっと説明からなうまわけです。僕が別低、近くて遠い思
じているいらいだってている言葉をが必要、つまり くにもら
街の国、だけ今を、ニューヨーが僕にこて以出てて
ない時が、するのもら「もう一つの国」だと、いつもと考
えているのです。

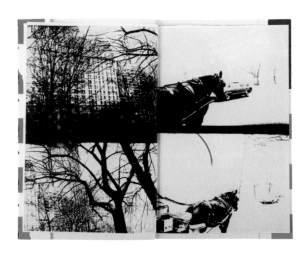

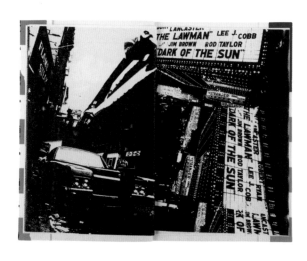

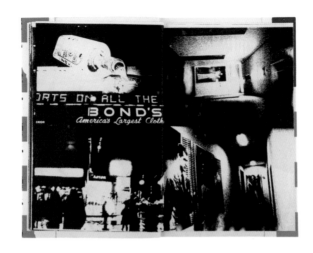

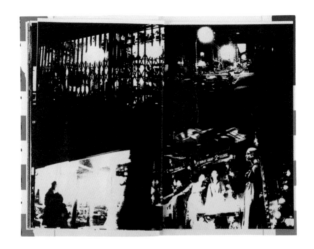

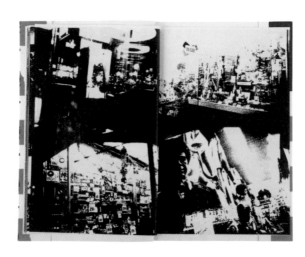

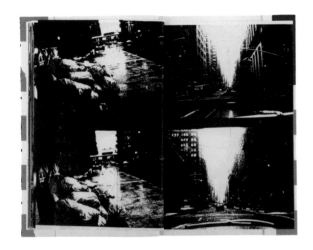

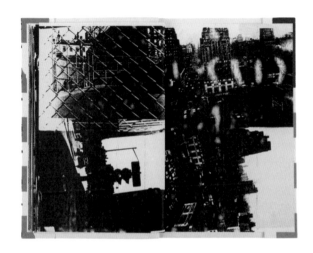

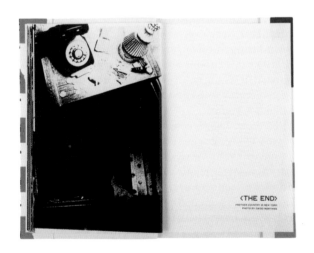

⟨THE END⟩

Jon Naar **the faith of graffiti**

Graffiti provokes only extreme reactions. Some consider it vandalism; others defend it as an art form capable of redeeming esthetic experience from elitism and democratizing it. The scandal of the apocalyptic reaction and the sympathy of the initiated are clear signs that all these *scribbles and paint* provide plenty of matter for reflection. Unfortunately, *The Faith of Graffiti* was not born out of a conciliatory spirit. On the contrary, it would become the tables of the law of the activity.

The photobook was begun in 1972, when Pentagram design studio commissioned Jon Naar to undertake a project about the "phenomenon" of graffiti in New York City. For two years, Naar photographed walls, the insides and outsides of subway cars, alleyways, etc. In *Mass Transit Art Subway Graffiti* (1989), Jack Stewart has described the moment as a milestone in the history of New York graffiti.

The editing and graphic design of the photobook is by Mervyn Kurlansky, one of the cofounders of Pentagram. Double page spreads, with bleeds, of fragments of the letterings, which seem to be the military epitaphs of paradoxically anonymous authors: fragments of something monumental that stretches on to the next corner.

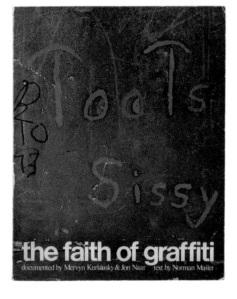

The title is taken from a phrase by Cay 161, a graffiti artist interviewed by Normal Mailer for the text that opens the book, also published in *Esquire* magazine: "the name is the *faith* of graffiti." He seems to have meant that graffiti at that time consisted above all of writing a name anywhere, since the ubiquity of the name was the objective and the sign of success. It might be noted that the artists' nicknames were conventionally created by combined a proper name with the street number at which they lived.

The book does not seek to burnish the stereotypes already existing about graffiti, in spite of the occasionally exalted tone—which happens to be very much in Mailer's line—and the exaggerated comparisons to the fresco painters of the Italian Renaissance. In fact, it catalogues styles and identifies significant figures in the manner of archaeological documentation, seeking to be rigorous and precise, though without any attempt to produce a lasting or canonic compilation. The truth is that no one sees it as a curse that graffiti is not turned into a relic. Accepting its transitory nature is another aspect of the faith in graffiti.

Some of Jon Naar's images combine the picturesque and the mystical; some of them recall the chapels of Romanesque churches; others, the overloaded decoration of Gothic façades. It is impossible, however, to escape the similarities with abstract painting, and not only from an obviously plastic viewpoint, but also in terms of a shared visual totality. Graffiti and abstract painting free themselves of the detail: they are always "all or nothing." Again, apocalyptic confrontation or integrating diplomacy, the two extremes of a religion in which having faith is all that absolutely matters. [C. G.]

New York: Praeger 1974 / 345x265 mm, [80]+[16] pages, illustrated softcover / 39 color photographs by Jon Naar / documented by Mervyn Kurlansky & Jon Naar / text by Norman Mailer / designed by Mervyn Kurlansky

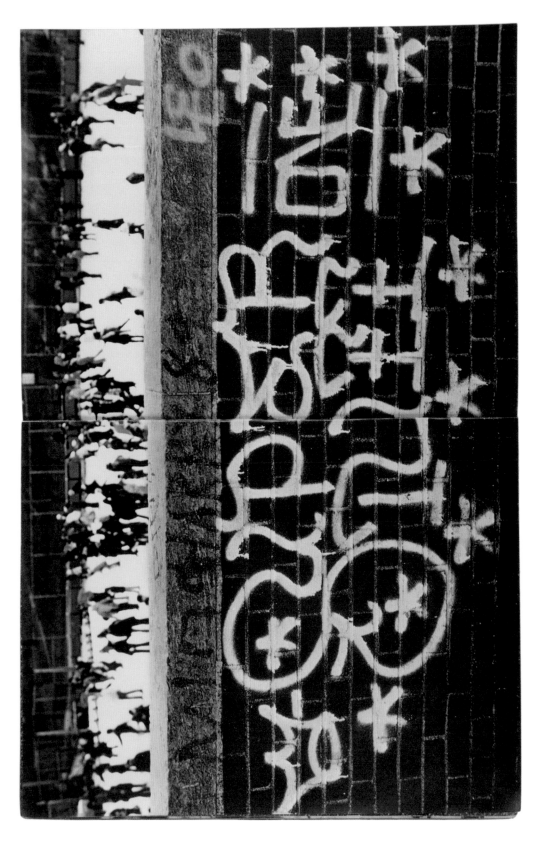

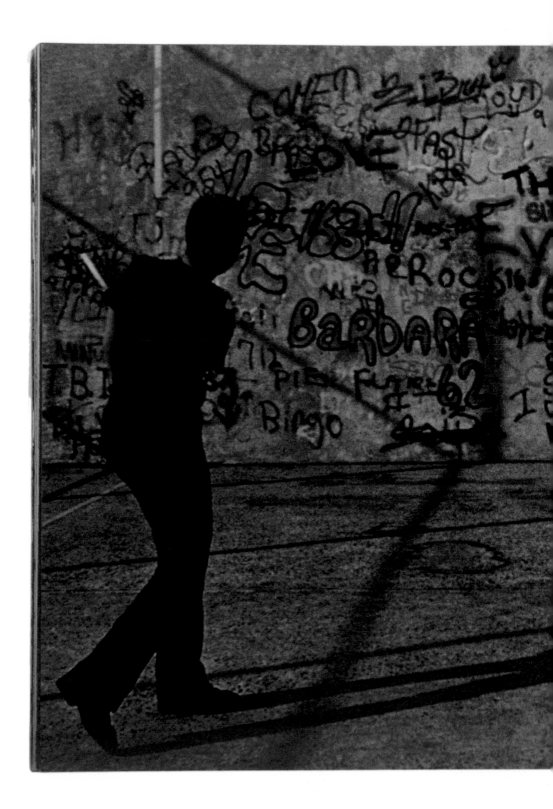

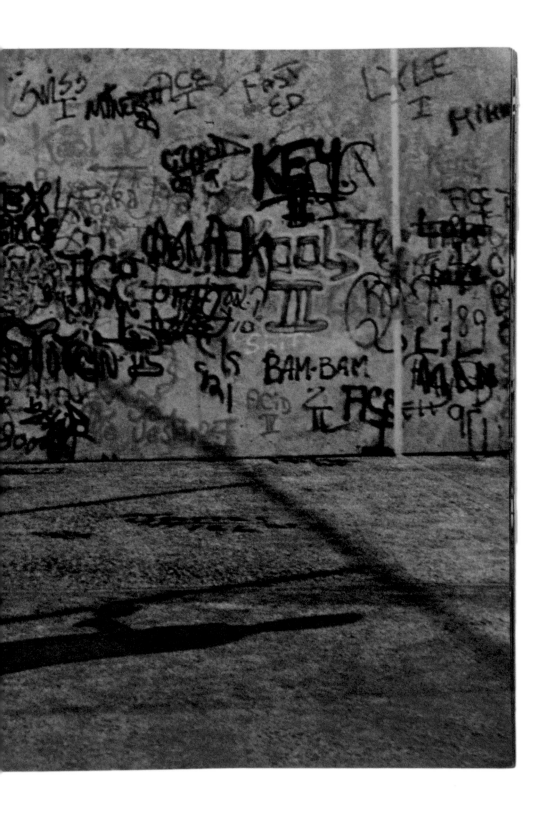

1976
André Kertész **Of New York...**

The melancholy gaze that characterizes the indispensable work of André Kertész is already present in the title. This marvelous book gathers photographs taken over a period of more than forty years, and includes some of Kertész's best-known images, such as "Lost Cloud" and the snowy landscapes captured in Washington Square, as well as others that are little known, even to those familiar with his work. Kertész is commonly associated with a certain nostalgic humanism, which he carried with him in the face of countless professional obstacles from Paris to the United States. He achieved it without travels to distant lands or exotic adventures, but simply through an innate capacity to blend into his surroundings. Nevertheless, he approached his task from a certain distance, rarely establishing prior contact with or seeking out the complicity of his subjects, always faithful to the idea of photographing people through what they construct around themselves: cities, atmospheres, architecture, furnishings. In this way, he finds his way through to the inhabitants of a place.

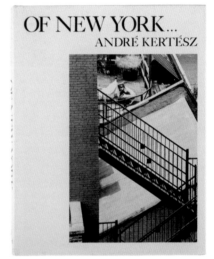

But if this books stands out for anything (apart from the exquisite printing of its velvety shadow tones), it is for providing an idea of André Kertész's work that goes far beyond the clichés habitually applied to it. If we ignore the minor design errors that hinder a fluid reading of the book (such as the dates at the bottom of each photo and a certain stiffness in the layout), we are carried along by a narrative that achieves pinnacles of sophistication. Perhaps the most surprising are the street scenes, presented as sequences of images, rather than by that single, decisive photograph. Also remarkable are the intelligent and poetic visual connections between the double-page spreads, the result of Nicolas Ducrot's editing, which foreshadow contemporary practice, where an apparent abstraction of the message is proposed through a coherent, carefully prepared sequence.

As if all that were not enough, the book holds another chilling surprise within its pages. From the balcony of Kertész's apartment, it is not only the New Yorkers themselves who are visible, but the then-omnipresent twin towers of the World Trade Center. On the double-page spread on pages 26-27, an airplane seems to be crossing the blank space on the right side of the photograph and approaching the towers, their summits half-concealed in low clouds, with the cross of a church delineated against the light in the foreground. It is one of the most unsettling double-page spreads I have ever seen. The somber premonition does not stop there, since the book closes with a contact sheet of images of a man polishing that same cross, which, thanks to the effect of the telescopic lens, seems to be incrusted in the façades of the fateful towers.

In spite of this backdrop, the book expands the figure of André Kertész beyond the humanist and/or surrealist genres with which he is normally associated, offering as many readings as a single city, narrated and experienced like New York, can possibly offer. [J. U.]

New York: Alfred A. Knopf 1976 / 285x225 mm, 192 pages, cloth, illustrated dust jacket / 191 b&w photographs by André Kertész / edited by Nicolas Ducrot / photogravure 'manufactured in Japan'

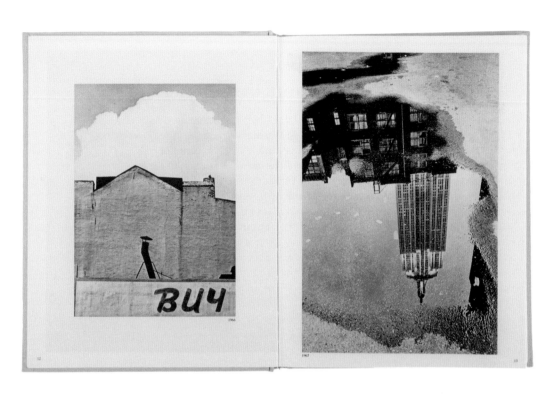

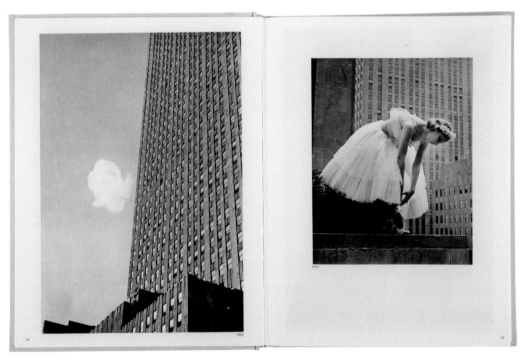

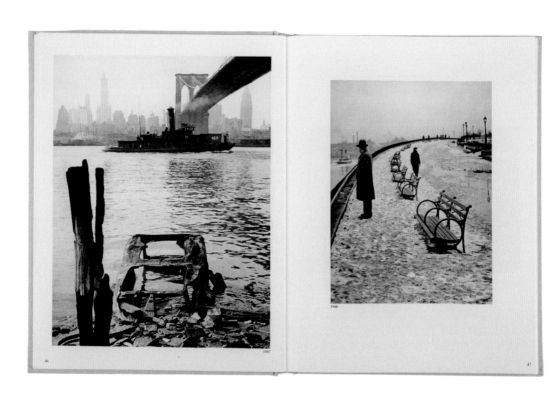

1947

1948

1959

1962

1970

1954

1947

1937

Harlem Document / Photographs 1932-1940: Aaron Siskind

Whatever the title might suggest, *Harlem Document* is not a report drawn up by an urban planning department, but a collection of forty-seven photographs by Aaron Siskind (1903-1991), taken with no official commission, as tended to be the rule in documentary photography projects of the period. In fact, the work was not published at the time. The words of Gordon Parks, also a photographer, and a selection of texts salvaged from the Federal Writers Project (1935-1939), edited by Ann Banks, accompany the photographs, providing context and guidance, in a book eventually published in 1981. At first sight, it is difficult to know whether *Harlem Document* is a homage or an act of historical recovery, since the images and the photographer himself figure among the milestones and central names of twentieth-century photography in the United States, at the same time constituting a socio-cultural reconsideration of the neighborhood of Harlem.

There are at least two major themes in the book, explicitly manifest in varying degrees. The introduction addresses one of them: displacement in time, with the photographs functioning for Parks, more than forty years later, as a mirror in which his memories are reflected. Siskind's photographic work of the 1930s, which could be described as the most object-focused of his career, converges with a life experience (that of others). In the end, Siskind came up with the list of photographs reproduced by drawing on two projects he had participated in at the time: *Feature Group*, a section of the Photo League of which he was a member, taken between 1932 and 1936, and *The Most Crowded Block* (1940). The works had been seen in exhibitions organized by the Photo League, and two of the photographs of Harlem were also included in *Images of Freedom*, an exhibition organized by the MoMA in the fall and winter of 1941, based on a competition for photographs that would provide an image of the United States in wartime.

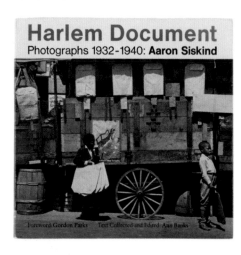

The cover photograph, also reproduced in the interior, announces the second theme: Harlem as a place where things happen, sometimes are seen, sometimes concealed, sometimes are bought and sold. Merchandise and packaging, of every kind and age. Of the neighborhood as a micro-city, Siskind captures amiable singularities, first exploring exteriors and then working his way back to them, after slipping into domestic settings and the private zones of public places. Street stalls, improvised playgrounds, storefronts, and apartment house façades lead on to kitchens and rooms where the bed is piled with clothes and other objects but there is no mattress. This sad silence of somber households contrasts with the exalted singing in the churches, the music bands in the dance halls, and the dance of a striptease artist. And amidst it all, many windows, literally, which happen to appear in the middle of the narration: two photographs of tenement house patios serve as a point of inflection or interior garbage dump. Frames, thresholds, and other devices that simply replicate and underline Siskind's characteristic gesture: seeing under the principle of forms. [R. R. T.]

Providence: Matrix 1981/ 200x210 mm, 80 pages, softcover, illustrated dust jacket / 52 b&w photographs by Aaron Siskind / introduction by Gordon Parks / text by Federal Writers Project edited by Ann Banks / designed by Malcolm Great Designers

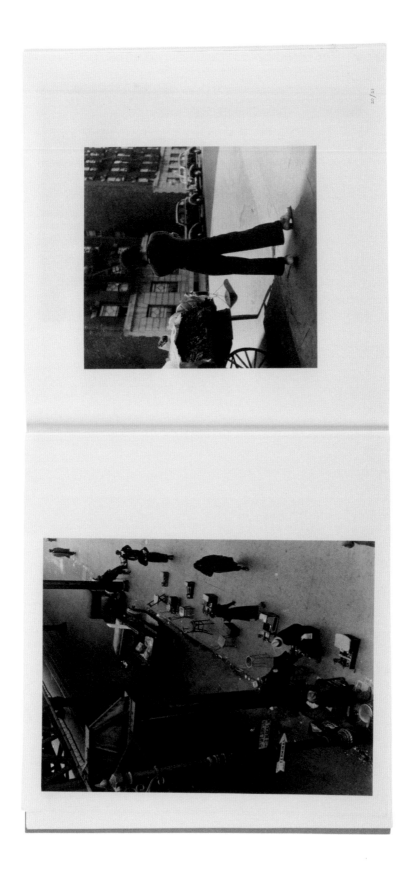

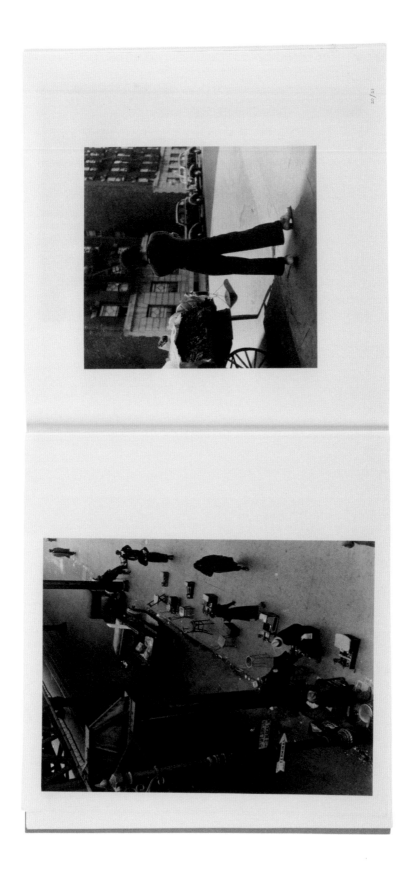

169

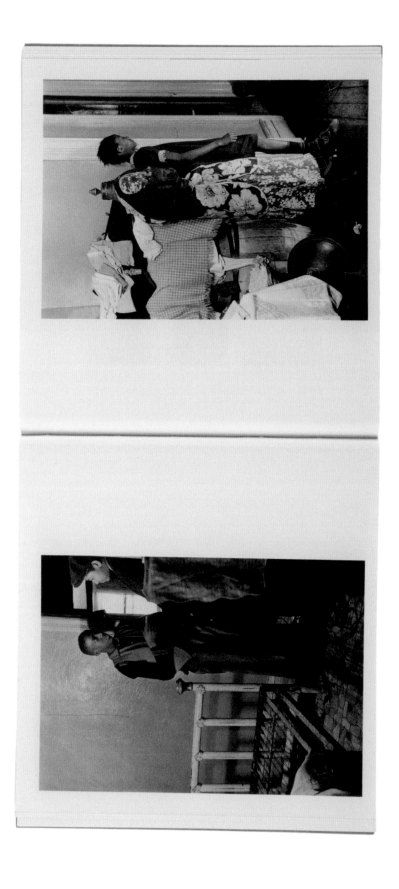

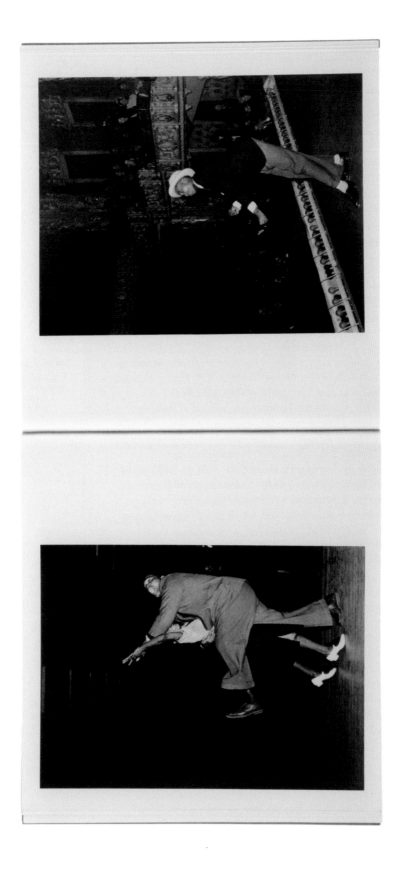

1981
Raymond Depardon **Correspondance new-yorkaise**

Correspondance new-yorkaise is an example of a serialized story: the modern adaptation, in photographic language, of a literary *feuilleton*. The origin of this correspondence is a trip made by Depardon, perhaps the last representative of the great French photojournalists of the twentieth century, to New York City in 1981. The writer and curator Christian Caujolle, then photography editor of the newspaper *Libération*, understood the value of the images taken by the Magnum photographer on his "strolls" and was able to transform them into a "summer photographic diary" which appeared daily in the international section (an important detail). The correspondence between the reporter and the *iconographe* turned into the first book published by the journal *Cahiers du Cinéma* at the proposal of filmmaker Alain Bergala, who also wrote the text entitled "The Absences of the Photographer."

Caujolle's introduction is a miniature treatise on the tribulations of the press photographer and how they can be overcome by an editor with the necessary imagination and vocation: the debate over the pertinence of images and captions; the "happy solution" they found of accompanying the images with articles written *ex profeso* by members of "Inter"; the protests of the workers at *The New York Times*, who did not want Depardon to develop his photos at their offices; the indispensable collaboration of the *International Herald Tribune* in Paris; the unprecedented character of this experience halfway between "postcards and notebooks"... First published in the collection entitled Écrit sur l'image, the volume was reprinted in a new expanded edition twenty-five years later, in 1981, with the addition of a dialogue between Bergala and Depardon and some photographs of New York taken before the summer of *Correspondance new-yorkaise*.

The 1981 photobook is a continuation, albeit in a different setting, of *Notes*, published in 1976 by the poetry publisher Arfuyen (and reprinted in paperback by Éditions Points in 2006), in which the author explored the serialization and contextualization of images, not without recourse to personal, meta-photographic notes: a determination imbued with a mood he calls the "happy solitude of the traveler." In 2014, André Frère Éditions would published a book of interviews between Christian Caujolle and Raymond Depardon.

It is interesting that, when Steidl decided to publish *Manhattan Out* in 2008, it did so turning against the poverty and volatility of the printed page, giving the photos of New York a lavish treatment and introducing them with a text by philosopher Paul Virilio which spoke of "trajectography," "traceability," and the consequences of "a society under constant scrutiny." The opacity of his arguments contrasts with the synthetic confession-text of Depardon himself, which complements his *Correspondence new-yorkaise* ("the Americans terrified me") and confirms the suspicion that there is no better photo caption than the sincere reflections of a thinking photographer who feels irremediably engaged by the image and its context. [J. P.]

Paris: *Libération*, Éditions del l'Étoile 1981 210x180 mm, 96 pages, illustrated softcover / 60 b&w photographs and prologue by Raymond Depardon / introduction by Christian Caujolle / text by Alain Bergala / photogravure print by Bussière Arts Graphiques

Ils ressemblent plus souvent qu'on ne croit, ces prétendus chasseurs d'apparences, à ces peintres qui plantent leur chevalet devant un paysage et peignent, dans un moment d'absence, une odalisque, c'est-à-dire une image qui est tout à la fois l'image de leur désir et celle de leur culture. Pour eux aussi, en qui l'on a toujours voulu voir les champions du réflexe, de l'instant décisif, de la rencontre, il arrive que le réel se dérobe et que l'acte photographique leur révèle dans l'angoisse cette vérité que le réel est ce que le sujet est condamné à manquer.

28

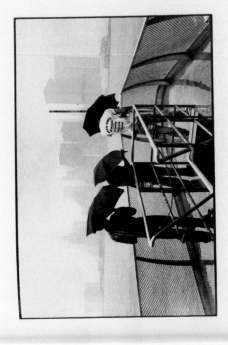

4 juillet 1981, New York. Il pleut, il pleut. C'est le jour de l'indépendance, c'est la fête, la ville est vide. Visite de circonstance à la statue de la Liberté. Discussion toute la nuit avec une amie. J'ai envie de rentrer en France, de tout laisser tomber. Je me force à faire une photo. Je me demande ce que je fais ici. Tout est triste. Mauvaise journée. Je commence à lire G de John Berger. (Paru le 8 juillet).

29

On s'est posé pendant trop longtemps une question un peu vaine : la photographie est-elle un art ? sans voir que cette question en cachait une autre, plus fondamentale : peut-il y avoir un sujet de l'acte photographique ?

Autrement dit, la photographie est-elle un acte, au sens où un acte véritable n'est pas un simple comportement, une réponse au réel (l'enregistrer, le copier mécaniquement) mais comporte toujours une dimension de projet, d'absence, de symbolique, qui le décolle du réel immédiat.

Autrement dit encore : photographier est-il un acte au sens où on peut le dire de l'acte d'écrire ? Cette comparaison n'est pas scolastique et ne paraît être, au contraire, une question juste.

Si l'écriture permet à l'écrivain d'évoquer d'ailleurs ou l'absent, c'est qu'il y a dans la nature même du langage que l'on puisse y faire surgir ce qui n'a pas besoin d'être là où l'écriture a lieu pour être présent dans l'écriture.

L'écrivain, donc, travaille toujours sur fond d'absence. L'écriture procède par nature d'un décalage qu'elle ne cesse de creuser, plus ou moins douloureusement, et où elle fait son lit : entre les mots et les choses, entre vivre et écrire. La photographie serait condamnée, par sa technique même, à l'immédiateté, au non-décalage : le photographe ne saurait s'exprimer qu'à l'occasion d'une coïncidence entre son projet et le monde, d'une rencontre heureuse avec le réel, bref d'un hasard, au sens plat du terme. Autant dire que par ce défaut de décalage dans le mode d'expression photographique, le photographe en serait réduit à une activité de prédateur. Cette comparaison, répétée ad nauseam, entre la pratique du photographe et celle du chasseur (ou du prédateur) est particulièrement agaçante de ce qu'elle fait force de loi dans le langage (les fameux « chasseurs d'images ») et qu'elle finit par imposer comme une évidence (de langage)

30

6 juillet 1981, New York. Ce matin je pars avec un photographe, Dith Pran, Cambodgien, du New York Times. Dans le métro qui emmène à la 116e rue à Harlem, il me parle du Cambodge, des rizières, de ses 4 ans passés avec les Khmers rouges : « j'étais pas prisonnier, c'était pire ». Il me parle en français d'une voix douce... avec pudeur. Sa femme et ses 4 enfants habitent Brooklyn, le reste de sa famille a été tué, il travaille depuis 1 an au New York Times. Nous parlons des photographes Sylvain Julienne, Son Vichit, Gilles Caron. C'est la 1re fois que je vais à Harlem, j'ai 39 ans aujourd'hui. Nous descendons du métro, les gens nous regardent. La police organise dans la rue des jeux pour les enfants. Quelques minutes plus tard, nous entrons à un incendie cent mètres plus loin... pas de victime. Par radio, nous allons dans le Bronx pour une meute de policiers, enssuite à Brooklyn pour un leader républicain, en fin de journée à une conférence de presse du métro de New York à la suite d'un accident il y a quelques jours. (Paru le 9 juillet.)

31

une idée tout à fait approximative, sinon fausse sur l'essentiel. Le chasseur, en effet, ne saurait rapporter le gibier qu'il a manqué, à plus forte raison celui que le hasard ne lui a point permis de rencontrer. Et on voit bien dans la « correspondance » que la question a dû se poser en ces termes angoissants, certains jours, pour Raymond Depardon : et si je n'attrapais rien, aujourd'hui ? et si je n'avais rien à envoyer au journal ?

Mais la différence — et elle est de taille — est la suivante : le photographe (si c'est un vrai photographe et pas un vulgaire chasseur d'images) peut toujours tirer une photo, et une photo réussie, de cette rencontre manquée. Je dirais même que ce sont ces photos-là qui m'intéressent le plus dans la « correspondance », celles qui ont dû coûter pas mal d'angoisses au photographe, celles de la rencontre manquée, de l'absence apparente de gibier photographique. Ce sont celles, comme par hasard, qui nous parlent de la façon la plus émouvante du photographe et de cette vérité refoulée (dont l'activité photographique est souvent le refoulement même) : que pour lui aussi le réel est ce qui se manque. Il se trouve, contrairement à ce que croient beaucoup de photographes, que c'est dans ce manquement même que le sujet se révèle : les plus troublantes de ces photos en témoignent.

M'intéressent moins, d'une certaine façon, les photos où la chasse a été fructueuse, où la rencontre a eu lieu, mettant un terme à l'angoisse du photographe, saturant parfois l'image de rhétorique ou de pittoresque, donnant à voir au lecteur rassasié l'image pleine d'une prétendue réalité où le sujet Depardon, curieusement, n'a plus sa place. Sinon de professionnel, de bon photographe.

Mais la photographie, dans cette « correspondance new-yorkaise », n'est que très rarement seulement une rencontre, elle est toujours aussi expérience d'un manque. Expérience du manque vécue

32

7 juillet 1981, New York. 96°F., il fait chaud. Nous roulons en direction des plages de New York. Je suis avec Keith Meyers, l'un des 18 photographes du staff du New York Times. Mon anglais est pauvre. Long trajet en silence. Air conditionné. Quelques photos des superbes plages privées. C'est peut-être la une de l'édition locale. (Paru le 10 juillet.)

33

un peu douloureusement, par le photographe, sur un mode légèrement dépressif :

« 4 juillet : la ville est vide... je me force à faire une photo.
15 juillet : plus seul que jamais.
21 juillet : l'annonce n'est jamais revenue.
22 juillet : je ne saurai jamais rien de cette petite fille.
30 juillet : tout ce que je fais n'a aucun intérêt.
7 août : j'ai l'impression qu'il me manque beaucoup de choses à cette chronique ».

On voit bien, à suivre ce thème de la rencontre dans les notes de Depardon comment elle est vécue par lui de façon nécessairement malheureuse : même quand la rencontre a lieu, c'est une mauvaise rencontre (le suicidé), c'est une rencontre forcée, c'est une rencontre volontairement manquée (Mia Farrow et Mick Jagger qu'il ne photographie pas), ce n'est qu'une rencontre à moitié réussie (l'annonce lumineuse sur Mitterrand), c'est une rencontre de toute façon insatisfaisante (la petite fille dont il ne saura jamais rien) et de toute façon incomplète (bilan du dernier jour) !

Masochisme ? pas exactement : tout se passe en fait comme si Depardon essayait de se convaincre lui-même que la photographie est malgré tout affaire de bonne rencontre, tout en s'évertuant dans le même temps à rater ou à déprécier toutes les rencontres réelles qu'il lui arrive de faire. Il ne serait pas le premier (et il ne sera pas le dernier) à se tromper sur son désir et à en souffrir : heureusement pour nous, Depardon ne cède que rarement, dans sa pratique, à ce faux désir de bonne rencontre. Il photographie le plus souvent dans la droite ligne de ce que je suppose être son véritable désir de photographier, qui est de préserver son rapport au réel ou saurait ses images de ces fameuses « bonnes rencontres » — dont la photographie française est si friande, et qui la rend si misérablement anecdotique par rapport à l'américaine. Mais s'il travaille ainsi, à l'intuition, contre les idées

34

8 juillet 1981, New York. Don Hogan Charles. 17 ans au New York Times. Dans 5 minutes nous partons ensemble à l'hôpital faire ses victimes du tueur de Bowery dont tout New York parle. (Paru le 11 juillet.)

35

174

reçues, tout particulièrement en journalisme, à propos du réel et de la rencontre photographique, c'est au prix du doute, au prix de faire à ses dépens la douloureuse expérience du manque et de la solitude.

9 juillet 1981, New York. Trois cents nouveaux pompiers à l'Hôtel-de-ville. Matif des conducteurs du métro. Entre deux reportages, Snapshot à Brooklyn. Sous cette chaleur, la ville a un petit côté « Beyrouth ». (Paru le 13 juillet).

36

37

Il faut dire que toutes les conditions extérieures se sont trouvées réunies, un peu miraculeusement, et sans préméditation (sinon sans perversion de la part de Raymond Depardon) dans ce dispositif inédit de « correspondance » photographique, pour que le photographe soit amené à vivre de façon aiguë cette expérience du manque à rencontrer le réel dans l'acte photographique.

L'idée même de correspondance implique une absence structurelle, celle du destinataire, qui ne vaut la peine d'être soulignée que parce qu'il s'agit ici d'une expérience photographique. Le décalage dont j'ai dit plus haut qu'il était la condition de l'écrit et qu'il faisait défaut à l'acte photographique est ici mis en scène, un peu théâtralement, par le dispositif de la correspondance, dans la distance entre celui qui photographie, à New York, et le destinataire de l'image, qui est un autre et qui est ailleurs, à 8 000 kilomètres de là.

L'absent, le destinataire imaginaire, devient donc ce qui cause la photographie, beaucoup plus que les sollicitations immédiates de l'extérieur. Et cette question : qu'est-ce qui cause la photographie ? est à mes yeux de la plus haute importance. L'absent, dans ce dispositif de correspondance, l'est si j'ose dire doublement : de ce qu'il ne s'agit pas pour le photographe d'un destinataire imaginable sous les traits d'une personne réelle, mais de ce destinataire imaginaire aux traits on ne peut plus flous, le lecteur d'un journal. Il y a donc bien une place du destinataire, mais cette place est vide. Reste seulement pour le photographe le contrat de correspondance comme forme vide de la demande : l'obligation d'envoyer une photo par jour, quoi qu'il en soit des circonstances extérieures et quel que soit son désir (ou son non-désir) de photographier.

Vide, cette demande l'est d'autant plus que le contrat accepté par le photographe le laisse entièrement libre de photographier ce qu'il veut, comme il le veut, sans consignes ; c'est à lui, dans sa soli-

7 juillet 1981, New York. Vélo en fin de journée à Central Park, avec Claudine et Bob, deux amis de l'agence Contact. Pendant que nous parlons, à 5 minutes d'intervalle, nous croisons Mia Farrow dans la Rolls de Woody Allen et Mick Jagger en bermuda rose avec un talkie-walkie. Je ne fais pas de photo. (Paru le 14 juillet).

38

39

tude, d'imaginer une demande au lieu de cette place vide. Telle n'est jamais la situation du photographe d'agence qui a toujours affaire, plus ou moins, au réel d'une demande, celle de la valeur marchande de ses images et à ce qu'elle induit de norme implicite.

Tout ce dispositif fait que la situation dans laquelle le photographe va se mettre au travail ressemble étrangement à la dure condition de l'écriture et ne peut que l'isoler dans une totale solitude, la vraie solitude, celle qui a l'absent pour horizon et qui est exposée, comme le dit Blanchot, au dehors multiple : « Il n'y a pas de solitude si celle-ci ne défait pas la solitude pour exposer le seul au dehors multiple ». Je reviendrai plus loin sur la nécessité de poser cette multiplicité ou variété des choses pour que le sujet fasse l'épreuve de ce manque-à-être qui l'expose au désastre, à la mauvaise rencontre.

« Plus seul que jamais », note Depardon le 15 juillet, et il faut le croire à la lettre, mais cette solitude, extrême, devant l'acte photographique était inscrite dès le départ dans le dispositif même de cette correspondance et il ne fait pas de doute qu'il l'ait d'une certaine façon désirée. Toutes les images de cette « correspondance », quoi qu'il en soit, en portent la trace : photographier y devient à la fois un geste pour sortir de la solitude (se projeter vers les autres) et un geste qui confirme irrémédiablement le photographe dans cette solitude en redoublant la coupure ordinaire entre le sujet et le monde par la distance d'un regard (le regard-derrière-la-machine), distance qui se retrouve inscrite dans les photos de Depardon sous la forme marquée d'un effet-de-rampe (distance + frontalité).

5 juillet 1981, New York. Il pleut ce matin. La ville est triste en venant au New York Times qui est près de Times Square. Un cinéma change de films. (Paru le 15 juillet).

40

41

1982
Robert Rauschenberg **Photos In+Out City Limits New York C.**

The artist Robert Rauschenberg declared, in a statement that has been quoted many times, that he wanted to work in the gap between art and life. Photography was a good medium with which to occupy that space. As he confessed, everything came out of his personal struggle to find himself between curiosity and timidity, which he resolved with the camera. At Black Mountain College, where he studied with Harry Callahan and Aaron Siskind, he took a lot of photographs. He liked them so much that he planned an impossible project: to photograph his country from coast to coast, inch by inch. A "fiction" worthy of a tale by Jorge Luis Borges, which he nevertheless undertook thirty years later, in the early 1980s, in the series In+Out City Limits, which emerged out of that student obsession given new life by a commission from Trisha Brown for the set design of the ballet Glacial Decoy: a backdrop on which hundreds of black-and-white slides, taken on the streets of Fort Myers, Florida, would be projected.

Those images resuscitated the Black Mountain College project, albeit toned down somewhat. Instead of photographing all of the United States step by step, it would be enough to do it city by city. Together with Terry van Brunt, Rauschenberg visited New York, Atlantic City, Baltimore, Savannah, Boston, and Los Angeles in 1980 and 1981, photographing urban details that were to become interchangeable: they worked by discarding the differential facts that made each of the cities individually recognizable.

Rauschenberg captured the trivial, ordinary aspects of urban experience, but with no pretension to improve it and no desire to transform the photographed fragments into monuments of any kind. He then selected a few of the images from all those collected in order to publish his experiment. Following the quest with the camera, in search of transitory, almost random images, there came the task of presenting them in a similar way to the viewer, in exhibitions and two photobooks: In+Out City Limits Boston (New York, 1981) and Photos In+Out City Limits New York C.

"The photos of In+Out City Limits make no attempt to totally document, moralize or editorialize the specific locations. They are a collection of selected provocative facts (at least to me) that are the results of my happening to be there," wrote Rauschenberg in the introduction to his photobook about New York. A declaration of intentions that precedes a dozen of his first photographs, with some portraits of artists and friends, and a small selection from the New York street series. The photographs evidence a calm, curious gaze, detailed and fragmentary, very different from the dizzying vision characteristic of the combination of painting, photography, and collage, not to mention objects and installations, that make up the better-known production of this total artist who was also a photographer. [H. F.]

New York: Untitled Press, ULAE 1982 / 325x255 mm, [156] pages, white cloth, white slipcase / 70 b&w photographs by Robert Rauschenberg / text by Colta Ives / photogravure

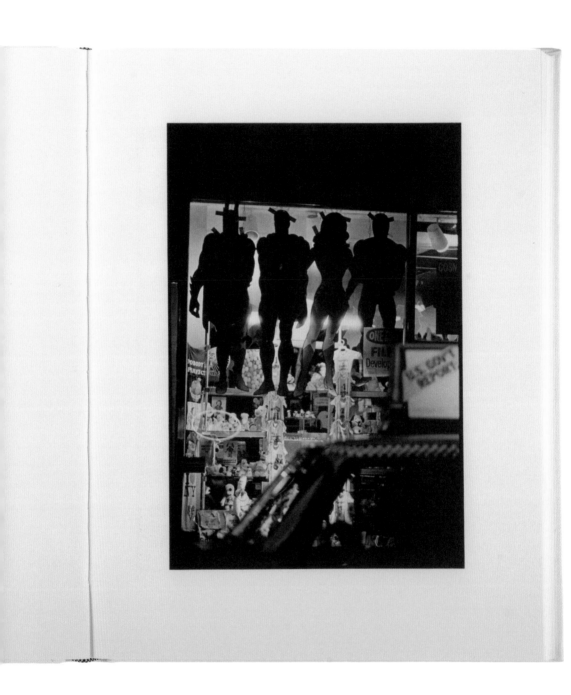

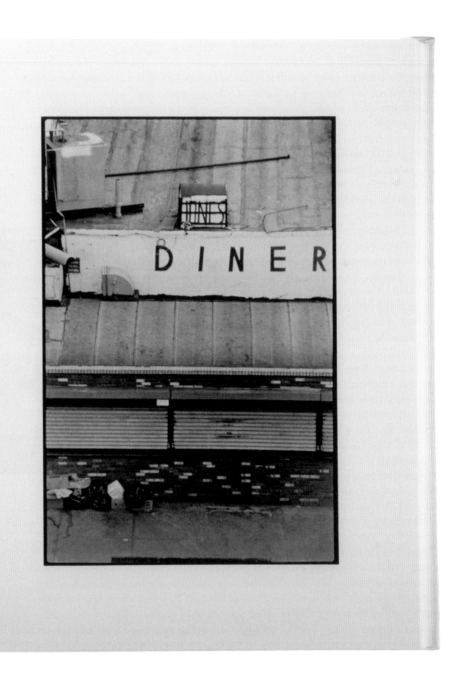

1982
Keizo Kitajima **New York**

In the interview included in this photobook, Kitajima defines himself as someone who only feels comfortable when he loses himself, taking photos, playing chess, or drinking. He does not carry his camera with him unless he is planning to use it. Surprises don't interest him, but neither does he pursue anything in particular. "I feel like I only really started to live after I began taking pictures. Through the conventional educational system, people told me that I should achieve some goal, like passing exams or getting good grades. But now I have learned that there aren't really such goals in life."

Kitajima was twenty-eight years old and already had a career behind him. After taking extended classes with Daido Moriyama, he worked in 1979 in a claustrophobic gallery: the walls covered with enormous photographic reproductions, many other images on the floor, among the folding chairs, and a shelf of magazines such as *Photo Express*, with its close-ups of Tokyo nightlife and the people of the Shinjuku neighborhood, a focus of underground culture swarming with politically engaged students. His own photographs, with their exaggerated contrasts, are not of great importance to Kitajima: to his way of seeing, they are simply a testimony of his life.

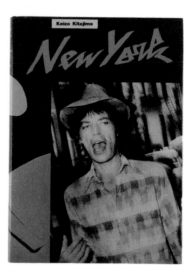

In 1980 he photographed Koza, the Chinatown frequented by the soldiers of the Okinawa military base, where he found emotional meanings: affection and hate, rejection and acceptance. Okinawa is the most *Americanized* city in Japan, a country where, in Kitajima's view, everything comes back, in one way or another, to American culture. In some way, he felt the need to visit his own particular America: James Baldwin's *Another Country*. With the help of some prize money, he was able to spend six months in the city of his favorite movie, *Taxi Driver*. He found a city full of foreigners like himself, an endless display window of emotions and differences. He loved the raw, chaotic spirit of the place, the fact that its streets were equally home to beggars and stars: "I photographed people like Mick Jagger, and Madonna before she made it big. Celebrities, immigrants, drag queens, high-class, low-class—it didn't matter."

Everything, absolutely everything, was visible. He understood why Weegee called it a "naked city," where a glance is enough to determine the status and rank that distinguishes the rich from the poor, the famous from the unknown. The poor are beggars: drunken, homeless, crazy, ugly, old. The rich are cheerful, decadent, ridiculous. The famous are visible, even exhibitionist. The unknown are the inhabitants of the streets and the punk and New Wave clubs of the East Village, violent, sensual young people, many of them disguised or cross-dressed in an endless carnival. For good measure, Kitajima throws in some pachyderms of all classes and styles. All captured in a tone at once somber and brilliant, whereby Kitajima evokes perhaps a tenebrous version of some reborn Middle Ages, with their vaguely European legacy of ancient, somber cultures. [H. F.]

Tokyo: Byakuya Shobo 1982 / 300x215 mm, [188] pages, gray cloth, illustrated dust jacket, obi / 140 b&w photographs by Keizo Kitajima / text by Kazuo Nishi / interview with Keizo Kitajima by Akira Suei

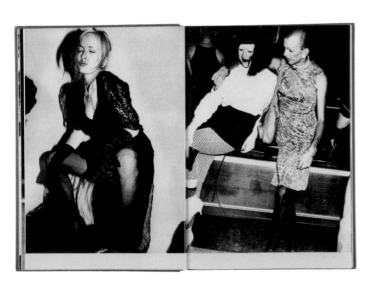

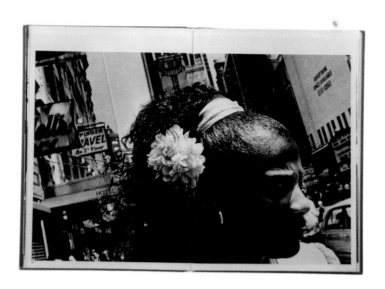

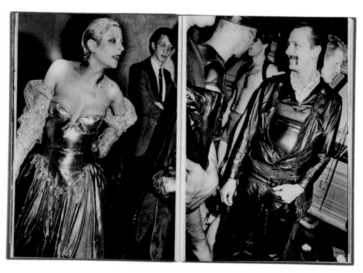

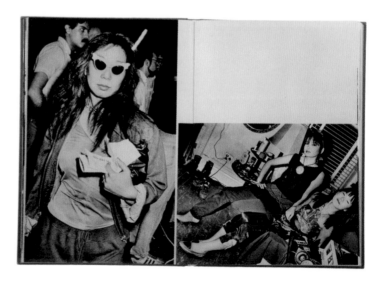

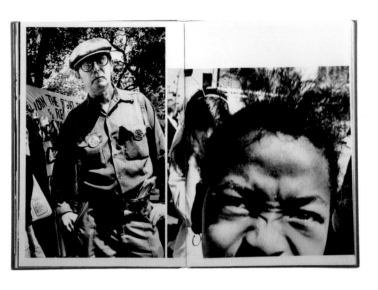

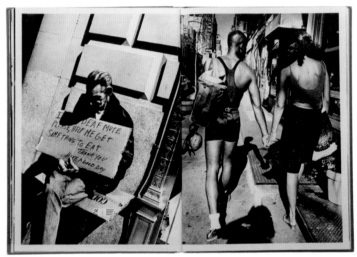

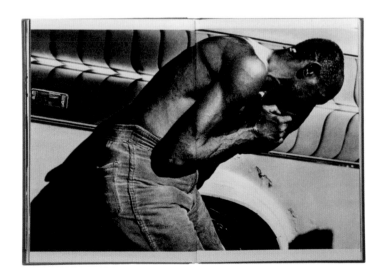

1983
Juan Fresán **New YO.rK.**

This book is not exactly a photobook, among other reasons because its author, Juan Fresán, was not exactly a photographer. It is a book of images by a graphic designer, whose discipline is indispensable to the making of photobooks, though it often goes insufficiently acknowledged. A photobook is a collection of photographs, but it is also, in the end, a work of art requiring production, typography, layout, proper paper, format, volume, printing, binding. And all of these involve graphic design decisions.

Fresán mostly organized his book about New York on the basis of photographs with scorching contrasts, taken from who knows what magazines and newspapers, recomposed on a photocopier in a particular kind of collage, and finally arranged in full-page or more often double-page spreads. As theorists of cinematic montage have pointed out, a series of two images, each one with its own meaning, produces a third image with a new and different meaning, or without any meaning at all until it ends up acquiring one, as in one of the double-page spreads of this book, on which Fresán placed a bandage just where, twenty years later, two planes would explode against skyscrapers.

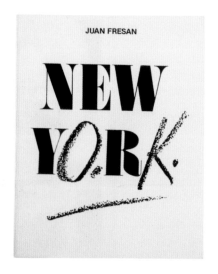

On other occasions, the sum transformed into multiplication produces humor in every degree, from irony to sarcasm, but without any moralizing. There is the good humor of pop culture when Spiderman becomes entangled in the spider's web of Brooklyn Bridge. But there is also a more bitter humor, which shows the city as appetizing as a frankfurter and as dangerous as a stick of dynamite. Or even black humor, in the big apple locked up with countless locks and concealing a sharpened knife. The skyscrapers squash the individual like a cockroach and turn into syringes, codes, cigarettes, crossword puzzles... And also into monumental dildos, which make up part of a hypersexualized city where even Superman is discovered, to his surprise, in another body. In any case, Fresán enjoys the city, from the very cover of his book, which bears the wordplay: *New York O.K.*

The economy of means of this collection of photocopied montages has some well-known ancestors, such as the Dadaist John Heartfield or the Productivist Alexander Rodchenko, an artist almost as versatile as Juan Fresán himself. The latter describes himself in this book as a "sailor, shipwreck survivor, beggar, newspaper distributor, journalist, swindler, searcher for magical Amazonian grass, sacristan, Parisian artist, etcetera, etcetera." Apart from this all-but-legendary autobiography, Fresán acknowledges that, in order make a living, he also works as a graphic designer and creative director. He began in these roles in Buenos Aires in the 1960s, where he prepared advertising campaigns and designed magazines and books, in addition to producing two artist's books: *Casa tomada*, an architectural adaptation of a story by Julio Cortázar, in 1969, and a year later a somewhat visual pseudo-biography of Jorge Luis Borges. He lived thereafter in Venezuela (where he made more books, successfully ran a political campaign, and prepared a newspaper), Cuba, Spain, and finally Argentina again. He died of pneumonia in 2004 in Buenos Aires. [H. F.]

New York: Universe Books 1983 / 280x215 mm, [96] pages, illustrated softcover / graphic design and 46 b&w montages by Juan Fresán

189

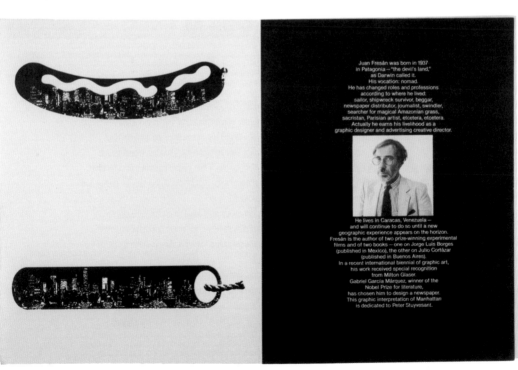

Juan Fresán was born in 1937
in Patagonia — "the devil's land,"
as Darwin called it.
His vocation: nomad.
He has changed roles and professions
according to where he lived:
sailor, shipwreck survivor, beggar,
newspaper distributor, journalist, swindler,
searcher for magical Amazonian grass,
sacristan, Parisian artist, etcetera, etcetera.
Actually he earns his livelihood as a
graphic designer and advertising creative director.

He lives in Caracas, Venezuela —
and will continue to do so until a new
geographic experience appears on the horizon.
Fresán is the author of two prize-winning experimental
films and of two books — one on Jorge Luis Borges
(published in Mexico), the other on Julio Cortázar
(published in Buenos Aires).
In a recent international biennial of graphic art,
his work received special recognition
from Milton Glaser.
Gabriel García Márquez, winner of the
Nobel Prize for literature,
has chosen him to design a newspaper.
This graphic interpretation of Manhattan
is dedicated to Peter Stuyvesant.

1983
Claudio Edinger **Chelsea Hotel**

Claudio Edinger ended up staying at the Chelsea rather unexpectedly, for mostly practical reasons. Even so, the special atmosphere of the hotel finally won him over.

Designed by Hubert & Pirsson, the building had been inaugurated in 1884. At twelve storeys, it was then the highest in Manhattan. Conceived as one of the first residential cooperatives in the city, it was converted into a hotel in 1905, the apartments being subdivided, with various different configurations, to adapt it to its new purpose.

Since the 1940s, the hotel had been managed by the Bard family, and until 2007 the Bards continued to welcome, install, and attend to the needs of guests, most of them involved in the worlds of art, music, literature, dance, theater, or fashion. Under the family's management, the Chelsea became a little vertical city where individual freedom and collective tolerance generated a space in which to share the creativity that pulsated between its walls. It was a genuine hotbed of twentieth-century culture: a meeting place that made possible an almost tribal sense of belonging, where absolutely everything, including even family life, had a place.

The first of many photobooks made by Edinger, *Chelsea Hotel* opens with an image of the façade of number 222 on 23rd Street. The oriel windows loom over the main entry. On either side, other windows and balconies, and behind each window a private space: a stage and a potential drama.

But above all an opportunity to create remarkable black-and-white portraits. Most of them reflect a great deal of complicity between sitter and photographer. Portraits of peculiar

PHOTOGRAPHS BY CLAUDIO EDINGER
With Centennial Reminiscences by Arthur C. Clarke • William Burroughs • Viva • Clifford Irving • Richard R. Lingeman
INTRODUCTION BY PETE HAMILL

people and also portraits of private spaces, full of significant details. Edinger avoids the most extravagant guests (of whom there was no shortage, eccentricity being a constant at the Chelsea) and focuses on the permanent residents, as well as on some of the hotel workers. Every portrait, almost all of them posed, allows secrets to be discovered and rooms—each with its particular atmosphere—to be pried into. The captions identify the subjects and usually include a brief statement, explaining their activities, or their reasons for living in the hotel, or some pressing existential concern.

Nor does Edinger let the lobby escape him, where lives cross and works by some of the residents are exhibited; the elevator, whose uncomfortable confinement promises passions and music; the artists' workshops; the birthday parties of children or of pets. To each its nest, to each person his or her story.

In spite of this focus on people, the Chelsea emerges from amidst the persons and objects, in the details of its cast-iron balconies, its windows, its paneled doors, its fireplaces, its friezes, a checkered floor... In this way we get to know the hotel, which is transformed into yet another subject, at times even more central than the rest. [C. P.]

New York: Abbeville Press 1983 / 178x227 mm, 156 pages, illustrated softcover / 86 b&w photographs by Claudio Edinger / introduction by Pete Hamill / contributions by William Burroughs, Arthur C. Clarke, Clifford Irving, Richard R. Lingeman, and Viva / designed by Len Zabala

23

"The atmosphere of the hotel is so creative...even the
bookers get pregnant." —bellman Gene Winfield

77

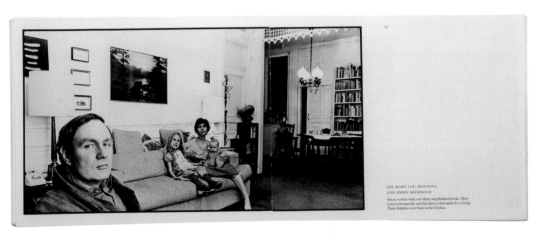

JIM, MARY LOU, ROXANNA,
AND JIMMY SHERWOOD
Jim is a writer with over thirty unpublished books. Mary
Lou is a housewife and Jim drives a limousine for a living.
Their children were born in the Chelsea.

02

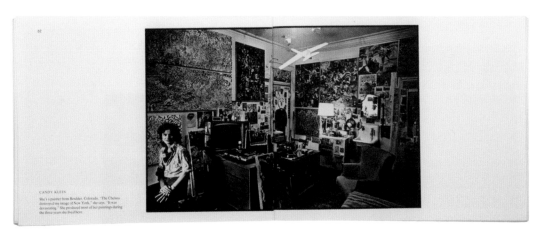

CANDY KLEIN
She's a painter from Boulder, Colorado. "The Chelsea
destroyed my image of New York," she says. "It was
devastating." She produced most of her paintings during
the three years she lived here.

STANLEY BARD

Manager and co-owner (center) of the Chelsea, he says that everybody has some kind of eccentricity. "You will find 'originals' all over town. I am an eccentric also— eccentric about this place."

ELEVATOR

It is said that the Chelsea's old elevator is haunted and will stop at the first floor for no reason. No one comes in and no one gets off. People say it's the ghost of Sid Vicious, the late guitarist of the Sex Pistols, whose last address was Room 100 at the Chelsea.

JASMIN MARJORIE PAGANELLI

She does catalogue distribution for the art auction house Sotheby Parke Bernet. A former dancer with the "White Dream Company" in Amsterdam, she says, "Here I feel I'm in Europe, not in America."

DAVID SCHWARTZ

As a newspaper reporter he has worked for the *Chicago Tribune* and the *Cincinnati Post*. He has written two books and paints with his fingers as a hobby. Every time the phone rings, he cleans his fingers on the wall before answering it. "My wall is a masterpiece," he says.

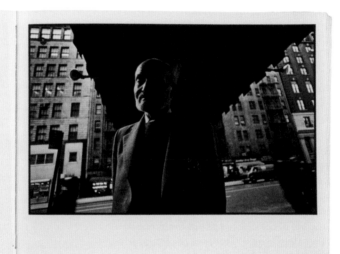

W. M. CORNELIUS HALL

He invented metallic mortars that are used to shield and contain nuclear facilities.

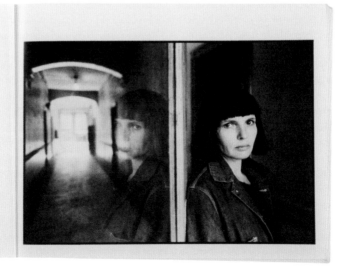

SABINE MONYRIS

A realist painter from France.

1984
Lenke Rothman, Tana Ross **OK OK No New York**

Lenke Rothman (1929-2008) was a Swedish artist and writer of Hungarian origin, whose family perished at Auschwitz. She herself, though sick, survived. Transferred to Sweden for treatment of her tuberculosis, she studied at the school of fine arts and became a well-known artist. In 1981 the Museum of Modern Art in New York awarded her a grant that included the organization of an exhibition. Rothman set up an installation with fabrics, some of them (such as a lace gown) brought from Sweden and others found in New York, to which she added other objects and images, especially papers and photographs tied up with yellow ribbons.

In preparing the exhibition, entitled *Life as Cloth*, Rothman worked with documentary filmmaker Tana Ross (b. 1940), also a death camp survivor (in her case, Theresienstadt) who had emigrated to Sweden after the war. *Silence* (1998), a film by Orly Yadin, recounts the long oblivion of her childhood, broken only when she visited an exhibition of children's drawings done in the camps. Ross was then able to write and interpret a work entitled *Through the Silence: for Cello and Survivor*.

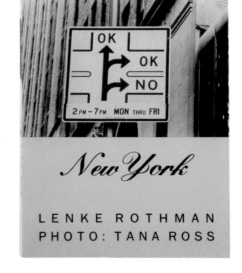

Rothman's work is also marked by her experience in Auschwitz, which often appears in the form of collages of photos, fabrics, and papers. This photobook (which is also an artist's book) gathers in its final pages some collages of the type used in the installation, but the best part is the harvest of objects found on the streets of New York City: an archive of things that bear the traces and impetus of life, seeming to shout out: "Don't ask why. We want to live!"

As Rothman writes in the foreword: "Between the angel above Central Park and the bag lady on a bench on Fifth Avenue, the life of the city has got its content and characteristic meaning formed. Traces of life left by lives. My seeing was drawn to all these traces almost magnetically. The pulse and the face of the big city became visible and tangible to me in what was trodden into the ground, in each fragment, in petrified remains of life, in a slip of paper welded to the asphalt by the sun. As if life itself had acted as a camera and frozen all the testimonies about itself."

Tana Ross's camera documents Rothman's searches. She is almost always looking at the ground, at abandoned things which, in images, cease miraculously to be discarded and are transformed into traces full of memory and meaning. At times the point of view rises and discovers announcements on the walls: "UNUSUAL TIME PIECES," "DANGER," "HISTORY," "PASSPORT." From time to time there are broken, abandoned umbrellas, symbolizing the fragility of all shields. In another section of the photobook there is a series of photos of very small, very familiar things: a thimble, pins and needles, a paper bag, a top, a doll... And a frightened rabbit, always about to flee, a constant in the work of Lenke Rothman. [P. M.]

Ahus: Kalejdoskop förlag 1984 / 220x170 mm, 112 pages, illustrated softcover / 86 b&w photographs by Tana Ross / 30 b&w additional photographs, 9 by Elias Arner / text by Lenke Rothman / designed by Lenke Rothman and Sune Nordgren

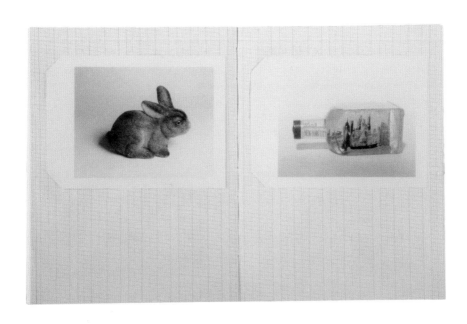

3.

4.

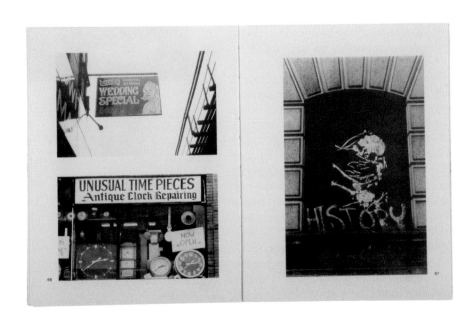

1985
Nobuo Nakamura **Harlem no Hitomi** / **The Eyes of Harlem**

In 1970 Nobuo Nakamura moved to New York without knowing more than a few words of English. He began by working as a kitchen helper in a restaurant, but soon obtained a contact in a photography studio, where he offered to work for free. One day he was given an old large-format Deardorff, and in his spare time, between the restaurant and the studio, he took photos. He had a theme in mind: joy, a feeling he had discovered one day as a child in the bathtub, listening to the playful laughter of his parents in the next room and feeling a sense of bliss invade his body. For Nakamura, joy means union, the ties that binds us one to another like members of a family.

He experienced that joy again walking through Harlem, where he saw the residents of the neighborhood bathed in the light of the setting sun. He saw in them the same delicacy, the same warm and friendly gazes as those with which a father looks at his children. He saw teenagers in a circle around a ghetto blaster, adults walking to church, young people dressed in the latest fashions. He approached them all, proposing to capture the "tenderness of Harlem" reflected in their faces. He was a little frightened occasionally, but he soon decided to take his own family with him on his weekend excursions, during which he also approached fruit and flower vendors, musicians, amateur fishermen, bikers, boxers, preachers, and newlyweds. His photos show individual and group portraits captured on the fly: a man in a wheelchair; a little girl with a ball; martial arts enthusiasts training in a vacant lot; children out on Halloween night; girls dressed up on a parade float. Dignified, satisfied people, who look at the photographer with the same warm curiosity as that with which he observes them. Nakamura also captures the changing of the seasons, the water suppliers that spring up in summer and the cemetery covered in white in the dead of winter. It is only in the last photo of the series (an empty building with broken windows) that the slightest note of melancholy is sounded, though Nakamura does not for all that fail to capture the floral graffiti with which someone has decorated the foredoomed doors.

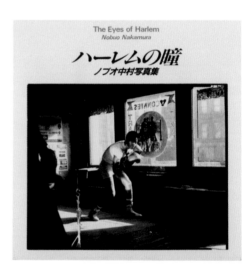

The Eyes of Harlem was published on 3 June 1985, by which time the author was back in Japan. The contents are distributed simply: an introduction in Japanese, another in English, and the body of images, facing each other on opposite pages or alone on the odd-numbered pages. It ends with another text in Japanese that includes a map of Harlem showing where the photos were taken, as well as a brief note on the author and two self-portraits taken *en famille*: Nakamura and his wife (topless) preparing a barbecue and Nakamura with his two children, the city at their backs. His book, with its warm appearance, radiates the same happiness he claims to have felt when a public library in New York bought the series of photos for its archives. [I. G. U.]

Tokyo: Chikuma Shobo 1985 / 290x290 mm, 108 pages, illustrated softcover, illustrated dust jacket, obi / 83 b&w photographs and essay by Nobuo Nakamura / introduction by Koko Yamagishi / designed by Kazuo Nitta

Vegetable Sellers —— 野菜売り

Vegetable Sellers —— 野菜売り

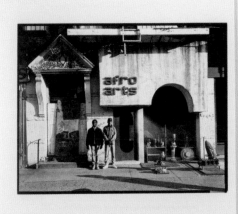

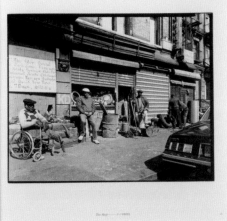

Two Men at Afro Arts —— アフロ・アーツ前に立つ二人の男

The Shop —— イスの利用者

Bull Paintings and Volkswagen —— 壁画とフォルクスワーゲン

Man with Shovel —— シャベルを持つ男

Boys on the Wrecked Car

John and Joe at the Farm

Higher Goals

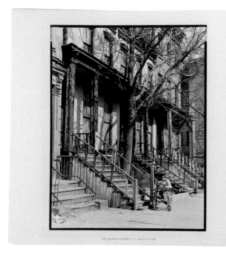

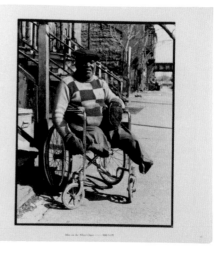

Man on the Wheel Chair

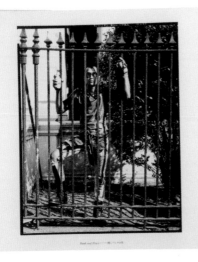

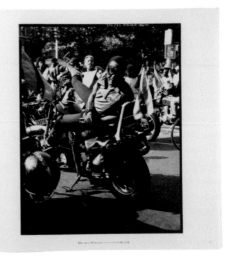

Dusk and Flora ——雨にうたれて

Man on a Motorcycle ——バイクの上の男

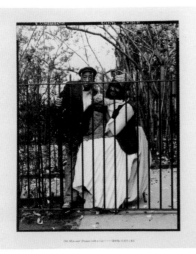

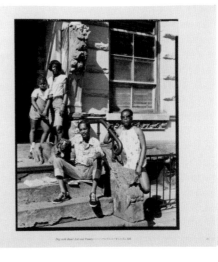

Old Man and Woman with a Cat ——猫を抱く老夫婦

Boy with Band Aid and Family ——バンドエイドをした少年と家族

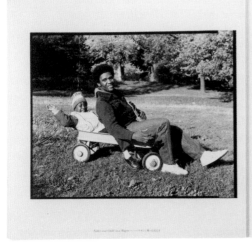

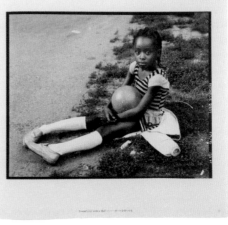

Father and Child in a Wagon ——ワゴンに乗る親子

Seated Girl with a Ball ——ボールを持つ少女

1986
Bruce Davidson **Subway**

Bruce Davidson thought the subway was a kind of social equalizer in the city. This opinion, which he formulated in the text contained in *Subway*, a photobook first published by Aperture in 1986, is the perfect synthesis for defining his work in the New York City subway system.

Over the years, Davidson revisited his *Subway* series on three occasions, adding new photos and eliminating others, changing the juxtapositions, significantly modifying the original form of the book, but maintaining its character of the visual record of an equal sign. The first edition has a highly cinematic cover design. Its shape is wider than it is high and it contains a sequence of sixty photos. The agile, rhythmically regular cadence of the layout is like the rattling movement of a subway car, with blank pages serving to slow down the gaze and bring it closer to certain images. The treatment of color underlines the oppressive, menacing sensation provoked by the subway, the mélange of lights, the heat of the cars without air conditioning. The CMYK color model is tight and dense, with color dominants.

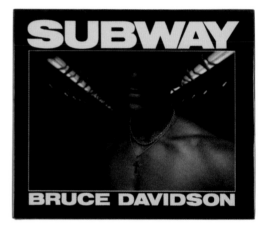

The second edition has more personality. The number of photos was increased at the request of the publishers. The format is again wider than tall, and the cover photo is the same. The size of the reproductions has also been maintained, but there are no blank pages. The treatment of color is rather extreme, with certain aberrations caused by the mixing of lights inside the subway cars endowing the photos with strange dominants that lend them an unreal touch, sometimes cold, sometimes violent and frenzied. It is difficult to know whether this is the result of an editorial decision or simply due to careless prepress preparation. In any case, it works.

The great increase in the number of photos also make this edition a different book, or at least it offers a very different viewing experience, much more intense and unsettling.

The 2011 Steidl edition is the least interesting. It has the rather cold, formal touch of books published by this German house. The square format makes for a less dynamic experience, as the photographic blot remains stable and the white grows around it, constricting it. A curious fact about the editing is that the main change is not the creation of new juxtapositions, but simply a modification of the order of the existing combinations. The negatives were rescanned and the color dominants and density of the images corrected, rendering them softer and giving them more light. An unfortunate decision. Color is not always something to be corrected in line with a supposed norm, but something to be managed, like a state of mind. What was previously powerfully evocative becomes insipid in this edition. Another curiosity is that the conclusion changes. The second and third editions share the same juxtaposition of closing images which, though slightly different, leave a bitter aftertaste. The conclusion of the first edition, on the other hand, remains vital and liberating. [G. G.]

New York: Aperture 1986 / 252x297 mm, 88 pages, cloth, illustrated dust jacket / 60 color photographs and text by Bruce Davidson / afterword by Henry Geldzahler / designed by Wendy Byrne

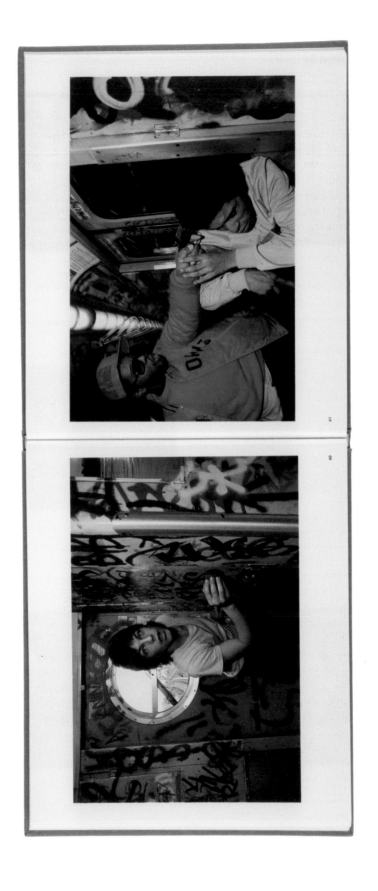

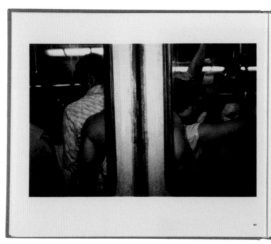

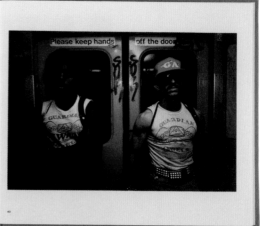

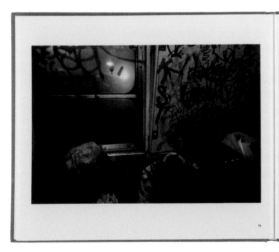
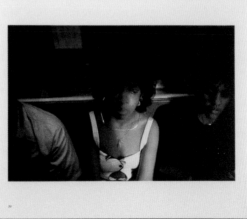

207

1988
Ken Schles **Invisible City**

Although many have tried, few have succeeding in creating a lasting and relevant book about one of the most hackneyed themes in the history of photography: street photography in New York City. One of these books in doubtless *Invisible City*, by the American photographer Ken Schles (b. 1960), and it succeeds on its own merits.

In the late 1970s, a very young Schles settled in the conflictive neighborhood of the East Village with aspirations to become an artist. Years later, under the influence of Larry Fink and then Lisette Model, he began to evolve his own photographic language, becoming familiar, thanks to his mentors, with the finest tradition of American street photography and studying a wide spectrum of forerunners, from Jacob Riis and Berenice Abbott to William Klein and Lee Friedlander.

For a decade he exhaustively documented his own violent, unsettling surroundings, a symbol of underground culture at the time, with no attempt to describe them objectively, but rather as he felt and experienced them. The result was an enormous archive on which he drew masterfully to create the book that concerns us here, working largely with the editing and sequencing skills he had acquired during his time as an assistant to Gilles Peress. Friends, lovers, strangers, situations, spaces... they were all given equal importance in his camera, avid for intensity, and everything was touched by a dark poetry shot through with traces of humanitarianism.

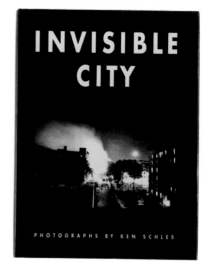

Still in his twenties, and with no career behind him, he faced the task of finding a publisher. He assembled a notable collection of rejection slips and then, just when he was about to throw in the towel, received an unexpected phone call from Jack Woody, the director of Twelvetrees Press, an imprint of the Twin Palms publishing house. Woody had a hunch on seeing the dummy and did not hesitate to turn it into a book.

The production quality of the book was excellent and the now denigrated photogravure printing brought out the deep blacks of Schles's original photos to perfection. The print run of the first edition was only 2,000 copies, risibly small for the time. The result was that the book was sold out within a year and became a coveted collector's item. The inaccessibility of the first edition to a wider public is a circumstance that the author still laments. It was only twenty-five years later, as a consequence of growing popular demand, that Steidl decided to reprint it.

The book is constructed in a simple, deliberate manner. The sequence of full-page bleeds carries a strong symbolic charge: as in a well-crafted symphony, it takes us through the mental and emotional landscapes of the author. The inclusion of texts by various great writers seems rather pretentious, as if this external scaffolding were necessary and the real power of the visual language were not sufficient. Schles is the author of five other books, including *Night Walk*, which revisits his photographic files of the time and forms a sort of diptych with the present volume. [I. D.]

Pasadena: Twelvetrees Press 1988 / 230x175 mm, [80] pages, black cloth, illustrated dust jacket / 62 b&w photographs by Ken Schles / text by Lewis Mumford, George Orwell, Jorge Luis Borges, Franz Kafka, Jean Baudrillard / photogravure printed in Tokyo / 2,000 copies

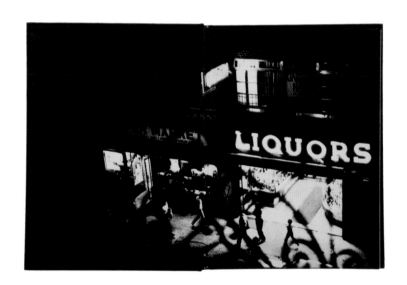

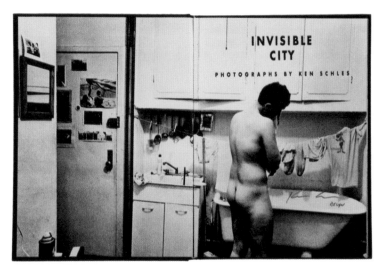

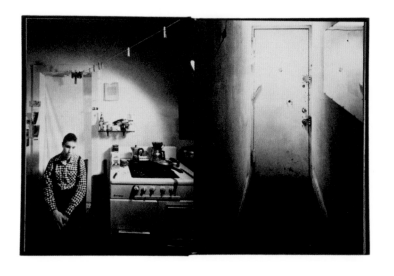

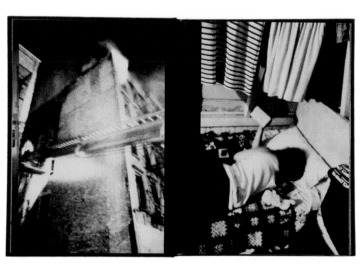

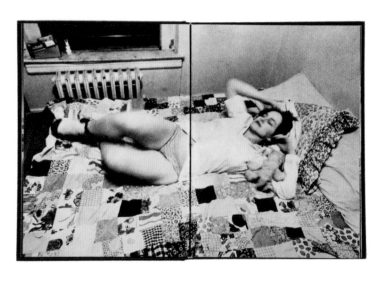

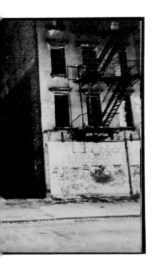

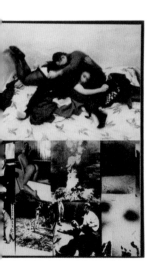

1988
Arno Fischer New York Ansichten / 150 Fotografien

It is surprising how many books were published in the Deutsche Demokratische Republik (the DDR, or East Germany) about cities in the capitalist West, given that travel to it was not even permitted to ordinary citizens. *New York Ansichten,* by Arno Fischer, belongs to this category of publication, as does *New York. Die explodierende Metropole,* by Karol Kállay (1967), and *London zu Fuß,* by Roger Melis (1986), all published by the state publishing operation Volk und Welt. Fischer, a professor at the Academy of Visual Arts in Leipzig and one of East Germany's most influential photographers, had the opportunity to photograph New York City in 1978 and 1984. His book, which won an award in the DDR, contains one hundred and fifty photos, half of them in color and half in black-and-white, in addition two other black-and-white motifs of the city by night at the end.

The book opens with a text by Heiner Müller that evokes the lugubrious atmosphere of New York, described as "one of the great errors of humanity." Designed by Jörg Brosig, it is organized into three chapters, the first and last of black-and-white photographs and the middle one reserved for color. The first photo—taken on the Staten Island ferry in 1978—is possibly Fischer's best-known image: in the foreground, a man with his head resting on his hand, lost in bemused reflection. Behind him, the other passengers lean on the railing, with eyes only for the New York skyline. The photograph is symptomatic of the ambivalent situation in which a photographer from the DDR finds himself in the big city.

The visual language wavers between subjective astonishment and more sober documentation. The outsider of East German socialist realism wanders around New York, photographing discreetly from the perspective of a *flâneur.* Fischer refrains from taking a critical tone with the capitalist system—normally unavoidable in photography books published in East Germany—for that is not his aim. There are "critical" motifs, but also colorful vistas of skyscrapers. In general, the photographer maintains his distance.

The jacket shows a red van moving down Broadway, with a young black man carrying a child on his shoulders in the foreground. The child has a Polaroid snapshot in his hand and is looking toward his left. The moment captured by Fischer is a typical motif of a genre in danger of extinction: street photography. It is also typical of Fischer and, who knows, even typical of New York City perhaps.

A surprising feature of the jacket is that it is printed on both sides: the back shows an infrared photograph of Manhattan, as if the city were being observed from above. The book also contains a detached map of the city, small and rather superfluous, which permits a certain rough orientation without actually invading the territory of a guidebook. The reader may leaf through the photographs, granted: but not travel to New York. [T. W.]

Berlin: Verlag Volk und Welt 1988 / 275 x 245 mm, 168 pages, loose map, cloth, illustrated dust jacket (double), cardboard slipcase / 152 photographs (77 b&w, 75 color) by Arno Fischer, 1 aerial view (author not stated) on the backside of the jacket / text by Heiner Müller / designed by Jörg Brosig / 25,000 copies

Fifth Avenue

Downtown

Eleventh Avenue, Midtown

Fifth Avenue - Columbus Day

42

43

Midtown

Columbus Circle

70

71

Fifth Avenue

Broadway

164

165

Avenue of the Americas

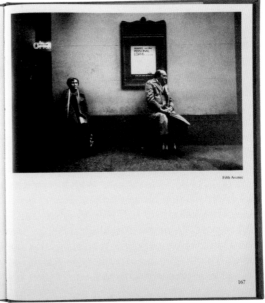

Fifth Avenue

166

167

Ryan Weideman **In My Taxi / New York After Hours**

A good start: the 1980s, and the Big Apple is full of worms. A guy raised in the Midwest, an army veteran, arrives in New York at the age of twenty-six. He wants to be a photographer, but he ends up driving a taxi on the night shift. To liven up his evenings, Ryan Weideman—that's our man's name—decides to attach his camera to the rearview mirror and photograph with a wide-angle angle lens every passenger that gets into the back seat of his old Checker cab. For the next decade or so, he becomes a hunter of butterflies, moths, and glowworms, the last tracker of what he himself calls the "Weegee hours." We now have the entomologist and his tool, so it's not surprising we will soon have his collection. The taxi will be a felt-lined box in which specimens of New York fauna will be pinned with a flash: a girl biting her hand; ladies and gentlemen of Madison Avenue; men who look like gangsters; women who look like prostitutes; Marilyn T-shirts; whole families; party-goers; unlikely couples; trios of aces; short skirts and garter belts; punks and kids; broken noses; a guy who looks like Basquiat; six queens laughing; Robert Duvall; plenty of mesh stockings; a snake as a pet; gangs and packs; a girl on crutches; puffs of smoke; a real jazzman; dark glasses; elegant hats; and, at the end, Allen Ginsberg giving the author a handwritten note that reads: "The backseat of a New York taxi is a human zoo. Ryan Weideman taxi-dermist has mounted these human species-types with humor, boldness, & precision."

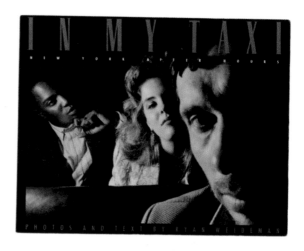

Some of the images are series in which the main variable is the rare bird that happens to have gotten into the cab that night, but others contain an additional charge: in 1983, tired of repeating himself, Ryan Weideman began to include himself in the photos, next to his clients, in a process on which he comments as follows in the introductory text: "These self-portraits become a continuation of my family's album from the Depression. True, I gather information about the city—what people look like, how they behave—but for me these photos form an autobiographical record of my episodes in the cab." With this strange decision, the author who began as a taxi driver and then became a photographer (or vice versa) now turned into a centaur—half-cab-driver, half-photographer—and into a protagonist of urban history, with his own collection of mythological beings. Men and women living to the rhythm of the night in those years, who remain together forever in this simple, rectangular book with no great claims to memorable design, but which for less than twenty dollars gives you an irrepressible urge to shout: "Follow that cab!" [J. V.]

New York: Thunder's Mouth Press 1991 / 200x255 mm, [96] pages, illustrated softcover / 84 b&w photographs and text by Ryan Weideman / cover designed by Tilman Reitzle

Gallery, I get a good crisis. I'm driving on lower Fifth Avenue and notice a familiar face. It's a girl who appears in a group shot I'm using for the gallery invitation—a photo taken two years earlier. How exciting it is to see her and have her ride in my taxi again, right before the opening of my exhibit. I hand her an invitation and ask, "Do you recognize anyone?"

"You're having a show, that's great!" She answers with a soft smile.

"Yes," I reply, "and you're gonna come to my opening, right?" She does. Two more years elapse before I see her again, standing on a street corner with some friends, hailing a cab. It's like a reunion. They're going to a night club and want me to join them. How could I refuse?

217

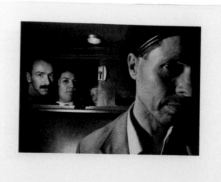

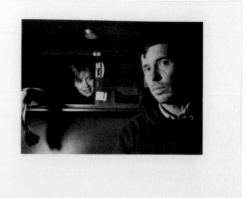

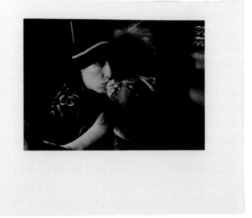

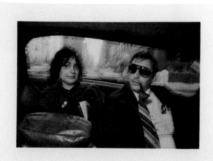

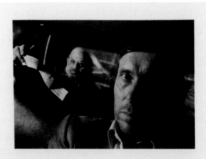

Backseat of a taxi 1990 Tokyo is a heaven. Zoot Kojak W. saigon taxi-driver was mounted two women fucking with human + colours + smiles A friends. A[...] 12/2/90

1992
Bruce Gilden **Facing New York**

It little matters whether you can orient yourself in a gesture, said Walter Benjamin. Losing yourself in a gesture, on the other hand, as you would lose yourself in the woods, has to be learned. *Facing New York* proposes an entire gestural poetics in black-and-white. Each page, a scene extracted from a comedy of the vanities; the whole, a motley gallery of expressions, grimaces, furious gesticulations. The laughter of men and women submitted to a play of the eyes, of mouths and hands, served in close-up. With his Leica, street photographer Bruce Gilden captures the gesture just at the moment it is about to erupt, making it explode before our eyes. There is not a single smile in this great theater of the world. For how to confront the world of New York in 1992? How to face it down? Here the city is not even a décor, not even a backdrop on which the bodies can be imprinted: it is reduced to pure atmosphere and it is a confining atmosphere, though an exterior one. The face of New York is the changing face of those who pass through it, whether New Yorkers or not, whether human beings or not: one has only to observe the gesture of the dog that seems to manifest his fear with his tail. No, not one of the characters on this stage laughs. Disconcertedness, however, abounds. No neutral faces. Here neutrality would be synonymous with death. There is a mimicking of surprise, of pain, of fatigue, of anger, of mistrust. One image leads to another image, and each one of them seems born of a spontaneous impulse. Thus, Gilden, the stray dog, is also an armed highwayman— armed with a camera—who divests the leisurely passerby of his cherished convictions. And photo by photo he seems to be weaving together fragments of an unfinished tale, through which, in some way, the mood of his time would be perceived. If, in general, the thought provokes the image, the opposite is the case here: it is the image that provokes the thought. The person being photographed is thinking, the viewer is thinking, but Gilden only undertakes to set the mechanism going. Flash in hand, he walks rapidly, tirelessly sniffing about and sticking his nose into where it doesn't belong, pillaging signs, ticks, mannerisms. With every click of the shutter he marks the

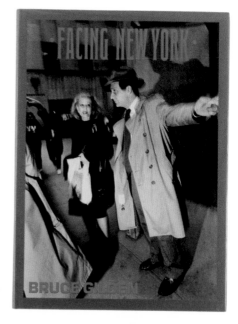

territory before leaving it and slipping into another one, in order to appropriate it. There is a touch of violence in his technique, the same violence that is laid bare in his photos. As Susan Kismaric has written: "The cast of characters in Bruce Gilden's theatre of the street is outrageous. Sometimes tawdry and out of this world, they are mostly mysterious.... In Gilden's world, no-one is on the margins of the centre stage, they are all star players." It was Karl Kraus who said there are two types of photographers: those who are and those who aren't. In the former, form and content go together like body and soul; in the latter, form and content go together like body and clothes. [C. R.]

Manchester: Cornerhouse 1992 / 342x252 mm, 92 pages, cloth, illustrated dust jacket / 44 b&w photographs by Bruce Gilden / designed by Yolanda Cuomo

221

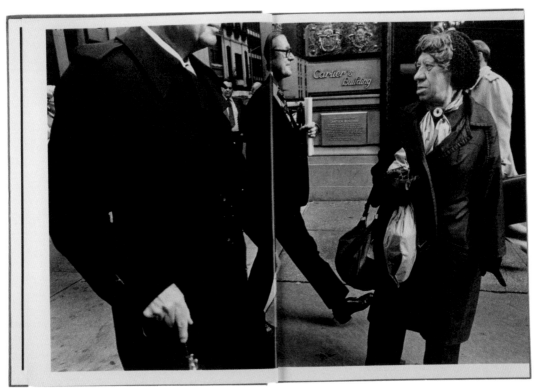

223

DESCRIPTION OF A JOURNEY. In an interview with Nan Goldin, Nobuyoshi Araki explains how difficult it is for him to work outside of Japan, since he forms relationships with his subjects through words and he only speaks Japanese. He made the comment in allusion to a trip to New York in 1979, undertaken to attend the opening of an exhibition in which he participated. He was there for just a few days, but that did not stop him from taking a large number of photographs, including the more than one hundred and twenty gathered in this book about the city. In terms of quantity and variety, they attest to an irresistible urge to snap the shutter. Photographic diarrhea, as he himself has described it.

His personal relationship with a place he was formerly unfamiliar with marks the book. Although it does not cease to be a description, what underlies it is the relationship of the photographer with his exterior surroundings, as in much of Araki's work, which has always engaged with external reality and the way one confronts it.

And how did Araki engage with New York? At first, as someone who knew it through visual references. Through William Klein, of course, who so influenced the Japanese of his generation: the beginning of the book seems a declaration of affinity with Klein's *New York* (1954), with all those scowling faces, in perpetual movement. As if, even before getting off the plane, Araki had already decided where he was going and what he was going to do.

Because if William Klein's photographs had a mythical quality, so did the place that generated them. And the artist who had already paraphrased the Walker Evans of the subway series and who delighted in the Cassavetes of *Faces* (1959) clearly had a preconceived image of the city in his mind. In time, however, the model began to fade and reality began to assert itself. Following the initial images, Nobuyoshi Araki seems to propose an immersion—progressive and partial—into a city that offered countless stimuli to someone as avid as himself. In the panoply of potential subjects there to attract him, sex had to have a place, but there were also elegant African-American families, paintings by Balthus, and street advertising of various kinds.

From the first images of the subway until the final panoramic views from a skyscraper, we accompany the photographer on a journey that almost suggests an allegory: from the unknown that circulates underground, a recipient of so many personal urges, to the lucidity of one dominating the landscape with a general view. A journey that definitely suggests a cinematic narrative: before becoming a professional photographer, Araki made films and, as mentioned above, Cassavetes was among his first influences. His journey took him from a relationship with a mythical territory to the description of that same place, now stripped of elegiac references. [P. L.]

Tokyo: Heibonsha 1996 / 225x155 mm, 256 pages, softcover, illustrated dust jacket / 117 b&w photographs and text by Nobuyoshi Araki / other texts by Jim Jarmusch and Akihito Yasumi / designed by Seiichi Suzuki Design Office

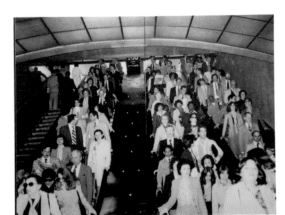

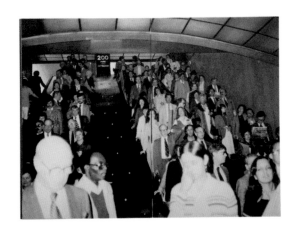

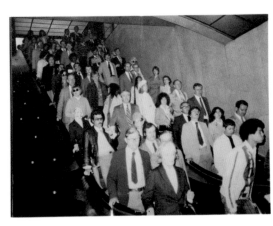

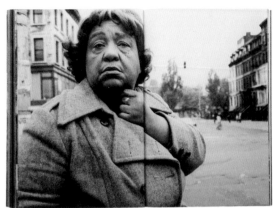

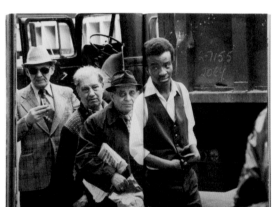

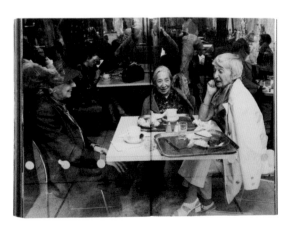

1996
Thomas Roma **Found in Brooklyn**

Thomas Roma manages to portray his home borough—that city within a city, Brooklyn, which he knows like the palm of his hand—from a distance, like someone from another place. In spite of certain discernible influences (perhaps that of his father-in-law Lee Friedlander is the most obvious), Roma has as personal a style as the camera he himself designs, builds, and uses. Taken over a period of sixteen years, starting in 1974, in rigorous black-and-white, the photographs of *Found in Brooklyn* demonstrate that the strange and the ordinary can go hand in hand. They are exceptional notes of street life, examples of occasionally eccentric architecture, and images of people who seem unaware of the presence of the photographer, all bathed in a magnificent, impressive, omnipresent light... Like the cover photo showing a girl in a convertible, her arms extended, absorbed in taking the rays of the sun to her face.

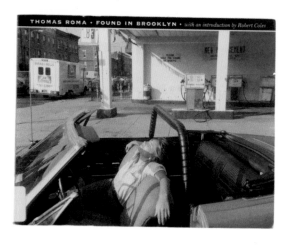

Roma's Brooklyn is perhaps the best demonstration that, in spite of everything, New York City belongs fully to this country that calls itself America: an ancestral place where history consists of human beings' stubborn will to tame their surroundings. The low houses have been erected on land robbed from nature, which nature is trying to recover: witness the trees springing up between chinks in the asphalt or withering for lack of moisture because of it, the vines twisting around the railings, the weeds invading the lots. That pigeon that extends its wings as the door of the pigeon coop opens. There are objects that seem abandoned and helpless, as if they were only there to stain the image: statues and easy-chairs, garbage pails and armchairs, a ladder leaning against the wall with no one to use it. In his introduction, Robert Coles describes a world of clotheslines and clothespins and towels transformed into the backdrop for some drama. When a human figure appears, it is never clear what is intended: some children burning something in the middle of the sidewalk; a young man watching the traffic from his perch up in a tree; a girl waiting beside a poster inviting her to come on in; a neighbor holding a hammer. Sometimes they put up an awning, or kiss on the hood of a car, or just make do with the pavement, or in front of an overhang.

Found in Brooklyn has no photo captions. One page limits itself to dating the images and another provides a couple of technical notes on how they were taken. The review of the book in *The New York Times* noted how Roma managed to describe beauty with unappealing materials. The book came out in 1996, around when Paul Auster and Wayne Wang were paying tribute to Brooklyn in *Smoke* and *Blue in the Face*. Next to theirs, Roma's is the Brooklyn of the Old Testament. [I. G. U.]

New York, London: W. W. Norton, Center for Documentary Studies 1996 / 190x240 mm, 94 pages, illustrated softcover / 45 b&w photographs by Thomas Roma / text by Robert Coles / designed by Molly Renda

39

43

47

49

2002
Here Is New York / A Democracy of Photographs

"They haven't seen anything," declared Jean-Luc Godard about the 9/11 attacks, in one of his famous *boutades*. And he was right in a way, since the news media circulated only a very limited number of images, repeated ad nauseam. And yet never had so many photographs been taken of an event. So, in that same year of 2001, the members of Magnum published *New York September 11*.

For New Yorkers, what happen on September 11th was not just a media event, but an incredible nightmare which, thanks to digital cameras, was thoroughly documented. It is that material, gathered by ordinary residents of the city, that is the subject of *Here Is New York*, a project that began as an exhibition and then grew into a website and a book. It was the initiative of a group of photographers who issued a public call for photographs of the attacks. The anonymous images received were scanned, printed in a uniform format, and hung without credits or any additional information. The exhibition opened on September 25th in a gallery in Soho and soon turned into a mass phenomenon. It was on the basis of this archive of five thousand images that the book was prepared, with a selection of almost one thousand of them.

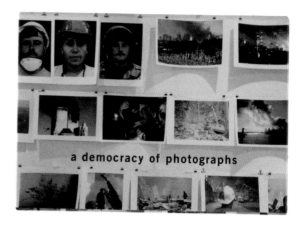

The project took its title from E. B. White's *Here is New York*, published in 1949 and full of strangely prophetic warnings: "A single flight of planes"—we read—"no bigger than a wedge of geese can quickly end this island fantasy, burn the towers, crumble the bridges..." The twenty-first-century edition abounds in images of destruction: ruins, stunned gazes, human remains...

The book is as sober in its design as the exhibition was: images on both pages, framed in a thin white border, the rhythm occasionally broken by full bleeds or shorts series on the same theme. The selection was made by the editors, who did not seek out iconic images so much as the most complete possible description of the event. "If one photographs tells *a* story," writes Michael Schulan in the introduction, "thousands of photographs not only tell thousands of stories but perhaps begin to tell *the* story if they are allowed to speak for themselves." This does away with any "decisive moment" of 9/11, proposing instead the multiple viewpoints that make it impossible to idealize the event (as also proposed by Alexander Rodchenko and other Soviet theorists in the 1920s). And it shows how digital technology has blurred the distinction between author and public: we are all potential photographers. Thus, Susan Sontag, was able to say that *Here Is New York* is a demonstration that, in photography, chance, spontaneity, rawness can be as valuable as technical perfection. Something which, in the book itself, is interpreted as an expression of democracy, whose basis is not the isolated individual, but the collective vision of a whole body of citizens. [J. O.-E.]

Zurich: Scalo 2002 / second edition / 208x300 mm, 864 pages, illustrated hardcover, illustrated slipcase / 938 photographs (b&w 174, color 764) by 480 photographers / a project by Alice Rose George, Gilles Peress, Michael Shulan and Charles Traub / edited by Alice Rose George and Gilles Peress / introduction by Michael Shulan / designed by Yolanda Cuomo and Gilles Peress

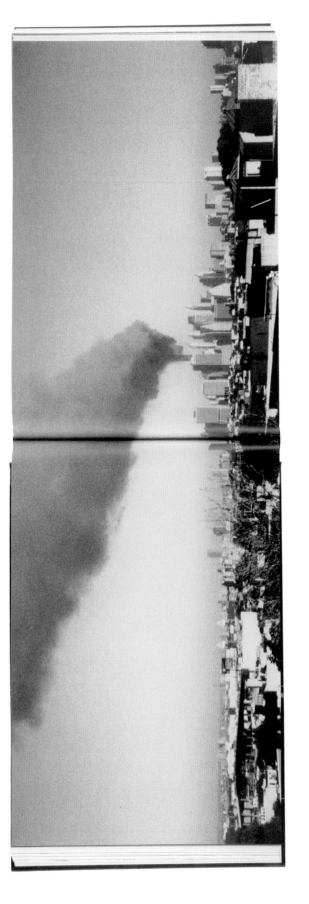

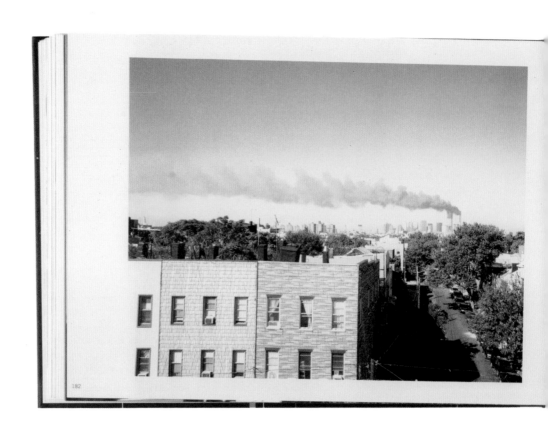

182

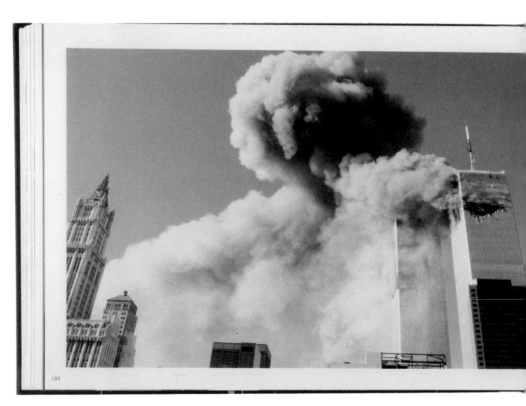

184